DAVID NASH

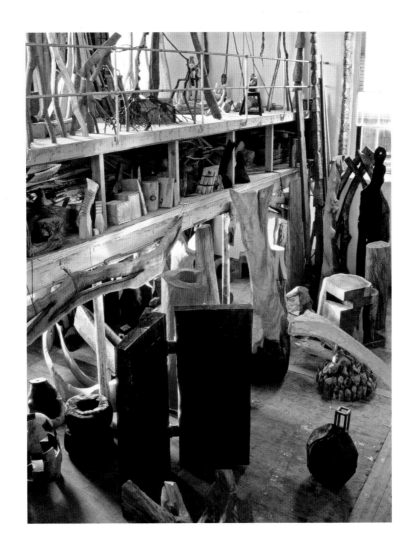

DAVID NASH

Introduction by
Norbert Lynton

Half title: Capel Rhiw, 2006

Frontispiece: David Nash at Cae'n-y-Coed, 2004

Endpapers: Vale of Ffestiniog, North Wales (front) and Blaenau Ffestiniog with slate tips (back)

Contents page: *Red Dome*, yew, Schwäbisch Gmünd, Germany, 2006, 110 x 270 x 270 cm

Acknowledgements
David Nash and Cameron & Hollis would like to thank the following for their kind assistance in collecting illustrations: Annely Juda Fine Art, London; Galerie Lelong, Paris, Zurich, New York; Galerie Scheffel, Bad Homburg, Germany; Galerie S65, Aalst, Belgium; Haines Gallery, San Francisco; L A Louver, Los Angeles; Nagoya City Art Museum, Japan; Nishimura Gallery, Tokyo; Metta Galeria, Madrid. Most of the photographs in this book were taken by David Nash, but thanks are due to the following photographers for their contributions: Shigeo Anzai pp.100 (top), 101 (top and bottom left and right), 102 (top left), 104 (bottom left), 106 (left – top, centre and bottom), 108 (bottom – left, centre and right), 109 (top left); Elizabeth Broekaert, pp.2, 53, 57, 59; Noel Brown pp.96 (left), 98 (top), Jan Caudron, pp.128-129; Rosa Feliu, pp.26 (top right), 27 (top), 111, 112, 114 (left and right), 115 (right), 149, 163 (top); Hartmut Hientzsch, p.5; David Hubbard, p.146; Eric Lombard, p.97; Wit McKay, p.126; Sue Ormerod, pp.89, 96 (right), 118, 119, 122, 135 (left); Ian Parker, 123, 144; John Riddy, pp.138, 159 (bottom), 163 (bottom), 166 (bottom); Rafael Suarez, p.39 and back jacket; Felix Tirry, p.139 (top); Wolfgang Uhlig, pp.32, 54 (top left), 55 (right), 78, 131, 133, 145 (left and right), 148 (bottom), 152, 153, 156, 157 (left and right), 162; Ferdinand Ulrich, p.113 (top); Sue Wells, pp.41 (right), 46 (bottom left), 67 (top right, bottom left and right).

First published in the United Kingdom in 2007 by
Thames & Hudson Ltd, 181A High Holborn, London WC1V 7QX

Produced by Jill Hollis and Ian Cameron
Cameron & Hollis, PO Box 1, Moffat, Dumfriesshire DG10 9SU, Scotland

Set in Gill Sans Light and Imprint by Cameron & Hollis, Moffat
Colour reproduction and printing by Artegrafica, Verona

British Library Cataloguing-in-Publication Data
A catalogue record for this book is available from the British Library

ISBN: 978-0-500-09339-9

Printed in Italy

CONTENTS

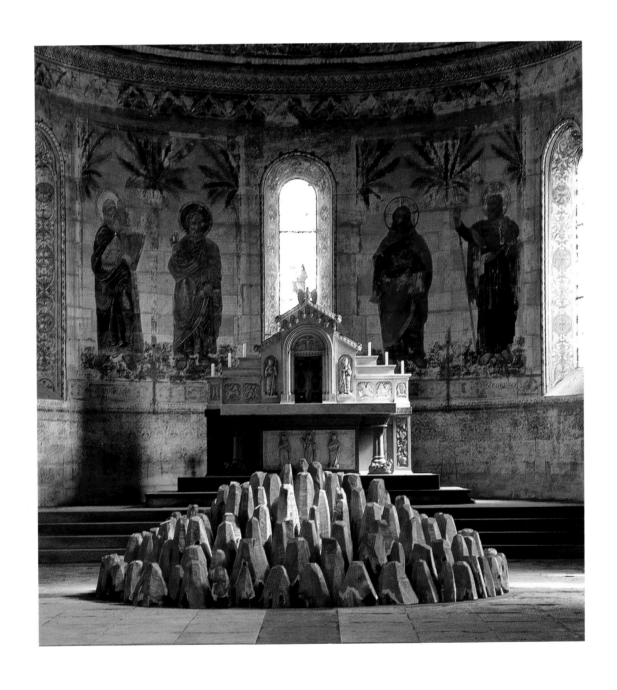

INTRODUCTION
Norbert Lynton

Mature, confident, fit, and incessantly and variously active: much to the surprise of anyone who meets him, David Nash is now in his sixties. He was a sculpture student at Chelsea School of Art in 1969-70, but as he was a post-graduate student, I and my colleagues in the History of Art and Complementary Studies department did not get to know him personally. The School's courtyard was not large and not considered a working area. But it invited elevation, not least because of the practice tower belonging to the fire station next door. We watched as Nash's tower (*Chelsea Tower 1*) grew and grew. Not everyone on the staff thought it a good idea to let someone erect there a rather undisciplined-looking assembly of found timber, with more than a touch of Dadaist anti-formality. But the Head of Sculpture, George Fullard, was encouraging the young man to work without formal or material restrictions. Fullard was strong, an anti-authoritarian authority, and he recognised the power of Nash's developing ideas and purpose.

In 1970 Nash was one of the first group of senior art students to exhibit in the Arts Council's series of young artists' exhibitions at London's Serpentine Gallery. His *Chelsea Tower 3*, built outside the Gallery, suggested a symmetrical, relatively formal and dignified gatehouse through which to approach the building. I had moved to the Arts Council early that year, but don't think I met him on this occasion either. I know he met with some difficulties over erecting this tower. He had wanted it to stand directly in and on the grass, but he was not allowed to disturb the royal turf and it had to go onto four stone slabs. Perhaps he was keeping his distance from Arts Council staff at that stage. By the time I was invited to write the introductory essay for his show at the Serpentine Gallery in 1990 (when I was at the University of Sussex) I certainly had some general knowledge of him and his work. Before I began writing, I visited Nash for two or three days at Blaenau

Left:
Tower 1
painted wood
Fuches Wen, Vale of Ffestiniog, Wales, 1967-68
900 x 750 x 600 cm

Centre:
Chelsea Tower 1
painted wood and metal
Chelsea School of Art, London, 1969
600 x 300 x 240 cm

Right:
Chelsea Tower 3
painted wood
Serpentine Gallery, London, 1970
750 x 300 x 300 cm

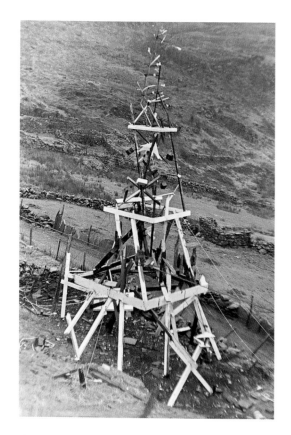
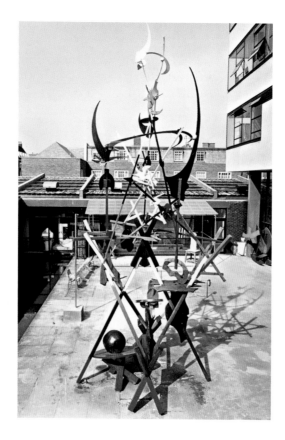
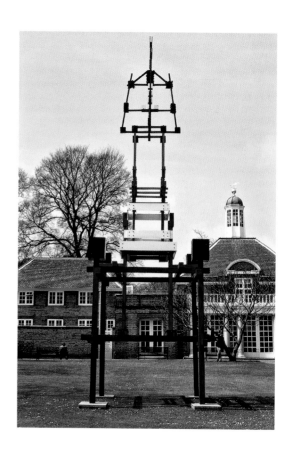

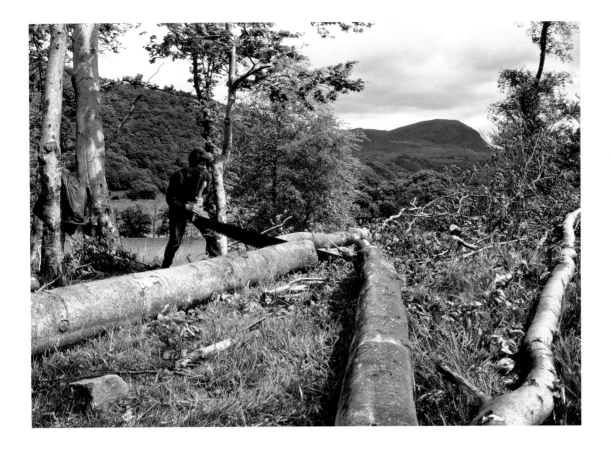

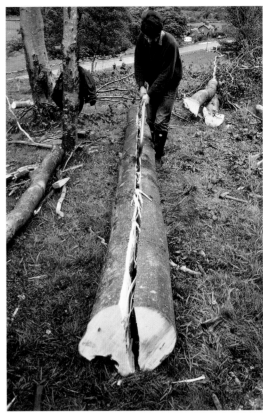

David Nash at Cae'n-y-Coed, Vale of Ffestiniog, North Wales, sawing beech (top left) and splitting a trunk along the grain with axe and wedge, (top right) for *Nine Leaners*, 1976 (above). The number of pieces was determined by how many could be split from the original trunk, their length by its length. They were leant against a pole strapped between beech trees. Overall size: 450 x 240 x 30 cm.

Ffestiniog in North Wales. I have recently returned from a second visit to the now significantly enlarged Nash establishment at and near Blaenau. Over the years he has grown both as artist and as the manager of his multifarious career. Growth, in this sense, is merely a matter of practicalities: better management of his work, materials and tools, the sending out and receiving back of sculptures and drawings, and of his professional records.

Nash now strikes me as a man of well-nigh Napoleonic strength and reach, but also as one at ease with his fellows and capable of something close to self-effacement while holding on to the reins that control his activities. He was soon involved in several other Arts Council exhibitions, at the Hayward Gallery in London and other UK locations, and then also in exhibitions organised and promoted by the British Council abroad. It was not difficult to have some awareness of his progress although he kept himself remote from the British art world. His early decision to live and work in North Wales kept him at some remove from art events in London and from the artworld debates and controversies on which the UK's awareness of contemporary art depended: notably the challenge issued to the St Ives School of abstracted landscape painting, and to British lyricism in general, by the artists shown in the Situation exhibitions, and the sudden emergence of Pop Art in exhibitions and the new colour supplements, as well as the largely disturbing impact made by the Tate's American shows in 1956 and especially 1959.[1]

Born in Surrey, Nash had visited and loved North Wales from boyhood up, and, as he finished his first art training (in painting), he witnessed the financial problems young artists had to shoulder if they wanted to work and live in London. His need to be away from that hubbub and those strains, to be able to work without those pressures while also doing his best to make his sculpture known and to experience working around the globe, reveals fundamental aspects of Nash's roots and priorities.

In the 1970s he was showing sculpture, and soon also drawings, in group exhibitions in Britain, and from 1979 on he was seen similarly in New York, then also in continental Europe, around the USA and, by 1982, in Japan. He has made public sculptures in many cities as well as for rural sites. He has had innumerable solo exhibitions in museums and in commercial galleries. During the 1980s he showed in New York, Venice, Otterlo, Japan, Australia, Los Angeles, Tournus, Calais and Paris, Amsterdam etc., as well as in Britain. This swell in his activity, and the welcome it met with in so many places, as well

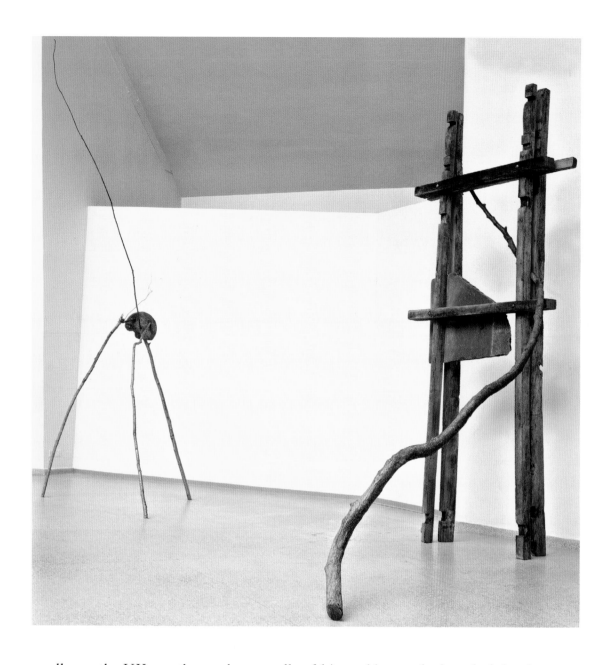

as all over the UK, are the product equally of his working methods and of the character of what he produces. To this day, his way of life has not changed fundamentally, nor is it likely to. He mentioned to me that he has not yet worked in, or shown in, Africa and South America, but of course this could change any day.

Nash has worked hard, physically and mentally, throughout these decades. He meets comments on his fitness and energy by outlining his ways of working – at first with the axe, chisel and handsaw, and increasingly since the mid-1970s with a set of chainsaws, from the small and relatively light one to the largest available and the heaviest. Physical action, most of it out-of-doors, is his way of life, and the physical as well as the mental benefits of that are plain to see. His work away from home takes him into all sorts of weathers and climates. In Japan, for example, in the mid-1980s, he learned that heavy timbers are moved more easily over deep snow and ice than over unfrozen ground. This was just one of the lessons he took from the team of forest workers assembled around him. Perhaps more important was his discovery that language problems disappear when a group collaborates out of shared experience and shareable skills and with guidance and hands-on example set by its leader. As the scale and character of his work has developed, Nash has called for heavier machinery to move, lift and help erect his sculptures; here. too. close understanding of the practical issues is essential. He has similar equipment in Blaenau now, operating it himself with a small group of devoted assistants. Our view of him has to accommodate this duality: the private man, working in and

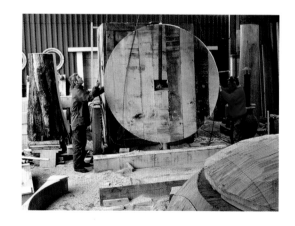

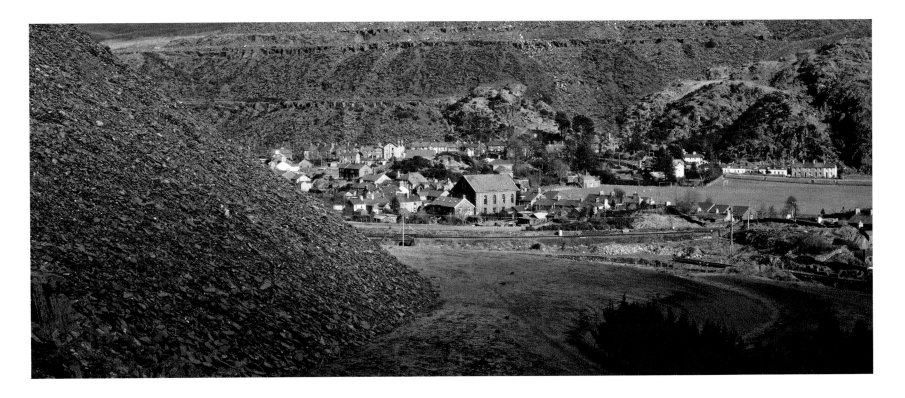

Above: Rhiw Brifdyr, Blaenau Ffestiniog, North Wales. The large building in the centre of the picture is Capel Rhiw, acquired by Nash in 1968 as studio and living space.

Below: interior of Capel Rhiw, 1969 (left), and front elevation of Capel Rhiw, with the slate tips of Blaenau Ffestiniog rising behind it, 1974 (right).

around Blaenau, often alone, and the head of a team, working in public and towards an immediate public outcome, out-of-doors or in a museum.

A key moment in his career was his acquisition in 1968 of Capel Rhiw. David Nash had not known he would want to stay in Blaenau when he arrived there the previous year. He had warm memories of the area from boyhood visits and explorations, but he knew only that he wanted to test his resolve to be an artist, to define it more closely for himself, and to see whether he could survive in the world on the strength of his various skills and interests. His fellow students were worrying about finding art-school places for advanced work; he felt this was a waste of time and attention, and decided that anything like an MA course would have to come later if at all. Living for some months in a pair of Blaenau cottages, Nash soon found he needed extra studio space and rented some in the basement of a hotel. The price of the chapel, for which he competed with a

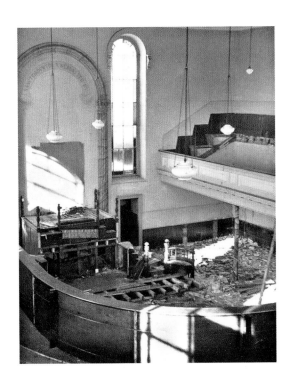

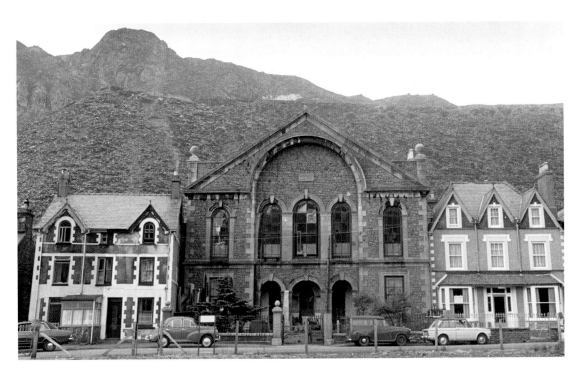

local man who wanted it for the stone, was remarkably low, but it strained Nash's finances, dependent as they were on handyman work around the town and for the Forestry Group (digging ditches and planting trees) and on teaching evening classes. From 1970 on, he taught a few days each month at Maidstone College of Art, giving a series of lectures that required him to formulate his ideas and their sources in words and specially prepared slides. (Soon he was teaching also in Newcastle, Norwich, Wolverhampton, etc., but he never allowed this to become a dominant activity in spite of the financial base it could provide.) The disused chapel offered what still strikes one as a vast hall including galleries and an end-to-end attic, together with a substantial Sunday School house and vestry attached to it and a piece of land dipping between that and the slate tip, in effect a mountain steeply rising to the north-west of the site. It was a bold move for a young man who was finding his feet in art at large and, more specifically, in contemporary art. But sculpture makes great demands – materials, working space and storage, equipment – and Nash had soon realised that sculpture would be his form of art.

Though now settled in Blaenau, Nash's next move was to apply to Chelsea in 1969 for a year of post-graduate study of sculpture – in effect a year of concentrated working in Fullard's department, with whatever guidance and opportunities the department could give him and with access to London's museums, especially the Victoria & Albert Museum which was within easy reach. That too must have been a momentous decision. In 1970 he emerged from Chelsea remarkably complete in himself, though young in experience and practice.

Perhaps I am overstating his lack of experience and practice at that stage. During the 'sixties he was still painting occasionally, and he always drew and sketched. If *Chelsea Tower 1* was shockingly informal, and *Chelsea Tower 3* was in sharp contrast to that, with its economy and its emphatic verticals and horizontals, in Blaenau he had earlier built *Tower 1* in 1967 which combined a relatively clear and legible structure with freely expressive forms. *Broken Archway* was built out-of-doors in 1968, with a straightforward structure supporting a host of poetic forms, and he re-used many of these in an installation he built in the chapel in 1968-69, *The Peaceful Village*. He was testing his range, tempted by the powerful appeal of expressionist paintings by Arshile Gorky that he had seen at the Tate Gallery in 1959 (during his time at Brighton College where Gordon Taylor was an outstandingly wise art teacher) and then also in books and catalogues. But the optimistic spirit and clarity shown by the work of western Constructive art, particularly that of Mondrian, was equally important to him. His means and materials, in this complex sculpture, were painted wood: found lengths, planes and lumps of timber and plywood, which he used as found or cut to the forms he needed. Painting the parts made for explanatory relationships between the elements of his sculptures and gave character and implied meanings to some of the forms. The culmination of this sequence came with a towering sculpture erected inside the chapel against the framed niche at its west end, *The Waterfall* (1970-71). Spreading wide at the bottom, and ending in a spire assembled of many pieces to rise to more than seven metres, with many curving planes and clusters of cut forms, large and small, attached to its rather spare structure, *The Waterfall* implies an act of homage to Gorky's painting of the same title by echoing some of its forms and much of its spirit, while also reflecting – with energy and joy but without any direct quotation from it – the natural world of North Wales. We know this sculpture only from photographs. Over that niche still curves a painted inscription retained by Nash to this day. It reads, in Welsh, '*Sanct Eiddiwydd a weddai i'th dy*', meaning 'Sanctify this house with prayer' or 'Reverence befits your house', depending on the interpreter.

These large constructed sculptures reveal only part of Nash's thinking at the time. He greatly admired the work of Brancusi, seen first in reproductions, but in 1965 Nash went to Paris, and again in 1967 and 1973, getting to know the reconstructed Brancusi studio well and sensing the way in which the artist united life and work. In Blaenau he was befriended by Phyllis Playter, long the partner of the novelist John Cowper Powys who had died in 1963. She translated some of Brancusi's aphorisms for the young man. He remembers many of them, valuing especially 'Good art heals'. In 1965 he saw also large exhibitions of the work of David Smith and of Alberto Giacometti at the Tate. If

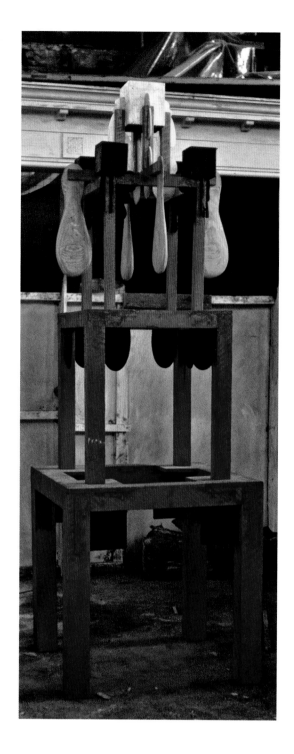

Tower with Props
painted wood
1970
270 x 120 x 120 cm

Capel Rhiw interior, 1971.

In the niche on the rear wall: *The Waterfall*, painted wood, 1970-71; in the centre of the photograph: *Table with Cubes*, pine, 1971; left foreground: *Bonk Pile*, sycamore, 1971; right foreground, partly seen: *Split and Held Across*, willow, 1971, and behind it *Pile of Bonks*, oak, 1971; above right, *Hanging Towels*, painted aluminium, 1970.

Balcony, Capel Rhiw, with *Archway*, painted wood, 1970.

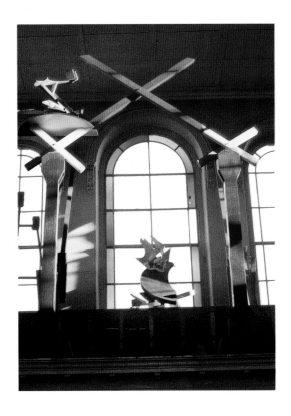

the Towers and the towering *The Waterfall* suggest a painterly, free-hand approach to making assembled sculpture, other early Nash sculptures, made in plaster and, in another case, of wood and Perspex, reflect both on the sculptures by Smith that combine drawing in space with suggesting imaginary places and on Giacometti's horizontal boards and divertingly shaped piazzas that invite imaginary perambulation and games. See, for instance, *Through the Arch* and *Three Planes of Distance*, made, respectively of wood and Perspex and of plaster. What these austere sculptures demonstrate is Nash's desire to examine horizontal space whereas the Towers had exploited vertical space. The maturing sculptor would explore both, and the polarity of vertical and horizontal continues to be clear, emphatic even, in Nash's work. What has also persisted, though in other guises, is his readiness both to sculpt, in the sense of shaping his material, and to construct by assembling and fixing found or shaped forms. For most sculptors these are alternative, opposed paths, but he makes no final choice between them.

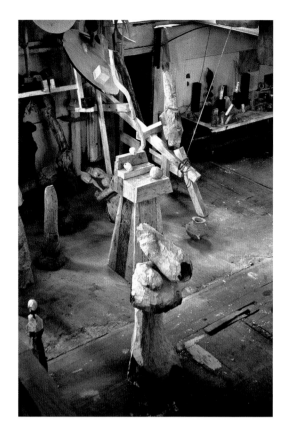

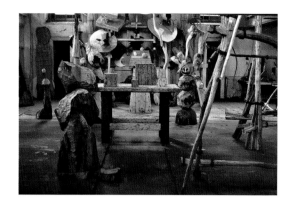

Fate, in the form of reckless tree-felling by a supposed expert who had performed randomly and left an area of woodland owned by David's father, near Blaenau, strewn with tree debris that this man could not be bothered to carry away, gave Nash the opportunity to make himself useful by clearing the ground while making what use he could of the timber he removed. He learned a lot about living trees and trees as material for sculpture at this stage, though his intimacy with nature was already long established. From 1971 on he worked with this gathered timber, often on the site and in solitude.

In 1972 he married the artist Claire Langdown. Their first son, William, was born in 1973 (and has become a sculptor too). That year David Nash had his first exhibition in

Above: details of Capel Rhiw interior, c.1971. The photograph in the centre shows (in the foreground) *Bonks on a Plinth*, 1971, and behind it *Bonks on a Rostrum*, 1971.

Below: leaflet produced for 'Briefly Cooked Apples' exhibition in York, 1973, which subsequently travelled to Bangor, North Wales.

The so far briefly cooked life of David Nash began in 1945. After usual schooling, he attended various art colleges - Brighton, Kingston, and a little later, Chelsea. After a long association with North Wales since childhood he moved to Blaenau Ffestiniog where his roots are now firmly laid. He and his wife live and work in a chapel at the foot of a slate tip.

What money that is needed to support a very simple form of living comes from visiting art colleges around the country as a lecturer; and odd jobs around the town as a joiner.

Colleges that he visits include Maidstone, Kingston, Norwich, Newcastle and Edinburgh.

"Briefly Cooked Apples" is David Nash's first exhibition which is organised by the York Festival.

BRIEFLY
AN EXHIBITION OF WOOD SCULPTURE
THE WORK OF DAVID NASH
COOKED
AT ST. WILLIAMS COLLEGE · NEAR THE
MINSTER · YORK JUNE 15 TO JULY 8 10—6 DAILY
APPLES

Taking it early in the morning. The sound of the axe bangs back off the hill from across the valley. Keep the thought to the elements of the action- the blade, its edge, the length of the handle, and the height of the toss up and pull down,- work round, this side, step over, that side. The white chips fly all around settling in the grass in a circle. Always keeping the wood between the blow and the ankle. Shave the angle of strike across the grain, not straight down. First cleave in and lift the grain, THEN, straight down on top of where it still holds and off it flies into the radius of white chips. The sound bangs back off the hill from across the valley. The rhythm of the effort develops into a steadiness of pace and time. Other thoughts happen in; thoughts back, thoughts forward, but the pace is of the time now.

York as part of the York Festival, curated by Gavin Henderson. It had a second showing in Bangor, in North Wales. Nash called it 'Briefly Cooked Apples', a phrase he collected accidentally by misreading a notice: he liked its many implications. For this show he produced a leaflet, with two pieces of text that are still relevant and characteristic, about himself and about how it feels to make sculpture in the open with (at that stage) axes, a mallet and wedges, an auger, a crow-bar, chisels and saws. It also reproduced a drawing, with brief captions, illustrating the exhibited sculptures and his tools, listing the sixteen sorts of wood he had used and including a few maxims for himself, such as: 'Do not sharpen the edge too keenly' and 'If you cannot go stop quietly'.

On another occasion, Nash described the physical action involved in making these sculptures:

> You don't just use your arms – you can go right down to your toes to get the rhythm going. I could saw for half-an-hour to an hour at a time, and it would be like a meditation, going through big pieces of wood … and this fluid, almost circular, spiralling, curving gesture of movement would be going into keeping the saw cut straight. And the actual wood I was cutting through had been formed in a 'gesture of process' … this growth, there's nothing straight about it – and there wasn't actually anything straight about my movements, to push and pull.[3]

'… keeping the saw cut straight'. It is the chainsaw that permits a curving cut and also a variety of ways of digging into a mass, where we might expect its powered action to be more proscriptive. But perhaps the key word in Nash's account of the spirit and the action called for by his work is meditation. It signals both an engagement in the working process that takes the artist to deeper levels and wider horizons and aspects of his thought that guide his work.

Looking through his sculpture of the early 1970s we witness a remarkable process of creative response to what nature offered, resulting in sculptures that are small, as in his sets of Bonks (a word he adopted from the miners' term for the access terraces cut into the slopes of their slate quarries, but used by Nash for chunky, rounded carvings), or his Balls (as in *Nine Cracked Balls*, 1970-71) or Pods, which again he would stack or gather into a carved container (e.g. *Pods in a Trough*, 1975), and others that rise to a substantial height, such as the *Rising Falling Column* of 1971 (300 cm high), a single piece of pitch pine carved into sections that suggest both motions at once, and the Tripods and other slender assemblies, mostly of hazel, that are roped or otherwise held together near the

Nine Cracked Balls
ash
1970-71
largest diameter: 40 cm

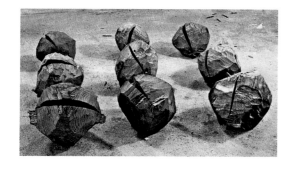

Capel Rhiw interior, c.1975.

In the foreground: *Three Clams on a Rack*, beech and oak, 1974 (left) and *Pods in a Trough*, walnut and oak, 1975 (right). Far left: *Up, Flop and Jiggle*, oak, 1975. Centre: *Cradle and Bow*, pine and rope, 1976.

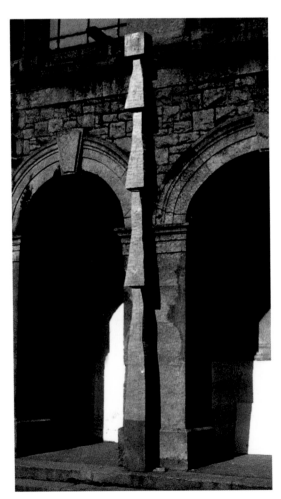

Rising Falling Column
pitch pine
outside Capel Rhiw, 1971
300 x 25 x 25 cm

top to stand their ground, resiliently but with little weight, lines in space more than solid objects. All these have their successors in Nash's subsequent work.

I must resist cataloguing his output and its ever-growing range. The point here is to emphasise Nash's tireless, loving exploration of what he could do with his simple tools and with nature's wide range of provision, even under the limiting title of 'wood'. Given a whole tree – none of them felled for his purposes but taken down because they needed to be removed for forestry reasons – he finds ways of using every part for a variety of sculptures. The natural forms themselves often propose this or that adaptation to him, but also certain formal themes and procedures arise in his imagination as available to him in the larger sections of a tree, from the spreading roots and the lower parts of the trunk, while he responds to its manifold branches and twigs. He saw, and soon referred to this bountiful raw material, as his Wood Quarry, each instance offering a variety of opportunities within limits set by the particular wood and its dimensions. But I must draw attention to one assembled sculpture of 1971-72, cut from pitch pine, small (16 x 13 x 13 cm) and simple in its forms as the title announces – *Sphere and Pyramid on Three Steps*. On the three horizontal planes are placed two balls or spheres and two pyramids, carved separately. About the same time, he constructed a table out of pine and placed on it five hollow, constructed pine cubes of different sizes: *Table with Cubes* (1971). Here and in other works around this time, Nash was using tables or steps and other supports when avant-garde convention called for sculpture to assert its reality by rejecting any sort of pedestal. Nash met and countered this edict: these are not gallery plinths but integral parts of the sculpture. In introducing the idea and visual effect of a support, Nash found himself able subsequently to invoke a sacramental character, as in the oak two-piece *Bowl and Platter* he carved for his show in France at the monastery of Tournus in 1988 – *see* page 94.) What matters here is not any technical ingenuity or even refinement, but rather the almost primitive presentation of these two stereometric forms, small but extraordinarily potent in their references to nature's work and to man's.

Plato praised the perfection of such universal forms, made with human means to deliver

Table with Cubes
pine
1971
98 x 155 x 112 cm

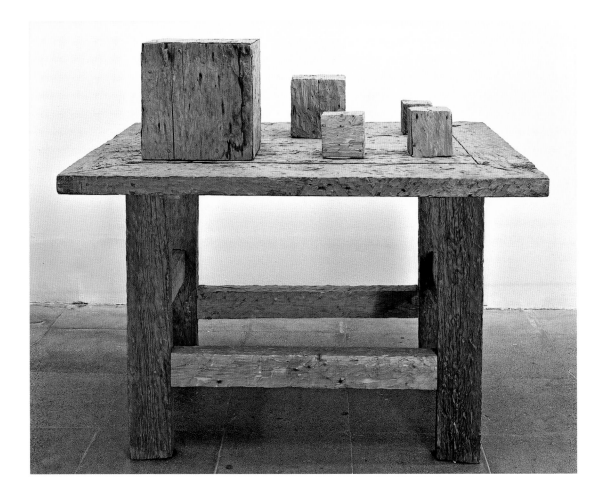

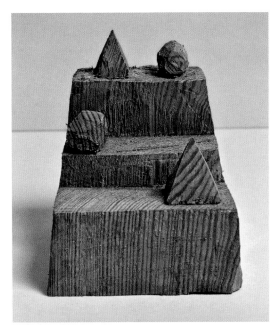

Sphere and Pyramid on Three Steps
pitch pine
1971
16 x 13 x 13 cm

ideal concepts. Classical art used them to underpin its two and three-dimensional compositions, and academic training recommended them for ambitious subjects, but man's examination of the basic structures of nature found what were considered evidence of human rationality to be essential elements in nature's own processes of growth and reproduction. In these early instances, Nash's use of these primary forms has something of the directness of prehistoric sculpture, but soon the sphere, the pyramid and (replacing the table or steps) the cube recur as a formal theme in his work to this day, cut and processed in a variety of ways, sometimes on a large scale, and combining the impact of the immediately recognised (i.e. accepted), forms and of the variety of expression Nash discovers in and imparts to them (*see* pages 158 to 168). A cubic box can also be built out of six thick slabs of oak, held together by staunch dowels. Brought indoors to dry out, the young wood cracks and opens along the grain, so that the ideal geometrical form changes in the gallery like a living thing, its natural forces working against man's decisions. The earliest *Cracking Box* is probably that of 1979, to be followed by others on various scales and sometimes in other woods, as in the case of the little *Rough Box*, 1990, made of yew and hardly moving at all. Nature's readiness to work with the artist, extending or, if you prefer, undermining his plans, is a theme we encounter throughout Nash's multifarious production, most plangently (I think) in the columns he has cut at various times from a variety of woods. These, usually exceeding a man's height, are sawn into horizontally every inch or two, so as to leave an invisible connecting core while dividing the vertical form into countless slices. As the wood dries, these slices warp and crack, animating the apparently finite, obelisk-like object he has shaped. These columns begin in 1985 and recur, never quite repeating themselves. Their plans and heights vary, as do the cuts that can be made into them and their subsequent movements, depending on the wood employed. The idea was proposed by a stack of poppadums in an Indian restaurant but there is also in a hint in them of the slate tips (with their insecure layers of rejected slabs and fragments) that make up so much of the landscape immediately surrounding Blaenau.

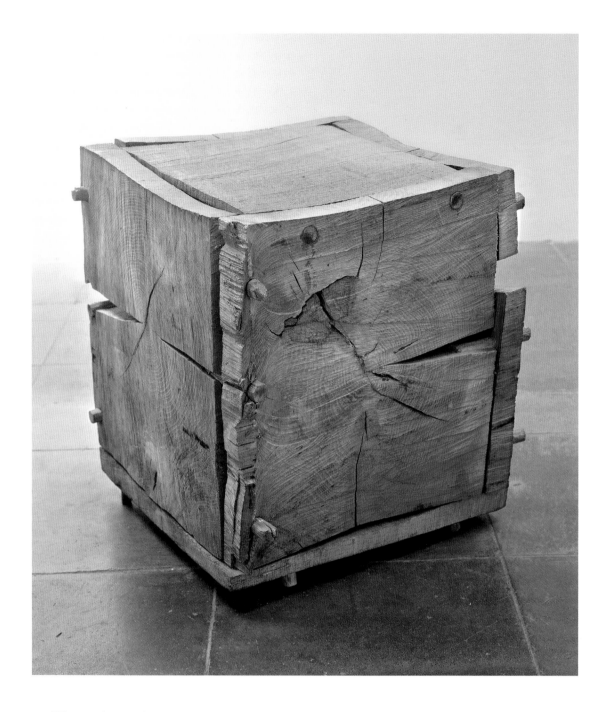

Cracking Box
oak
1979
70 x 70 x 70 cm

The welcome he gave to this form of natural collaboration in his work reveals an essential aspect of his thinking about both. Art historians refer to this as the *non finito* in art, that is, the artist stopping short of pursuing his work to perfect completion, as in a smooth surface in painting or carving, and to detailed finality. Some of Michelangelo's marble figures appear to emerge out of unhewn rock, and Titian's paintings are a mass of brushwork. In both cases the artist eschewed full delineation, leaving some of the details uncertain, and thereby exploring the virtue of the *non finito*. This shifted the definition of skill from the ability to make a fully informative imitation of the subject to making a version of it that touches us precisely by not telling us everything. There is meaning in this act of non-completion: the artist seems not to be claiming total mastery over the subject, his means or even his intentions, and invites viewers to engage more deeply in the work by bringing to it their own imaginations. Romanticism showed intense interest in this opening up of the art object in its relationship to the world. Turner is a particularly striking exponent, and the rivalry of Ingres and Delacroix in France is instructive: one of them insisting on perfect finish, his younger rival demonstrating 'painterly' methods the academies were still reluctant to accept; see Degas who benefited from both traditions. Impressionism can be seen as the ultimate

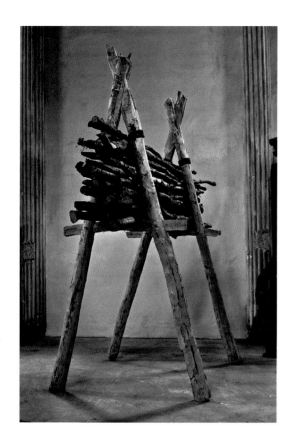

'A' Frame
beech and rope
1975
280 x 140 x 350 cm

Below left:
Ash Branch Cube
ash
1979
140 x 200 x 100 cm

Below right:
Flying Frame
oak and steel
1980
216 x 343 x 120 cm

triumph of painting without clarity. Rodin made dramatic use of the *non finito* in both his carved and his modelled figures. Cézanne, fusing Impressionism with the old-masterly approach he found in the classical art of Poussin, made his art much more solid than that of the Impressionists without abandoning his primary subject: nature as experienced personally, a living, fluid thing, changing every moment. His paintings are visible products of an intense dialogue with nature, conditioned by his spiritual and physical state.

David Nash was always aware of this aspect of Cézanne's art. There is in Nash's use of the *non finito* an additional message that matters greatly, and gives him a special place among modern artists. For one thing, it displays his happy intimacy with nature. I say 'happy' because we meet it as something close to comedy, as in the early Cracked Balls, Clams and Pods; the Cracking Boxes of 1979 come closer to serious drama. We may see these sculptures – and also the daring but essentially joyous Crack and Warp Columns, carved and then moving in their diverse ways – as his comment on Plato's separation of geometrical forms from nature's gift. 'Intimacy' is the right word since Nash's embrace of nature means that together they produce a living sculpture, cherishing it with nurture and culture, until the time comes for it to leave home and develop in its own way. And is not David Nash's work in general, his entire career, a great example of 'not finishing'? He says he finds beginning a new sculpture the most compelling and invigorating stage of his working life. His career has been one of not ending but always commencing again.

It is the core element in Nash's artistic persona that he works out of a deep sense of union with nature. Trees are of many kinds; no two trees are the same; the artist is never quite the individual he was yesterday and many of his sculptures complete themselves by the changes they undergo after he has finished working on them. The Heraclitean maxim of never stepping into the same stream twice here applies doubly, even though Nash's knowledge of trees and what they can offer becomes ever more complete and steadiness is one of his chief characteristics. Sculptures like the Crack and Warp columns silently encompass both geometry and distortion, as well as the human desire to reach perfection and deny death; and still there is nature's reminder that whatever we do remains part of a cyclical process from birth to submission to natural re-use. It is formal poetry at its highest and most profound. The man goes out to nature, armed with his tools, to engage with his angel in a Jacob-like struggle, and comes away having achieved – in nature's arms, so to speak – a metamorphosis that removes his sculptural product far from its source while still singing the praises of its origin. This is most obviously true of those sculptures in which neat forms, say a square or cube outlined in straight cuts, are accompanied by what seem to be interfering, reckless branches. These may be substantial, supporting the frame in space, or, as in the case of *Ash Branch Cube* (1979), become a wall object that allows us to see that the untamed branches in fact

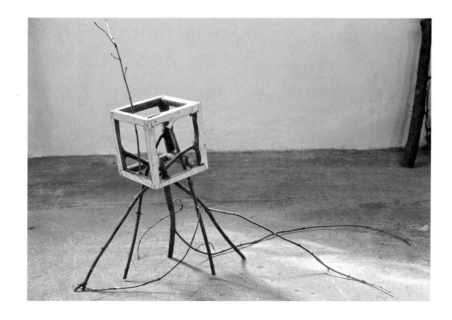

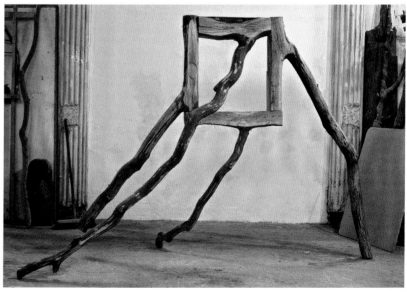

belong to the cut elements that form the cube. In not removing them, indeed in working to avoid losing them, Nash revealed an astonishing duality within the single material.

Soon, in 1977, Nash began using the chainsaw, a powered tool not credited to that legendary craftsman-designer-inventor of ancient times, Daedalus. (We refer often, in our essentially Romantic way, to his son Icarus whose disregard for his father's instructions led to his falling to earth as they sought to flee Crete with wings fashioned by Daedalus. It is the father who should be our hero. He made statues that moved and spoke, and created the Cretan labyrinth and possibly the pyramids of Egypt, as well as countless other marvels, and invented the tools with which to fashion them.) We would expect these modern tools to be intrusive in Nash's energetic and relatively quiet work, but no. The chainsaw, he remarked to Richard Mabey, combines many of the functions of older woodworking tools. Nash likes to get the main form of a sculpture established quickly. The heavy chainsaw brings with it a particular closeness, and he enjoys 'feeling the tool work with your body'.[4] Also, the chainsaw invites carving and detailing other than that proposed by the old tools, as Nash's sculpture soon demonstrated.

Nash here was attaching himself (unconsciously I suspect) to the long tradition of artist-workmen, through his continuous physical commitment (and thus his physical competence) as well as in his thinking and in the sources of that thought, in the complex, ongoing business of making art of many kinds, some of it with practical functions. A telling instance is his use of lengths of timber to make secure steps on slippery, overgrown ground in St Louis, USA, contributing a strong colour statement in the opposition he set up between the installed charred, blackened, beams, and the ever-new greenery that flanks them and seeks to envelop them from the sides. Having painted some of his first sculptures – colour played a prominent role in avant-garde British sculpture in the 'sixties – David Nash soon saw colour as an element provided by nature through the various woods he came to use, and black, produced by charring, as its natural complement.

Charring wood is, of course, an action carried out by nature as well as by man. Forest fires regenerate forests. Man chars wood to preserve it, giving its vegetable surface a mineral one of carbon. Nash began in 1983 to fire the surfaces of some of his sculptures, and sometimes to contribute to shaping them, or, in the first instance (*Charred Column 1*), to give increased reality to cuts he had been making into American sycamore and found insufficiently expressive. Burning the column's surface as it lay on the ground and he rotated it slowly produced new visual qualities as well as material results and, as always, philosophical associations.

The artist-worker, resonantly mocked by Leonardo da Vinci who demanded an elegant environment for his painting and drawing and despised sculptors for the mess they could not fail to make, as well as for the muscular labour their work demanded, is not distinct from the artist-philosopher. Nash does not work to another's instructions. Making sculpture from, and in the midst of, nature is always an enquiry and an adventure. The outcome may be planned but cannot be wholly foreseen. The artist sees possibilities in the material made available to him but he is not in full command: 'the objects I make are vessels for the presence of the human being, aware and surrendering to the realities of nature'.[5] On many occasions, when Nash has agreed to make an exhibition in a distant location, he will carry out a first inspection of the place and of the space in which he is to show, and then go there for a period sufficient for him to find suitable material and build a small or large team, and where necessary call up machinery, in order to create a new set of works that represent him in a way the gallery can well house and people in the locality will be prepared for by news and rumour. Going out to engage with places that may seem to many of us remote and perhaps even seductive is for him the perfect way in which to engage with his essential partner, and also a reaching out to all humankind – not just to the international art world – as he works around the globe. Rodin's team of executant art-workers swelled, we are told, from two or three required to carve museum-worthy marble sculptures from his little modelled figures to a host of up to fifty specialists in this or that process. Nash's teams are never like that. One gets the impression of much closer collaboration as, often without a shared language, he and they come together in the work as he enacts the next step in the process and they learn it from him.

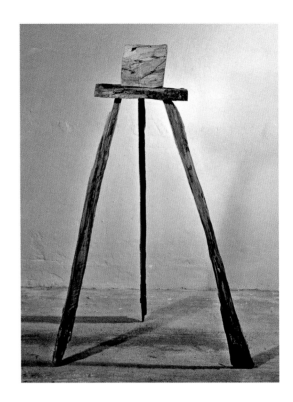

Rough Block
sycamore
1977
160 x 101.5 x 101.5 cm

The first sculpture made by Nash with a chainsaw.

'I needed logs for the fire in our house and was fed up with using a bow saw. I could afford a small chainsaw and I promised myself I would not use it to make sculpture. I was trying to make work only with hand tools. I tackled some logs and within about three hours I had my first chainsaw work [now in the Guggenheim Collection, New York].'

From an interview with Susan Daniel-McElroy, 2004.

Capel Rhiw, interior, 1976.

Against the rear wall: *Big Stack*, charred oak, 1976, later to become *Ancient Table* (*see* page 118); halfway back on left, *Spiral*, pine and rope, 1973; left foreground, *Up, Flop and Jiggle*, oak, 1975; right foreground, *Grey Slat Table*, pine, 1974.

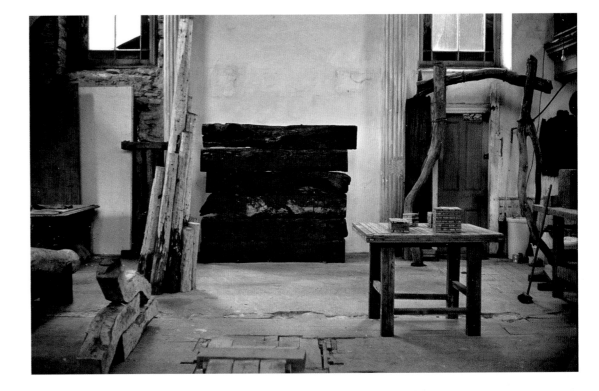

Capel Rhiw interior, 1977.

Against the rear wall: *Elephant Passing the Window*, wood and slate, 1977; back right, *Roped Arch*, oak and rope, 1972; in the centre, *Corner Table*, applewood, 1977.

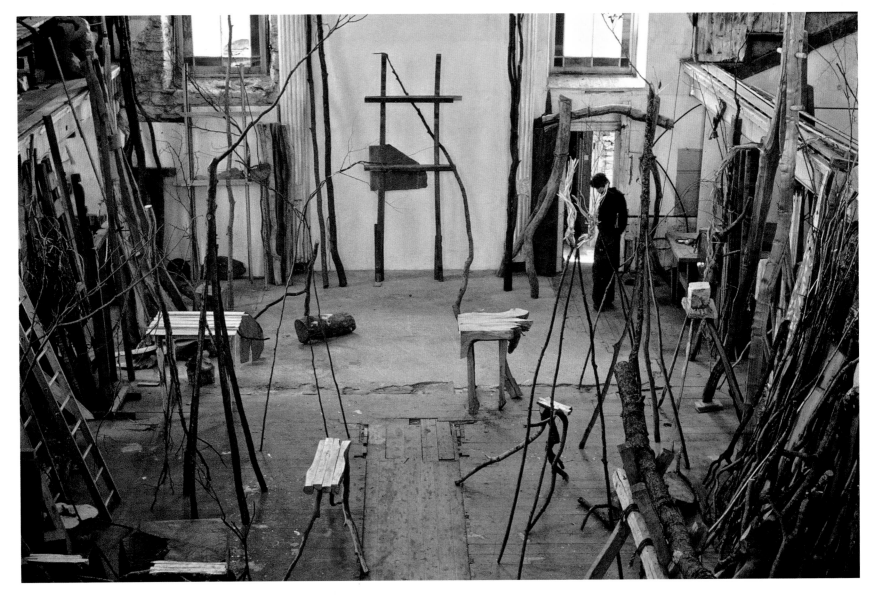

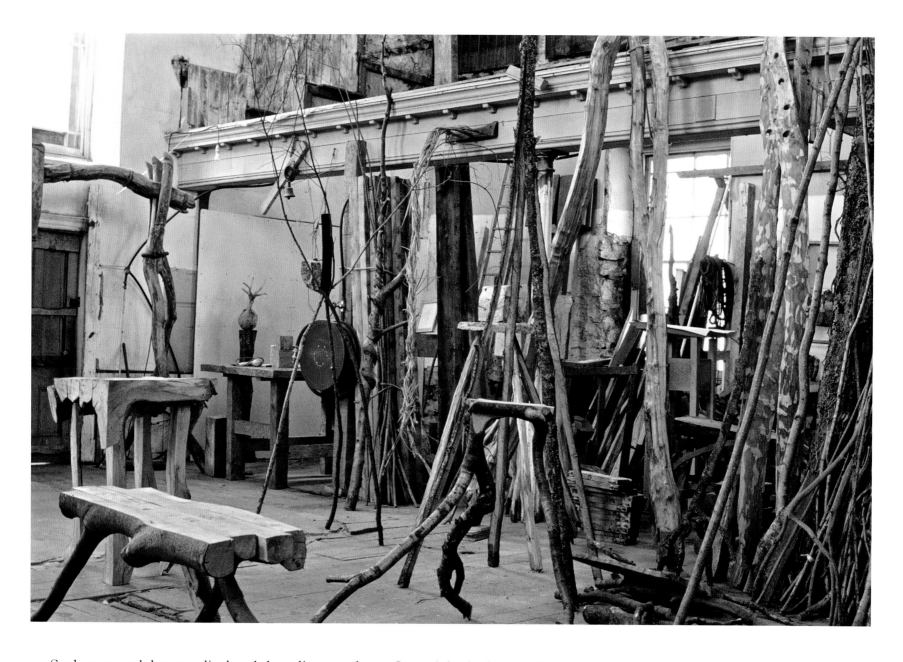

Such teamwork has not displaced the solitary sculptor. On an inherited piece of land comprising four acres near Blaenau, sloping down to a stream and greatly varied in its formation, Nash embarked in 1977 upon a quiet collaboration with nature that may at first appear opposed in spirit and action to his normal activity of turning trees into sculpture, but in fact confirms it, turning the relationship between the two into something like a marriage. He planted twenty-two ash saplings in a circle; he then encouraged and directed their growth through mulching, grafting and fletching, watching also over adjacent trees so that his ring would have enough air and light to flourish, and returning frequently over the decades to guard and guide these hostages to natural forces. (Bacon, long ago, described children as 'hostages to fortune'.) He is persuading these ash trees, as they grow, to form an *Ash Dome*, and it is happening because his control is a nurturing, caring commitment. This working with nature in a particular place and *ab ovo*, complements his work with felled trees but may well make less of a contrast for him than it does for the bystander. He has initiated other schemes of this sort on his land, using a range of trees and forms: oak, larch, birch, brambles, etc. He has also worked similarly abroad, and then he has had to plan for regular return visits to keep the project going as intended.

Another action requiring nature's intimate support was that of *Sod Swap*, made by Nash in 1983. This was his contribution to a Serpentine Gallery exhibition of current British sculpture, and it recalled the problem that Nash met with in 1970 when he

Capel Rhiw interior, 1977.

Capel Rhiw interior, 1980.

The largest piece, in the centre, is *The Whale Appears*, pitch pine and sycamore, 1980.

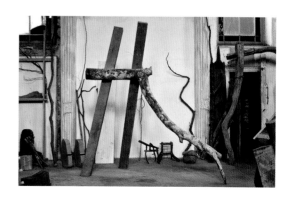

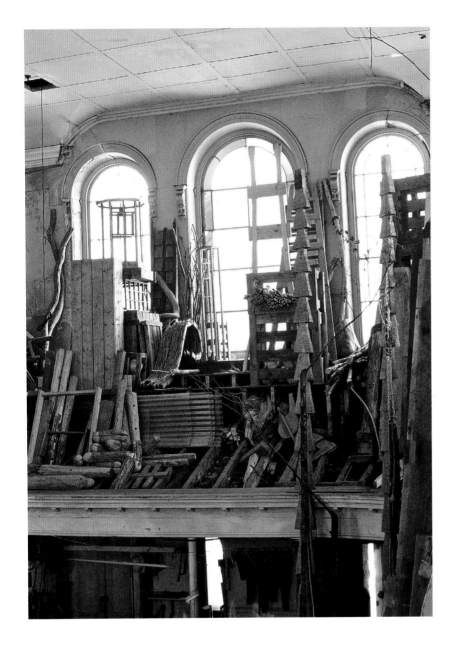

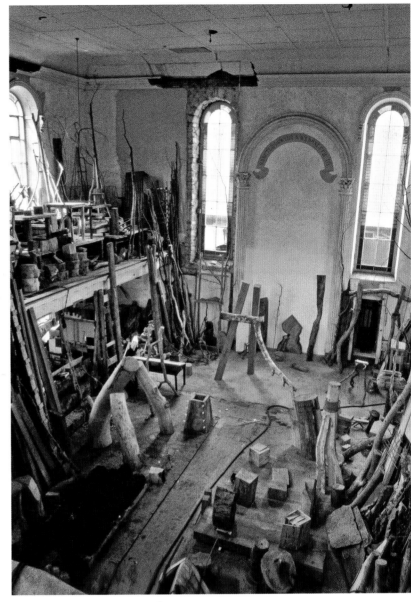

Capel Rhiw interiors, c.1975 (left), and 1980 (right).

Wooden Boulder–Maentwrog
charcoal on paper
1997
85 x 100 cm

wanted to remove four small turfs outside the gallery in order to allow his tower to stand directly on the ground rather than on stone slabs. Regimes had changed, and there was no official opposition now to his proposal to exchange a ring of sods brought from his land in Wales with one removed from Kensington Gardens. The Welsh turf was full of plants of many kinds and attracted a lot of positive interest in the Gardens; it was subsequently moved to the lawns of Kenwood House where it thrived until it was dug up in 1992. The Serpentine ring, smooth and polite, lives on in Nash's care in Wales, an urban visitor in a rural site.

A particularly stirring instance of Nash's working, or is it playing?, with nature is his *Wooden Boulder*, carved in 1978 from the broadest part of an oak to resemble some of the massive stone boulders he had noticed in the area. Nearly a metre in all directions and immensely heavy, this roughly hewn lump was returned to nature. It soon lost its golden appearance. More importantly, Nash thought of sending it down a waterfall by way of returning it to Mother Nature, but the thing got wedged halfway down, with water pouring over and around it. Well, it was still a gesture from the artist to his environment. But the boulder moved, of its own accord it seemed. Heavy winter rains brought it down into the pool below the fall, and Nash decided it should attempt the next waterfall and the pool below that, where it sat for eight years, amid water at various levels, and sometimes snow and ice, looking more and more like a stone. All this was only the beginning of what became a great adventure. The boulder remained a little

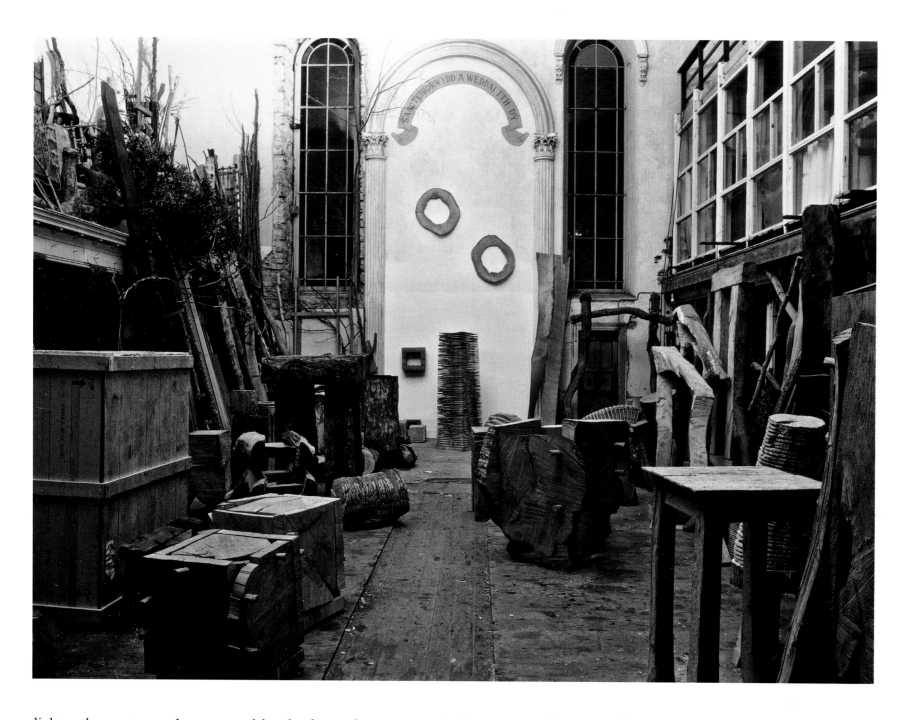

Capel Rhiw interior, 1985.

On the rear wall are *Lime Rings*, and, beneath them on the floor, the first *Crack and Warp Column*, ash, 1985. The pegged work, right of centre, is *Cloudbox*, mizunara, 1984; the two in the left foreground are Cracking Boxes made in sweet chestnut and ash in 1985.

lighter than water, and was moved by the force of water towards the sea, sometimes afloat, at others stranded for a while. Floating, wet and barnacled, it looks more like a marine animal than a lifeless object. Now it has gone out to sea and has disappeared from sight. Nash documented its journey from the start, and there is something peculiarly personal about his relationship to this fruit of his intercourse with nature, its history a symbolic echo of the sculptor's own.

In Japan, in 1982, he installed a large chunk of hollowed-out Japanese oak as a timber tunnel in a river. Working in below-zero temperatures, Nash and his team needed a fire at which they could warm themselves from time to time and also prepare food. He bored a hole through the heart of the trunk and built a fire inside it. It burned for ten days. Turning the log meant that the fire could act equally all round, turning the trunk into a cylinder and also, by charring it, extending its life. So now the Japanese river flows through it to the sea, and somehow, somewhere, meets and mingles with the water bearing Nash's *Wooden Boulder*.

In many places, for warmth and often also for charring purposes, Nash has found it interesting as well as useful to build some sort of stove and kiln. The phrase 'wood-burning stove' amused him: he would make such stoves out of wood in several places. He also

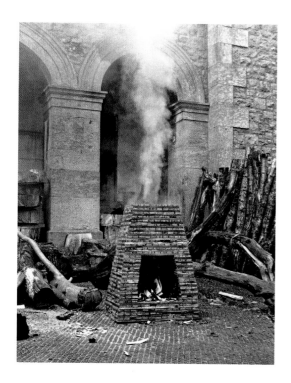

Above:
Slat Stove
recycled pine roofing slats
outside Capel Rhiw, 1980

Below: Capel Rhiw interior, 1981.

In the centre, *Buttresses*, sweet chestnut, 1980;
left, *Hut*, pine pilings, 1981(here in the process of
reconstruction having returned from being
exhibited in Rotterdam); left foreground, *Pegged
Box*, elm, 1980.

Overleaf:
Family Tree 1967-94
pastel on paper
1994

made remarkably successful ones of rejected pieces of slate, and then also of willow sticks and moist clay, and subsequently of other materials and in other situations: dry-stone walling within inches of a waterfall, so that the flames would rise beside the water leaping downwards, heaped-up snow, neatly layered lengths of bamboo, slabs of ice, and so forth. These are ephemeral works, of course, recorded in photographs that become the exhibitable work. The Robinson Crusoe instinct – making patient, inventive use of whatever a situation offers – is very strong in him. But this awareness of practicalities is accompanied by a need to address the world in deeper, more essential ways than are permitted by the parameters of the contemporary art world.

Marina Warner has written eloquently of the loam of folk legend, classical myth and world-wide symbolism in which Nash's work is rooted, often consciously, sometimes unconsciously.[6] Nash, as behoves any artist growing up in the 'fifties and 'sixties, reached out beyond Western religions and philosophy, to the teaching of the East, through Chinese poetry, Chinese and Japanese treatises on art, Zen and Buddhism. He has, like other major figures in modern art, studied Theosophy's spiritual teaching, and especially its climax in Rudolf Steiner's Anthroposophy – despised by some, partly because of the often weak art associated with Steiner's teaching. Nash's engagement with nature had in it, from the start, a sense of entering a dimension remote from most of us, with its own life, its own time and conditions; a sense of touching on the struggle of humanity throughout the ages for daily survival coupled with a reaching out for the sacred as a source of enduring value. Nash himself has quoted Lao Tsu on nature and its sovereignty over all we do, as well as the Chinese recognition that wood is one of five elemental phases in a circular process of interactions, implying time as a necessary context, and immediately we are aware of his commitment to working with them all when we consider his working with wood. Warner quotes Primo Levi's study, *The Periodic Table*, on carbon as being 'the key element of living substance', itself part of a natural process of recycling in order to preserve its role as the transmitter of the sun's energy. Steiner's writings taught Nash of carbon's significance, placing it above the alchemist's highest aim of creating gold. Black carbon is basic to all life, and thus above gold in Steiner's hierarchy … and in Nash's. The tree is the living proof of the interaction of these elements, as well as one of the most potent symbols known to humanity throughout time and in all cultures: the tree of life, *axis mundi*, etc., a multivalent image which represents for us the interrelatedness of things, the Tree of Knowledge of the garden of Eden and of sacrifice on Golgotha, the philosophical tree springing from the loins of Adams, and the genealogical Tree of Jesse which culminates in the Virgin and the Messiah. Some of us cherish our family tree. Nash from time to time draws a *Family Tree* of his sculpture, showing it spreading from *Tower 1*, built at Blaenau and over seven metres high (it ultimately blew down in a storm bringing with it television cables, one might say re-enacting the Tower of Babel's role in severing human communication), along many branches that, between them, imply a degree of inevitability belied by the sheer diversity of his output.

Any attachment to inherited symbolism and to spiritual enquiry is frequently decried or disregarded in our day by people who deal only in irony and judge anything deeper to be fey and fanciful. Nash says the opposite: 'I've always considered spirituality to be an immensely practical business'.[7] It is an essential, inseparable element in his working equipment, a consolidating base to his widening experience, a tool that guides his actions as does the wood he is working with and the axe or saw that conveys his energy and ideals. It is also, I suggest, the means whereby he and his work connect with his assistants, museum curators, art lovers and a wide section of the general public. We know that he is addressing us at several levels of experience, from the immediate thrill or calmer satisfaction of seeing his sculptures and beginning to read the often amazing skills he brought to making them, through to the references his spirit has been drawn to embody in them, additional to their general message about man's creativity amid nature's conventions and variety. Even the sculptures that do not change much over time grow in meaning and warmth as we return to them or hold them in our memories. We marvel at their range of form and scale and something akin to key signature: some are certainly *allegro* while others are *lento* and solemn. Some refer us to utensils, others to thrones and shrines, and yet others to experiences that may never be, as when a pointed, hollow form (one of

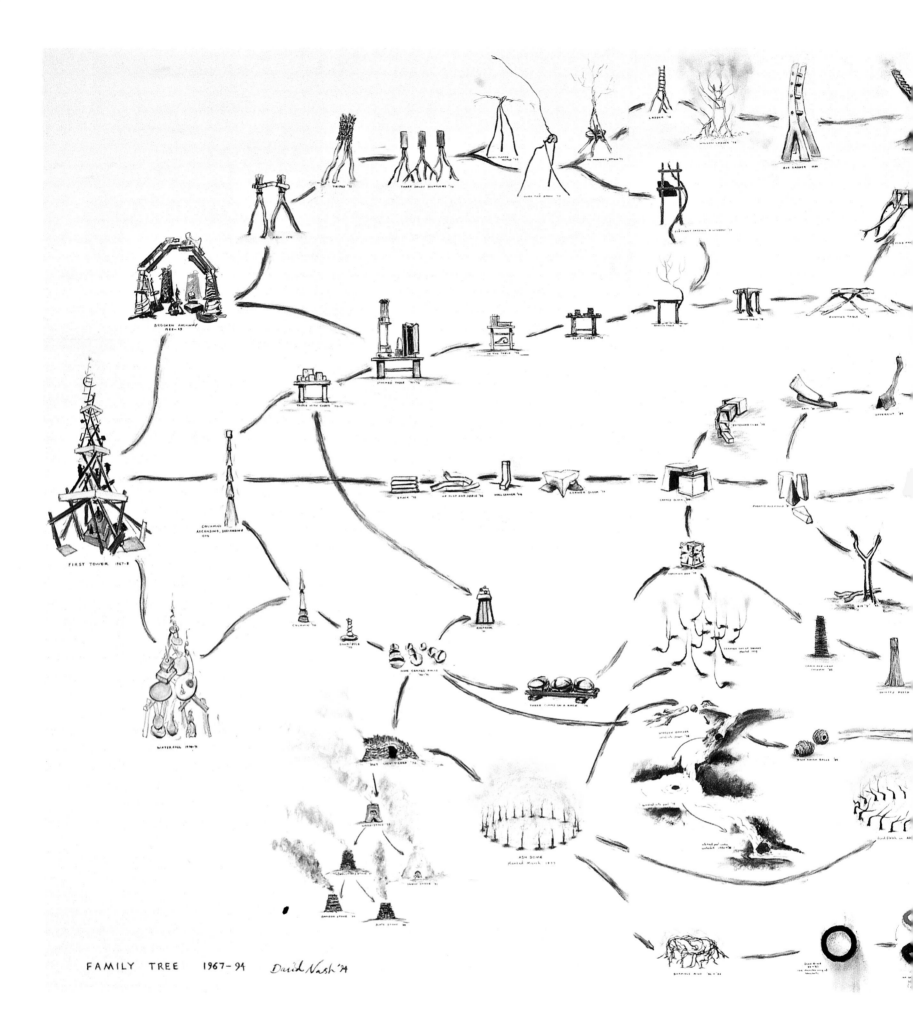

FAMILY TREE 1967-94 David Nash '94

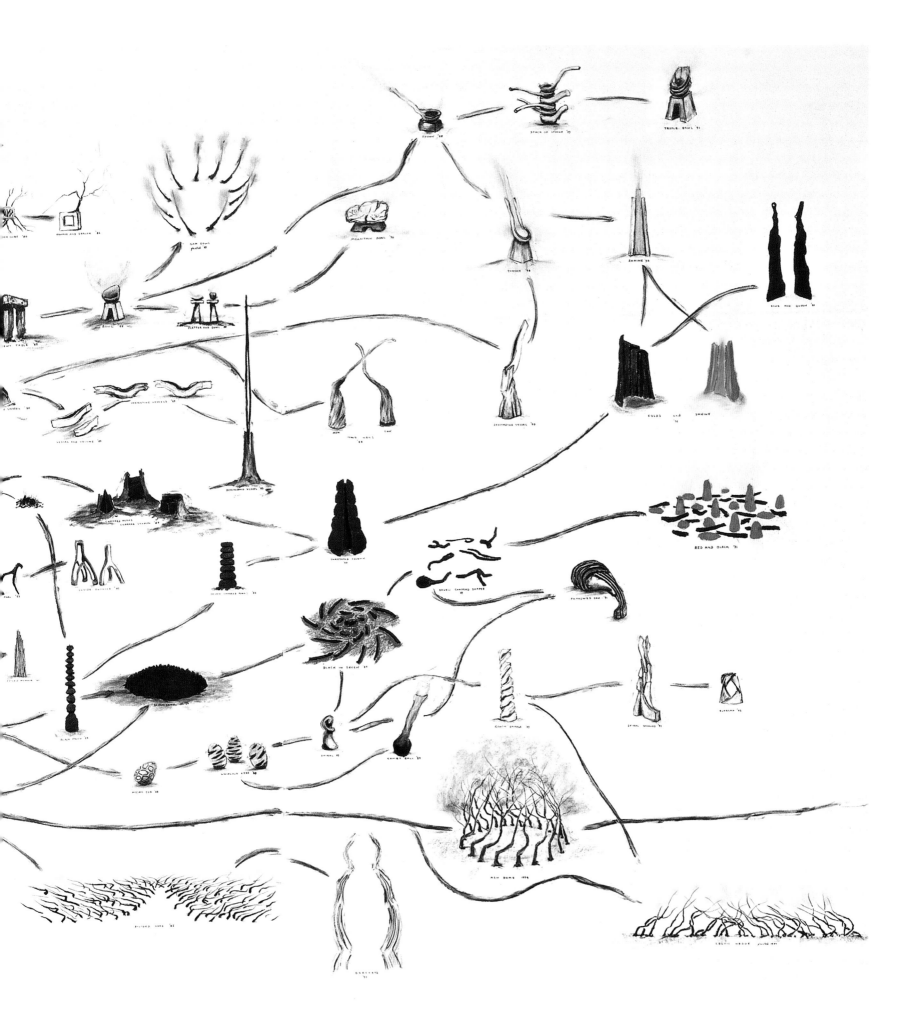

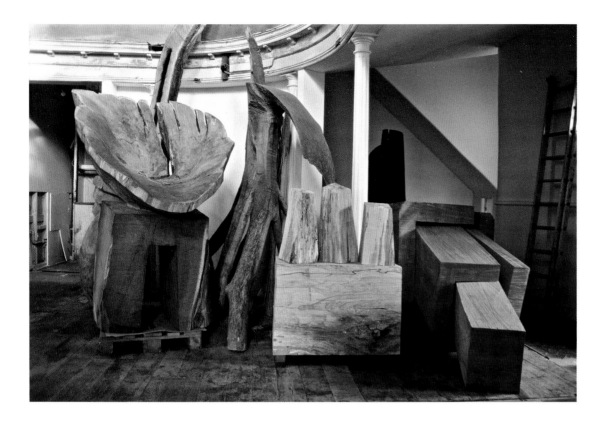

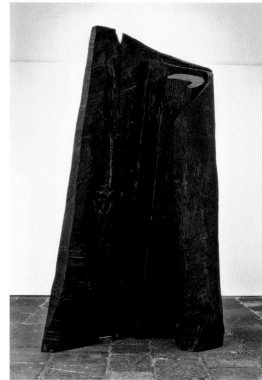

his Vessels) descends out of the sky to be grasped by a blunt form of the same wood, together one piece of wood. It turns out that Nash noticed such forms in the surfaces of certain Australian trees and saw them as wounds of some kind, noting also their sexual connotation. Subsequently he learned that those scars were left when Aborigines removed areas of bark in order to make their light, highly manoeuvrable canoes. He is exceptionally attuned to such fruitful encounters, and to inventions that are in great part surprises to himself. Would it be possible to create a sculptural form that suggested movement up and movement down at the same time? His *Rising Falling Column* of 1971 was the unexpectedly simple answer, a static object asserting a two-way motion.

In his brief but keenly observant essay 'An Engagement with Nature', featured in a catalogue of 1998,[8] Richard Mabey brought his own experience of the life and forms of nature to an attempt to convey the special character and value of David Nash's work. He credits the artist with an especially acute perception of the possibilities offered to him by grown trees and the saplings he plants, and views what guides him as a moral and aesthetic stance vis-à-vis the world and art. For Mabey, as for Nash, living intimately with nature in her many guises and phases underpins mental and physical health. Like the writer, the artist makes a present of this to us all. Nash's art shuns political slogans and social gestures but is rooted in principles of economy, openness and simplicity that prove its social morality.

Others have written essays about Nash's work, often in conjunction with exhibitions, sometimes presenting insights that are valuable to us and may have surprised themselves. I suspect that individuals engaging with David Nash's art will find themselves enlarged by the experience and ready to let others share it as much as words permit. The catalogue of Nash's 2002 show in Cologne, at Galerie S 65, has an introduction by Lieven Van Den Abeele. He focuses on the sculptor's use of black in his controlled charring of the cut wood. Indeed, the entire exhibition consisted of eight charred Nashes in a range of woods, some of them of monumental size, all of them exhibiting basic geometrical forms, as well as four charcoal drawings related to them. It must have been an awesome sight in the Gallery's white space. Van Den Abeele discusses Nash's use of black, referring to the greyness of his slate surroundings at home, to Ad Reinhardt paintings in closely adjusted blacks and to the last paintings, grey and black, of Rothko. He quotes Nash referring to Steiner's reflection on how carbon produces in us a double response through an emotional reaction, of repulsion and withdrawal, but then through thought which draws us closer.

Above left: Capel Rhiw interior, 2006.

Left to right, *Big Bowl*, mizunara, 1994; *Big Tongue*, ash, 1988; *Still Life*, spalted beech, 2006; *Extended Cube*, cedar, 1996.

Above right:
Folds
charred redwood
1990

Red Shrine
redwood
1989-90
235 x 140 x 81 cm

Right: Capel Rhiw interior, 2007.

The stepped form on the left is *Apple Jacob*, applewood, 1986; the large black work is *Millennium Book*, charred beech, 2001-02; the black box forms on the right are *Four Square*, charred oak, 2002; in the foreground: *Sliced Egg*, birch, 1991.

Opposite page, below:
Vessel and Volume
charred chestnut
1988
vessel: 28 x 86.5 x 16.5 cm
volume: 24 x 61 x 11.5 cm

He quotes Nash himself: 'The sense of scale and time are strangely changed, the charred form feels compacted yet distanced in an expanded space', and 'Art makes us think about a feeling and feel about a thought'. Van Den Abeele comments that black, often associated with evil and death, is also a fertility symbol, as is the tree, and refers to earth's fecundity when refreshed by rain falling from dark clouds. 'In its quality as the mother of all things and of the astral nebula, the night contains also the promise of the day. There are many blacks in nature and in art, including Hokusai's 'old black' and 'new black', but 'the black of David Nash is jet black'. Here one hesitates. Black can be read as the absence of colour or the presence of all colours. Charred beech, charred oak and charred tulip are not the same black; charred mahogany adds an evident colour to black. Among these impressive sculptures was Nash's *Millennium Book* (2001-02), a pair of tall and massive beech panels standing at a slight angle to each other, held in position by rusty iron hinges. It is now at Capel Rhiw, and speaks of age and significance, possibly of a religious kind, doors from an ancient temple, leaves from a book Moses might have handled … the associations picked up depend partly on one's own mental store and spirit. They may include Richard Serra's weighty presentations of large steel rectangles supporting each other, but with this comparison comes the awareness of implications of time's breadth and of living matter in Nash as against the dramatic but time-bound essence of industrial steel as used by Serra. *Millennium Book*, like some of the other large charred works of recent years, suggests a remarkable widening of Nash's range of expression, from the more spring-like sculptures in pale woods to these dark and sometimes massive carvings that one might call autumnal. Photographs tend to make them look gloomy, understating their energy, and the fact is that they represent one end of Nash's present spectrum, from the lighter toned and often less monumental pieces, via many that are partly charred, surrendering part of their natural, living character, to these all-over charred pieces with surfaces that the sculptor reminds us are more mineral than vegetable. They do not indicate a change of principles or direction.

Among the most rewarding essays on Nash and his work is that by Hugh Adams in the catalogue of the 'Sixty Seasons' exhibition, shown during 1983 at the Third Eye Centre in

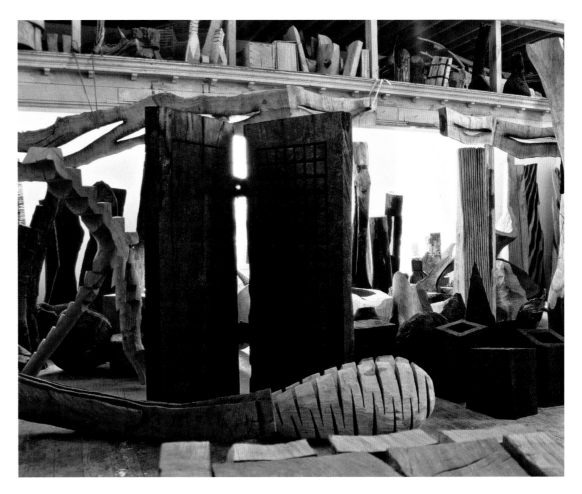

Glasgow and toured to other centres in the UK and to Dublin. Several themes sound from his wide-ranging presentation, beginning with the artist's early withdrawal to North Wales, for so many reasons. In discussing this retreat (*pour mieux sauter*?), Adams invokes the words of Thomas Jefferson on men who live and work in a rural setting, and Thoreau's book *Walden* with its detailed account of this journalist's chosen isolation away from the cities and society that were his normal habitat and arena. Two in some ways different views of man and nature, one focusing on social relationships and influence, the other on finding liberty away from these, disencumbering one's mind through living in and with nature. (Jesus Christ's second mature act on earth, after coming to John for his Baptism, was to withdraw for forty days into the wilderness.) Adams stresses that in Nash 'romanticism and pragmatism are inextricably combined' – which associates him, to my mind, more with English Romantic writers such as Wordsworth than with the English Neo-Romantics of the 1940s and '50s who wore out their hearts on their sleeves as they looked back (in admittedly difficult years) at the art of Samuel Palmer and his friends. Nash works so intimately with time that his dependence on it can seem like independence. The essential fact is that he and his art are always of now – like nature herself, never nostalgic. Adams charts neatly the major reorientation in Nash's progress, from constructing his Towers (he quotes Nash: 'stretching to infinity – each over twenty-five feet high and chock-full of contradictions') out of painted wood, through his *Waterfall* assembly made with stained rather than paint-coated wood, which (significantly) had been collected outside rather than bought from a saw-mill, together with his key discovery: that the changes that occur in newly felled wood could be central both to his process and to his intentions. He was confirmed in this new direction by his Brighton art teacher's thoughts about sculpture advocating, above all else, simplicity: 'The way ahead is surely to say more with less and less. And of all kinds of art true sculpture is the least trivial' (from a letter of 1968). Following closely on this came the idea that the best place for a sculpture to be is where it was made, and the associated thought that a group of works for an indoors exhibition might best be made in the locality. Work to be shown inside a particular building would be made from local material, indicating its aptness to the landscape and the manscape, while also reflecting the character of the interior in which it was to be seen. The dialogues into which good art enters vary profoundly with its companions and its physical contexts. The principle of simplicity also involved abandoning a mode of presentation of carved objects placed in or on a sculptured setting – as in *Stacked Table* (1974) which has groups of Nash carvings on a four-storey table + table + shelves construction. Adams points out that the stimulus to this kind of supported sculpture came from a press photograph showing a ransacked tomb chamber in Egypt, with artefacts dumped under and over other artefacts, as in a cellar. A constructed setting could be at once humbling (mere storage) and honorific (display). David and Claire Nash, visiting Paris, were much taken with the way French bakeries bundled and stacked their loaves.

Adams also refers to, and quotes from, an article by the New York critic, Dore Ashton, written in 1970 on the wide issue of Land Artists and even then finding for David Nash a particular position in what was then a new and broadening trend. She quoted, and Adams quotes again, the artist's own words from that early period:

> I want a simple approach to living and doing. I want a life and work that reflects the balance and continuity of nature. Identifying with the time and energy of the tree and with its mortality. I find myself drawn deeper into the joys and blows of nature. Worn down and regenerated; broken off and reunited; a dormant faith revived in the new growth on old wood.

Adams also paraphrases some of Ashton's main points, such as the issues we may find in Nash's work, reaching out from its nature-art symbiosis, towards social concerns as well as the ecological issues we are now becoming aware of.[7] Nash's embrace of nature is easily observed when he plants a ring of trees and nurtures them over thirty years to form the *Ash Dome* on his own patch of land, but what about when he carves and assembles his Ladders, large and small, or turns a sequence of cut logs into an aqueduct? Even as one writes or reads about them one is led towards memories of biblical stories.

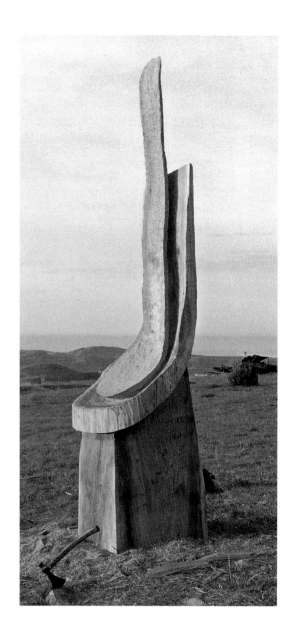

Red Throne
redwood
1989
325 x 95 x 85 cm

28

My essay for the catalogue of Nash's exhibition at the Serpentine Gallery's in 1990, opens: 'Good husbandry lies close to the heart of David Nash's work', and continues by bracketing his deep involvement with nature with his pragmatic management of individual projects. I also noted his tendency to make both compact, concentrated sculptures and looser, more centrifugal ones, large and small, as well as his returning to some of them in different situations with results that can vary significantly. But the theme of David Nash's Wordsworthian 'natural piety' linked everything for me, though I responded also to his attachment to oriental thought and to western mysticism, especially Rudolf Steiner's firmly built structure of ideas and principles, springing originally from research into Goethe's colour theory. (So, in a sense, Wordsworth's Lake District becomes Nash's North Wales, and one recalls Wordsworth's close friendship with Coleridge, Goethe's great champion in Britain.) Sixteen years later there is much more information about Nash. Knowing him and his work better, I feel the need to enlarge briefly on other aspects of his art and his career.

It is simple to see Nash as one of the sculptors of his generation who have sought alternative paths to the highways of Modernism, sometimes in the name of Post-Modernism or Conceptualism or Neo-this and Neo-that. It still seems to me that each of the innovations offered since the 1950s has been a development (at times merely a repetition) of propositions planted by Modernism itself. This search has sometimes involved a physical withdrawal from the centres of art. Richard Long, Nash's contemporary and admired by him, walked in nature and left modest signs that he had passed that way. Soon he was travelling to uninhabited regions on other continents. He returned with photographs and brief verbal accounts of what he had done, and before long he would bring back stones of various sorts which he arranged in geometrical forms on gallery floors, combining mankind's respect for such 'rational' forms with nature's variousness. David Nash is readily associated with art and artists of this kind, with categories such as Land Art and Earthworks, and more broadly with Italian *arte povera*, conceived by a critic in 1967 and presented in 1970, exactly at the period when Land Art, etc., began to be explored, all under the umbrella of Conceptual Art, and Nash was beginning his odyssey. All such ventures were said to elude art's hustling by not resulting in saleable art objects, but of course artists have to finance their work and while the artists of *arte povera* wanted, like Diogenes, to discard even the little ceramic bowl from which they drank, it was the materials and processes they reduced to austerity, not themselves.

In the book *Song of the Earth, European Artists and the Landscape*, the work of five artists (including two Britons, Long and Chris Drury) is illustrated and discussed, together with interviews of all of them. Mel Gooding provides a perceptive and scholarly introduction, in which the work of Nash and others (Hamish Fulton, Andy Goldsworthy) is mentioned and illustrated, and Fulton, whose work is mostly in the form of photographs, is quoted memorably: 'Change perceptions – not the landscape. The Landscape as location – not raw material'.[10] All significant art changes perception, though museums, galleries and publications are increasingly full of art intended merely to please or thrill us for a moment. With the aim of widening their appeal, they risk jettisoning it. Since art lost its traditional roles – a religious scene painted for an altarpiece, a philosophical lesson pictured for a palace or a drawing room, an erotic subject for a bedroom, a victor's statue for the centre of a city – the gap between these two ambitions has become ever more blatant, until much of what we are offered reveals itself as a form of fast food and bids for media celebrity. That Nash began his career with a retreat, from the artworld of London to glamourless Blaenau (which then seemed impossibly remote but is now well known to art directors and curators from around the globe) is proof of his sound instinct. How many sculptors have been as wise in rooting themselves? One thinks of David Smith at Bolton Landings and, at the other extreme, Brancusi in his Paris studio-home, and perhaps of Rodin operating both in Paris and in suburban Meudon. Firm roots permit the freest mobility. David Nash is so firmly attached to North Wales that he can adventure anywhere in the world to make his sculpture and bring people into closer understanding of it through his presence and words.

The five artists in the book were chosen to represent diverse but cognate activities and principles. What they do can come close to overlapping, but their individual priorities are clear and generally distinct. Some of them set up cairns or make other structures

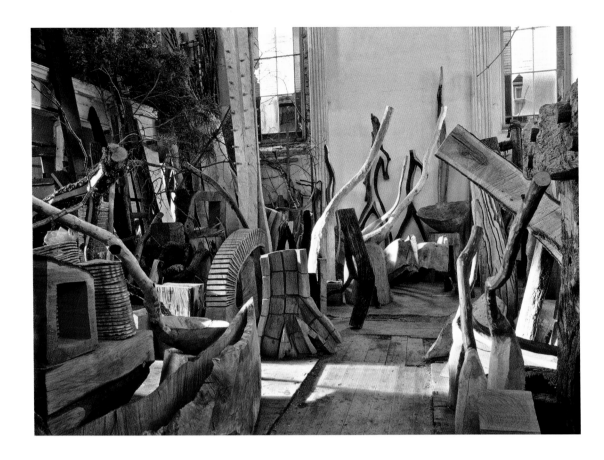

Capel Rhiw interior, 1989.

from the stones and other materials they find in nature; these must be ephemeral. Some devote much of their time to quasi-scientific pursuits by studying, collecting and bringing us, in some chosen form, every botanical species within a prescribed area, or every leaf that fell from a certain tree and, on occasion, the random arrangements these made on sheets of paper put out to catch them. The results can be interesting and beautiful, but the artist's role is mainly that of the curious admirer. Penone's way of cutting away parts of a tree-trunk to reveal its core growth and the branches coming from it is both moving (like images of a developing foetus?) and of immediate interest, but the realisation of the idea does not seem to lead further and relates more closely to death than to new life or to nature's cyclical time. Nash reckons that Land Art and other phenomena of the sort spring from an impulse in the evolution of human consciousness towards engaging directly in the land and the elements. He thinks that, a century earlier, he and the others would probably have been landscape painters, portraying preferred scenes and freezing them to make them suitable for indoors consumption. Those who work to make art with (not from) nature, and in many cases leave the products where they were made, are exploring what he calls occurrence, the phenomenon of things (art as matter) existing in time.

David Nash is significantly different from the artists presented in this book, as well as from other major figures in Land Art, such as Robert Smithson and Michael Heizer, in a number of ways. He stands apart from all of them in the character and intensity of his engagement with nature, signalled by the manner, range and scale of his work. Even the most passive of his outdoor pieces, whether or not they involved powered machines and no matter what assistance was needed in making them, restate the man among trees. His intimacy with them, clear already around 1970, has grown with his experience of other trees, sometimes of great size, in other places and climates. Today he can have great redwood trunks brought to him in Blaenau from the United States; he receives them as old friends. Old Nash themes recur – particularly the cube-sphere-pyramid triad. For Nash they represent or symbolise many interrelated aspects of the world: the cube speaks of earth and material, and, being static, refers to death; the sphere speaks of movement, fluidity, especially of water; the pyramid evokes sensations of light and space. He has used this triad on several scales and treated it in dramatically different ways.

There is no sense of his invention waning. So close is his alliance with nature that one is tempted to think of her as his essential muse, his guide and mentor and basic inspiration, however difficult or convenient the situation may be for each new undertaking. Allied to this is his acute sense of mankind's endlessly searching, endlessly trusting, engagement with nature, ever our essential, inescapable partner. Others work with nature, knowing and using her in ways that feel predetermined, with results that announce their artificial basis. Some 'earthworks' speak of power: I can make this form and shall impose it on the landscape, impressing the human world. Some are delicate and decorative, as though nature was to be wooed by art, and these certainly imply a felt response as against an imposition; here the danger is that the results are slight, pretty and fey. But I must beware of presenting my own enthusiasm for the particular nature of David Nash's in terms that set him against other artists who work in ways that show some of the same priorities. He respects many of them but is properly conscious of their distance from him.

As the years pass, the sheer variety of his production makes one reluctant to categorise him finally. He may well astonish us tomorrow with work that further widens his range of processes and meaning. In recent years he has begun to use cast iron and also bronze on some occasions, and, in a particularly arresting instance, combined cut timber with poured bronze – the springing, perhaps, of a new branch on his family tree of sculpture.

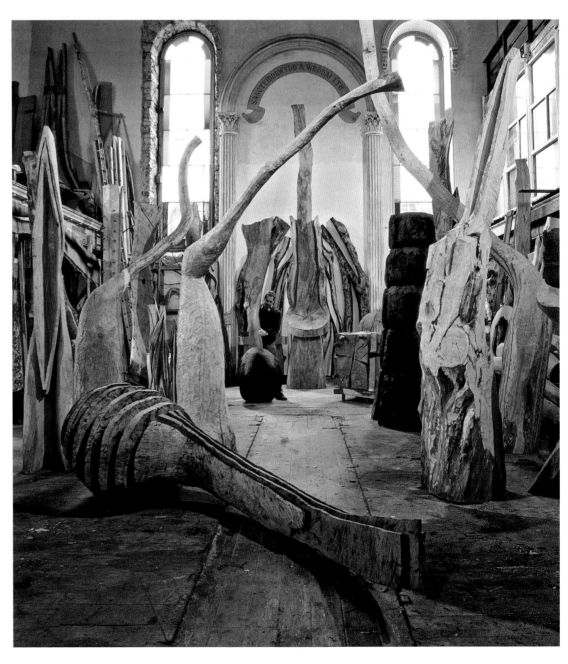

Capel Rhiw interior, 1994.

In the foreground, *Furrowed Oak*, oak, 1991; far left, *Descending Vessel*, oak, 1991; left of centre, *Two Ubus*, oak (left) and ash (right), 1988, and to the right, *Descending Vessel*, hornbeam, 1990-91. The black sculpture halfway down on the right is *Threshold Column*, charred elm, 1990. David Nash stands behind *Comet Ball*, partly charred elm, 1989, and behind him is *Throne*, beech, 1991.

Having often drawn with materials he found ready to hand in nature and cognate to the sculpture he was working on, including earth and seeds as well as charcoal, he has taken to making powerful colour images using powder colours moved into position by his handling the paper. Since 1985, he has sometimes set sculptures, such as the cube, sphere and pyramid, against drawings showing the same forms on the same scale; in other instances, the drawings relate less to the three-dimensional forms but record Nash's adaptations of them. Always, even with his most completely charred pieces, whose surfaces are now mineral rather than vegetable, and even when the results are in cast metal, wood was the starting point and often the mediator, as when Nash provides a wooden mould for the molten iron to be poured into, devouring the wood in the process.

Nash's particular position becomes a little clearer when we look for his connections with other kinds of artist and other tendencies in the art of his time. British sculpture underwent dramatic developments in the 1960s, led by the example and the teaching of Anthony Caro. Caro, partly through contact with David Smith in America but also responding to aspects of the new US movement in painting known as Post-Painterly Abstraction, turned from modelling ungainly but powerful figures to welding or bolting abstract configurations in steel, painting them a strong colour and setting them on the floor of galleries, not on any kind of podium or base. In 1963 he had a show of this new work at the Whitechapel Gallery, which demonstrated his broadening development from that second starting point. He was using aluminium as well as steel, leaving some sculptures unpainted and giving others two or more colours. His constructions were becoming more spatial and often less solemn, playful even (e.g. *Hopscotch*, 1962, in unpainted aluminium, over fifteen feet long, and *Month of May*, 1963, steel and aluminium, with its stabilising chunks of girder, on the floor, painted magenta, and slighter elements, rising to nearly twelve feet, painted orange and green). He was proposing not one direction in abstract sculpture, as had been assumed, but a widening world of possibilities. Expansion and complexity were followed by a sort of minimalism by 1965, and by 1967 Caro was making smaller sculptures, in painted and in highly polished steel which require a box-like base so as to lean off their tops, teetering on one or two of their edges. Altogether, Caro demonstrated an unlimited range of expression and means where he had seemed to be issuing limiting commands. He invited this sort of freedom also through his teaching, and some of his students picked up on it, so that, in the course of the 'sixties, dominant British sculpture changed tone and character to a remarkable degree, distancing itself from the heritage associated with Moore, Hepworth and their immediate successors.

Among Caro's mature students were Phillip King and William Tucker, whose work was strikingly distinct from his in its forms, materials (notably fibreglass in resin, plaster with steel, wood laths) and colours. Steel sculpture, thanks to Caro's example, came to seem quite natural; it was the brightly coloured sculpture in strange forms that contributed a new thrill of artificiality and unconventional inventiveness for a time. In 1965 the Whitechapel Art Gallery showed recent work of amazing variety by nine sculptors aged twenty-six to thirty-one. They tended to be seen as Caro disciples, but their paths were divergent rather than dependent on any given direction. Soon there were other young sculptors who sought to reject Caro's captaincy. Barry Flanagan in 1967 made *four cash 2'67*, an arrangement of four columns made of sacking filled with sand, a flat linoleum ring and a length of thick rope, a composition emphasising height and horizontal expansion on the floor but above all seeming random. Subsequent Flanagans explored randomness in a variety of non-art materials and were encountered more as events than as objects or compositions. Happenings and Performance Art had been presented, in the USA and then in the UK, since about 1960, while Minimalism emerged around 1965 as two or three-dimensional art calling for acute succinctness for the sake of maximal impact. In the later 1960s, Conceptual Art emerged on a broad front to challenge the need to make art objects when there were many other ways of representing, or reporting upon, artistic ideas. Photographs, video tapes, texts and other means were found for making such ideas public, but the art public, confronted also by the entertaining movement called Pop Art (new in 1960-61), and thus invited to connect with new figurative work as well as a wide range of abstract painting and sculpture, was slow to accept an art that did not deliver familiar objects for study and appreciation.

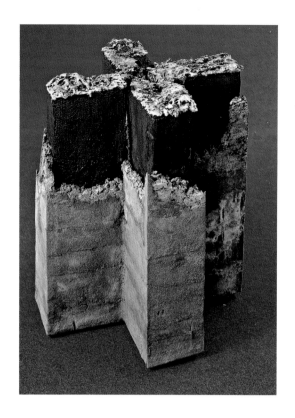

Encased Cross
oak and bronze
2003
95 x 70 x 70 cm

Opposite page, below
Left:
Bowl
elm
1988
143 x 95 x 107 cm

Right:
Six Birch Spoons
birch
1989
185 x 300 x 100 cm

This very incomplete account of what was making the news in contemporary British art (and of course there were other developments, or similar ones, elsewhere) is part of the context of David Nash's move to Blaenau Ffestiniog where he could be out of touch, or choose to be in touch whenever he felt the need, but would not find himself beset by artworld pressures that could well distort his search for his essential artistic personality. He was fortunate to have such good memories of boyhood visits to North Wales. (Where would he have gone, lacking them?) And he had skills and a willingness to work that would keep him afloat in this inexpensive part of the country. Acquiring Capel Rhiw was a master stroke, the buildings giving him work space and a home for his wife and family, as well as a sense and symbol of professional existence.

In the mid-'sixties he had been able to see the work of David Smith and of Giacometti in London, and he saw the Whitechapel British sculpture shows of 1963 and 1965 as well as other exhibitions in London and the Brancusi studio in Paris. He particularly admired Smith's early sculptures that have the appearance of hieroglyphs drawn in the air in bronze, his later steel sculptures constructed from off-cuts or used and discarded metal forms, and then also the Cubis of Smith's last years in stainless steel, their ground surfaces shining with light and thus denying their mass and weight. Smith was the artist who taught Nash that he must become wholly fluent in his chosen material and respectful of it, so that economy and full expression are at one. Smith's use of his farmland at Bolton Landings, his favourite exhibition space from the 1950s on and still serving as that, has some similarity with Nash's commitment to his much smaller property near Blaenau, where he grows trees to be sculptures, and to the Ffestiniog Valley in which he launched his *Boulder*.

Brancusi's partly hermit-like existence at the heart of Paris, sawing and carving his wood sculptures of several kinds, but also modelling increasingly elegant forms for casting in bronze and then polishing them to produce an almost perfect surface which seems to counter their solidity, made a deep impression on David Nash, a few of whose sculptures could be presented alongside certain Brancusis as kith and kin. Most obviously this applies to Brancusi's wooden columns and his domestic objects as carvings, or carvings as domestic objects, always reminding us of their natural origins. In and after 1918 Brancusi carved a series of wooden Cups, hemispheres with a protruding flange as handle, at once very cuplike and wholly unlike cups anyone might use because they are both solid and way over normal size. Sidney Geist wrote of them: 'After the *head as object*, and the *torso as object*, *Cup* is the *object as object*; the gambit is quintessentially Brancusian', and he stressed *Cup*'s 'monumental innocence' beside the implied wickedness of Picasso's *Absinthe Glass*.[11] Nash has often and repeatedly made sculptures that resemble objects

Below:
Mountain Bowl
ash
Arthog, North Wales, 1990

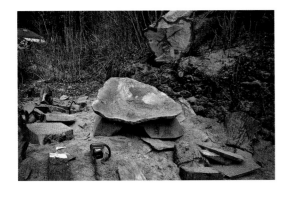

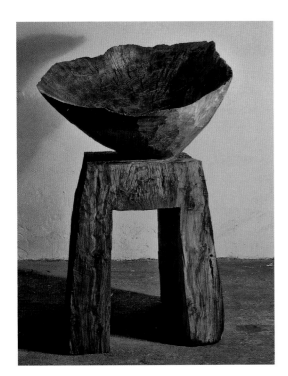

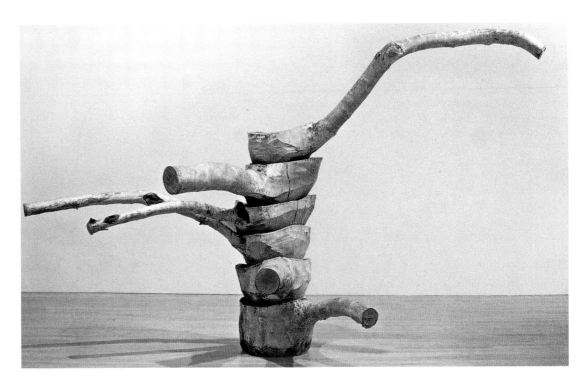

of use, from Tables to Ladders and rising Steps or stacked Spoons and Ladles, and could in some instance be put to practical use, as well as other things that hover between vision and reality, such as his grand Bowls (carved in one piece together with their bases), his Thrones and his mighty Frames. Less obvious parallels between Brancusi's work and Nash's may be worth drawing attention to. Brancusi exemplified the Modernist principle of truth to materials; for Nash this was a self-evident basis, adopted unambiguously once he ceased painting the wood of his assembled sculptures. Brancusi's work, once he had distanced himself from expressive modelling in the general manner of Rodin, moved energetically between compactness and modest size, as in the Muses and Heads, and his egg-like *Sculpture for the Blind*, and his rising Columns, culminating in his *Endless Column* in Rumania, his slender Bird sculptures, rising ever higher, three of them intended for a 'Temple of Love' to be built in India. Nash has not proposed anything as a temple, but his growing sculptures, such as the *Ash Dome* near Blaenau, suggest a kind of sanctum, and when he sets us his Platonic triad on a large scale and in a public space, whether on a hillside in Wales or against the skyline of Chicago, he is inviting us to meditate on their complementarity to nature and to the harsh shapes on the modern world. His first box-cubes, spheres and pyramids were tiny but they did not take long to grow (and crack and warp), taking on gallery presence and life, but from the Towers on he has often sought height, finding it also in his *Descending Vessel* sculptures, rising to (descending from) more than two metres, or his Steps and Ladders, the tallest of them, in Japanese oak, reaching well over five metres. From early on he has made standing Leaners and Sheaves whose linearity was stressed by their height.

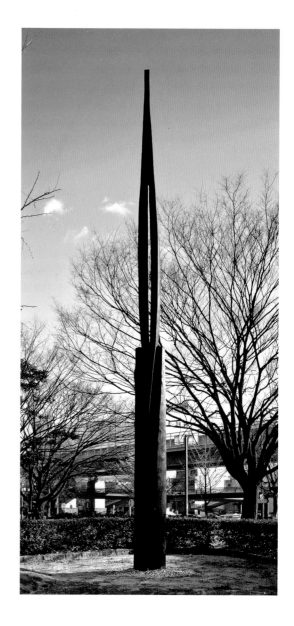

Some of Brancusi's sculptures have always struck me as thoroughly amusing without shedding any of their quality: I think, in the first place, of his *White Negress*, a brilliantly refined and delicately unbalanced head image in white marble consisting of a tall ellipsoid plus a chignon at the back and a knot of hair almost at the top and a pair of lips slightly askew on the front, and no other details. Nash's sculptures of Bowls or Dishes on a base, carved in one piece, recall some of David Smith's Cubis, such as the Tate's *Cubi XIX* (1964), which has a gathering of cubes and near-cubes as well as a rounded form set on a table-like support not unlike the *guéridon* + still life paintings of Picasso and Braque. In other instances, it is more the spirit of Smith's working than the forms, as when he makes his great immovable Chariots in response to materials found where he was working, and the sheer untiring generosity of Smith's production that suggest a deep kinship between the American and the British sculptors.

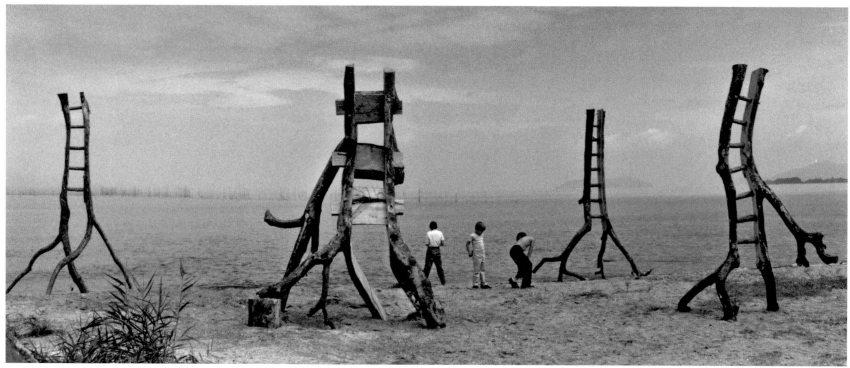

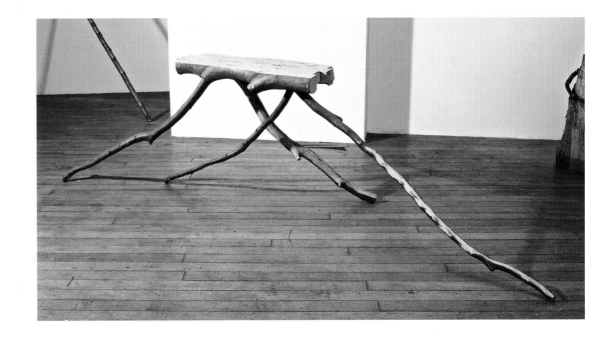

Opposite page, above:
Descending Vessel
red pine
Nagoya, Japan, 1994
1000 x 80 x 80 cm

Opposite page, below:
Ladders
mixed wood
Lake Biwa, Japan, 1984

Right:
Running Table
beech
1977
100 x 310 x 120 cm

Below left:
Three Dandy Scuttlers (The Chorus Line)
oak and beech
1976
157 x 240 x 75 cm

Below right:
Three Ubus
beech
Sussex, 1989
largest: 285 x 62 x 62 cm

The encounters offered by some of Nash's object sculptures are humorous as well as awesome. In his 1983 essay, Hugh Adams comments on Nash's way of naming sculptures 'mischievously … as a child might' to imply meanings and purposes that appeared only after their abstract forms were made. The title of his first exhibition, 'Briefly Cooked Apples', was a joke, partly against himself. His grinning Clams come close to being Disney characters, and he refers to them thus: 'Three large clams crack and chuckle revealing their interiors to each other, and Chestnut tripod one trunk split turned inside out, plugged together, has a skin like a giraffe.'[12] *Three Dandy Scuttlers* makes us smile even before we see this unreliable trio. We noted surrealist tendencies in his *Chelsea Tower 1* without needing a suggestive title, but *Running Table* is plainly funny as a title and as an object. So are the *Ubus*. Nash carved two of them in France in 1988, preparing his exhibition in Tournus Abbey, and they are of an unusual form, their lower halves standing firmly on the ground, their upper parts consisting in each case of a powerful branch that is angled from the rest and gesticulates oddly. Thought and skill have gone into matching the

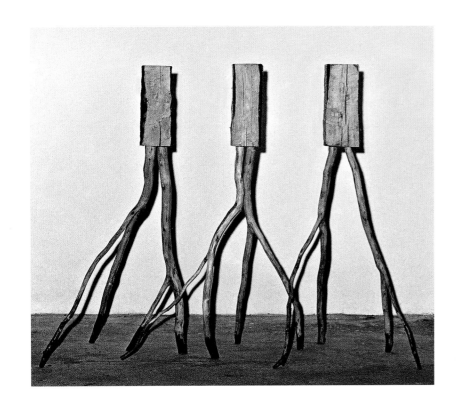

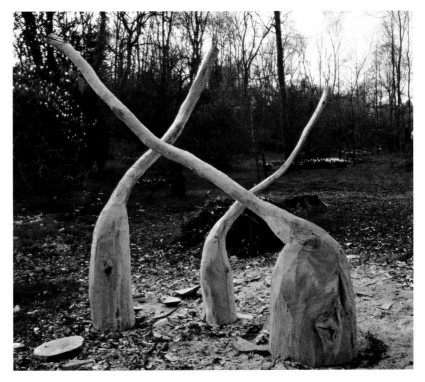

tapering circumference of the standing part to the dimension of the branch where it springs away from the trunk so that the two forms fit each other. The length of the wandering branch is determined by gravity: it must not be so long as to topple the whole piece. A student working with Nash recognised these as the protagonists of Alfred Jarry's wildly satirical play, *Ubu Roi*, which caused such a rumpus in the Paris of 1896 (when its author was twenty-three). The sculptor welcomed the baptism as wholly apt and has made additional *Ubus* since. This said, it is important to know that the impulse to the *Ubu* forms came to Nash from walking into the Tate's Rothko Room where the painter's *Seagram Murals* of 1959 are shown in soft light and in silence. Nash noticed that one of them had marginal forms, more or less vertical and then horizontal, coming towards each other, and from these came the idea of making his firmly asymmetrical sculptures. Two of them stand in Capel Rhiw today, still drawing attention to themselves. The point is that he sees no contrast, no enmity, between sacred and profane, between the solemn and the humorous, and welcomes their coincidence. It is the man frightened by religions who thinks laughter a sin. Nash said, in 1996, that 'the practice of art can be a religious, certainly a spiritual, experience'. In 2003 he commented that some of his work 'comes close to comedy'. Much of it, I'd say, raises the solemn spirits we tend to bring to art. We find ourselves smiling and even laughing, and moved to a deep joy as we sense the positive spirit and energies that feed into his work.[13]

In the case of the Powis Twmps Nash was responding to an extraordinary sight. Yew trees were planted in the gardens of Powis Castle from the end of the seventeenth century on, to be trimmed into geometrical forms as befitted formal Renaissance gardens. They were later allowed relatively free growth when wars and other problems made staffing the gardens impossible. They grew into vast, informally rounded forms, their dense foliage making them seem solid though inside they are structured like other trees, with strong trunks and a multitude of main and minor branches reaching out towards the light. They are grand and at the same time amusing because of their scale and bold surfaces. One thinks of clouds and rocks, and of large animals such as elephants, but also (perhaps I speak only for myself) of some of Henry Moore's grandiloquent but not always convincing Reclining Figures.

Nash made Twmps drawings (the word derives from a Welsh term, *twmpath,* meaning mound or pile), and he made sculptures echoing and developing some of their shapes. Encountering them in 2000, he was awestruck by their size and power and also by their age: many of them had been seeded three hundred years earlier. Man had collaborated with nature in establishing them; nature had taken over in letting them grow beyond the sizes and forms topiary would have insisted on, and more recently men with trimmers had merely kept them in reasonable, rounded order. I find these sculptures deeply humorous as well as masterful. Nash's sculptures vary in size, colour and presence. Some are free-standing solid objects. Others, though free-standing, are like two-sided reliefs. Others, again, are made to stand against a wall or to be fixed to one, in the manner of a relief. Some are charred, or partly charred, and some are not, but when he chars these sculptures Nash goes out of his way to leave bands of the original wood showing as colour between the charred areas. None of these sculptures is made of yew: the woods used are elm, ash, oak, beech, palm and redwood. In carving the reliefs, especially, he seems to have been seized by an image-making urge close to that of heraldry, with large, evidently meaningful forms surfacing in a work only a few centimetres deep. As one looks at them, admiration vies with amusement, and I suspect that Nash too was moved in this way. In making his Twmps from those he saw in the Castle's grounds, he came the closest he has ever got to using his art mimetically. To a substantial degree he was representing, in sculpture, part of what he saw there. But then those monumental yews were already products of man's collaboration with nature, and there was no call to undo that, any more than that Nash had to attend to the tree-trunks rather than to their swelling exteriors. Of course, in his drawings he explored and explained both, bringing out their complexity and might.[14] I do not want to portray David Nash as a funny man and an entertainer – which he could well be, beguiling his British and foreign publics with that special English weirdness we treasure in Lewis Carroll's Alice books, for example – because he is also an artist with a deep sense of the sacred and a desire to find in and

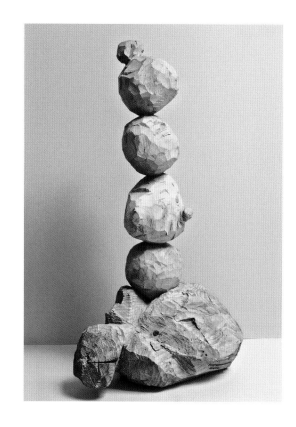

Bonks Pile 1
ash and pine
1971
84 x 50 x 32.5 cm

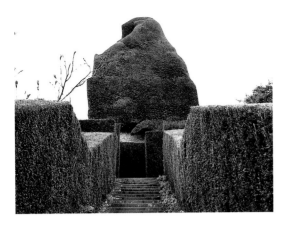

Above: one of the huge 300-year-old twmps (mound-like clipped yew hedges) in the garden of Powis Castle, Wales, 2000.

Right:
Beak Twmp
charred ash
2000
102 x 74 x 8 cm

Above:
Twmp Top
charcoal and pastel on paper
2001
30.5 x 30.5 cm

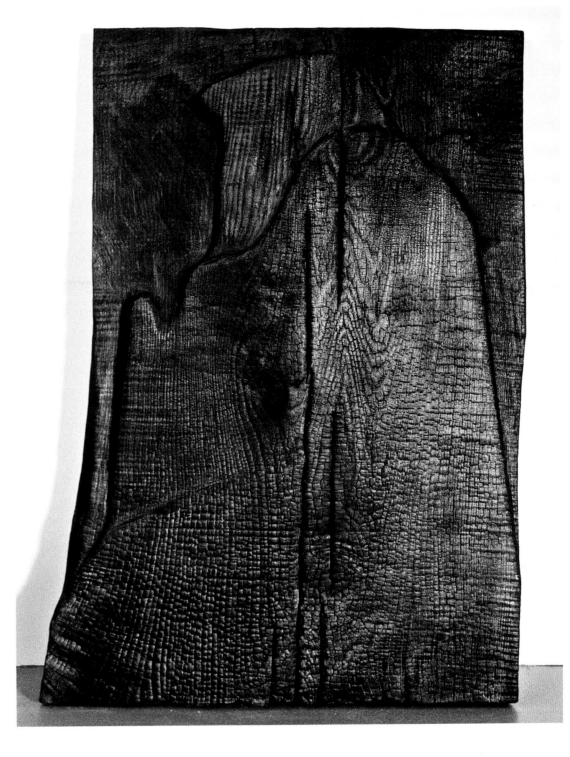

give to the world significance. He laughs as readily as he thinks; both are part of his working process.

Joseph Beuys came to England in 1974, preceded by his reputation as a politically as well as culturally challenging force in German art. His image, underlined by the clothes he wore for his appearances, his keen interest in literature and mystical philosophy, including the writings of Steiner and Joyce, enhanced by his dramatic war experiences, made him a giant among the artists of his generation and a particularly public one, working to shock his students, and then also the wider public, into facing essential moral and social issues which 'civilisation' seeks to hide. Local government tried to repress him, as a teacher and initiator of public works, but he emerged from the struggle stronger for it. No direct echoes of Beuys are to be found in Nash who has tended to keep out of the grasp of officialdom, engaging in teaching only occasionally and on

short-term contracts, but it is clear from some of that teaching, as well as from his writings, that he sees himself similarly committed to socially beneficial example and instruction.

The last years have seen developments in Nash's work and activities that call for special notice. From ranging widely over the globe, his activity has become more often home-based as his workshops and equipment have developed and modern transport systems have made it possible to import massive tree-trunks and to send out large sculptures. He continues to want to see where his work is going to exist or be shown temporarily, though he is less likely now to begin on a planted work abroad that needs visiting and nurturing. He still, however, travels frequently for his work.

A telling example of his striking ability to work and communicate with people through the process of working, is provided by his visit to Ashville, among the Appalachian Mountains of North Carolina, in the spring of 2003. Invited to work and teach for a month as a resident artist at the Center for Craft, Creativity and Design in Ashville, he had paid a brief visit the previous September, to agree with the organisers on which tree would be his 'wood quarry', and to see the stone building in which the resulting sculpture (his and the students') would be shown. He had already noticed the traditional ways in which wood was used in the American countryside, for fencing and other long-term utilities, sometimes charred to arrest decay. As soon as he arrived, he immediately set to work on this tree, starting with its brushwood and branches and involving students in handling and shaping this material. He set them graded tasks to familiarise them with the forms and rhythms of the wood and the physical act of working with it. 'I don't teach tools or skills, but help people to find what they are and have.' Soon he was sharing bigger roles with them, and encouraging them to pursue ideas of their own. In the evenings he would speak to them, chalk in hand in front of a blackboard, about the thinking that goes with being his kind of sculptor. He spoke, for example, of originality, that old cliché of art talk. For him, he said, originality has nothing to do with uniqueness, invention or innovation, but everything with alertness to the origins of things and to the nature of processes, to the four elements of western philosophy (which he recalled being thrilled by when he heard of them as a schoolboy) and the five phases recognised by the Chinese. (Since ancient times, we in the West have spoken of four elements – earth, water, air and fire – and have sometimes wondered about the existence of a fifth element, the 'quint-essence'. Chinese thought has traditionally referred to five elements or 'phases', emphasising their active interrelationships, including an element akin to 'spirit', an originating or energising principle. One sees at once how this broader and deeper grasp on the world would please Nash for whom a tree is a magnificently efficient 'weave of the four elements'.) Similarly, he spoke of the principle of truth to materials but stressed also truth to tools; here, too, collaboration is the basis of good work, not domination and force. There is much talk these days of the authenticity that stems from improvisation. Nash maintains that this too is not to be forced. If you are to work with spontaneity and spirit, you must plan and prepare for it, establishing a work ethic that is rooted in energy and zeal. Beginning on a new sculpture can be a particular pleasure, but this depends on a working routine, and, if you are working with others, an easy social flow. (Students remarked on Nash's smiling good humour as well as his wit.) Artists work with people's expectations, shifting or jolting these rather in the way that a joke shifts our picture of the world with an un-expected punch-line, sometimes evoking a much deeper satisfaction than laughter alone. 'We are guardians, and finders, of truth', he said. 'An artist's work is a manifestation of his higher being'. He added that too much contemporary art clamours for notice and lacks tenderness.

The students were clearly astounded by Nash's energetic, unfaltering application, his emphasis on the working process, and his quick responsiveness to situations as they arose. For example: it snowed unexpectedly. They assumed that this would put their course on hold since all the practical work had been pursued out in the open. But Nash got them to join in building a beautiful and efficient wood stove from heaped-up and compacted snow. In one of his evening sessions he spoke of the conventional notion of teaching children by filling their empty heads with things adults consider useful, but also of the wiser concept of the child being born complete, with the seeds of everything

Penland Stove
snow
North Carolina, 2003

Above: *Red Flash* in progress at the Llwyngell workshop, Blaenau Ffestiniog, 2003.

Right:
Red Flash
yew
2003
170 x 225 x 140 cm

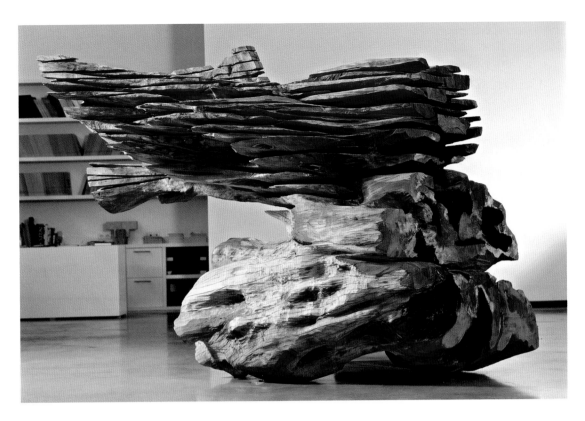

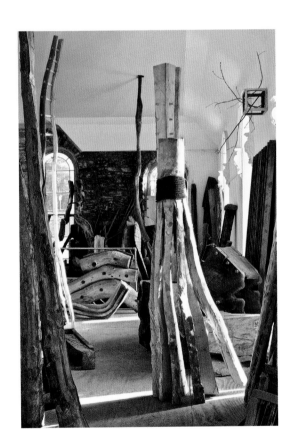

Balcony, Capel Rhiw, 2007.

In the foreground: *Split Wedged and Roped*, beech and rope, 1977; centre, with top let through ceiling: *Wood Fibre*, sweet chestnut, 1969; top right, on wall: *Branch Cube 3*, ash, 2003, made from prunings from *Ash Dome*.

inside it, and needing only to be encouraged to recognise what it has and what there is: not a filling-in process but one of opening up and making connections. When he heard that there were professional iron-pourers at the University, he involved them in his sculpture and took the opportunity to make his first works of iron cast in wood moulds, as well as a potent combination of a wood sculpture partly coated with poured iron. He recognised the nature of iron: primordial matter created by heat, extracted from earth and further heated to become a liquid that can, via a mould, become a significant and useful form in many cultures and since ancient times. On every occasion, he showed how the artist, in responding positively to what confronts him, can raise it and himself to a higher, more intense, level of being.[15]

Looking back over all this, one realises that David Nash's activity rests on, and in a sense represents, three bases. He had the chapel from, almost, the start. He inherited four-and-a-half acres of land, Cae'n-y-Coed, where he has 'sculptures' growing. He fathered (with nature) his *Boulder* and sent it out into the world. As he says, the *Boulder*, once he decided not to bring it home but to launch it into a nearby stream, was a sculpture 'going'. The *Boulder*'s adventure, over many years, has taken it down waterfalls, under a low bridge, into pools and an estuary, and thence into the Irish or it may be the North Sea. There, somewhere, it floats, just visible, borne, befriended and moved along by the Gulf Stream. Over thirty years Cae'n-y-Coed has given birth to eighteen sculptural installations, many of which are still flourishing while others have been absorbed back into the land. The chapel, Capel Rhiw, gradually renovated over forty years, has become a repository of Nash's other sculptures: early and early-ish pieces to which he is especially attached and which he hopes will stay there, but also recent works which may or may not be sold at some stage. He calls this 'the family collection', and clearly hopes it will stay together more or less the way it is. Individual pieces go away on exhibition from time to time, but are expected to come back into the family circle, and whole groups go on museum tours to Europe, America and the Far East. As I write there are over thirty sculptures in Schwäbisch Gmund in southern Germany, and an exhibition of the largest chapel works is being prepared for the fourth in a series of biennial sculpture shows in Lewes, Sussex, in which Nash's predecessors were Rodin, Anthony Caro and Henry Moore. Nash has many years' work ahead of him. As you enter the chapel you are struck by the profusion of forms, stored on several levels. But through this sense of profusion comes also a sense of purpose and of peace. It is a good place.

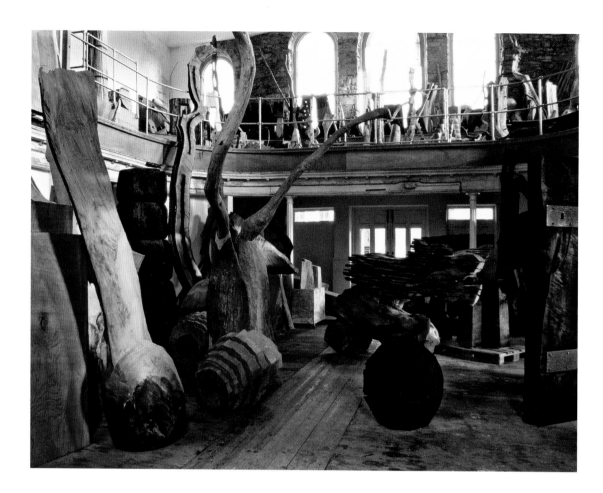

Capel Rhiw interior, 2007.

Left foreground: *Comet Ball*, partly charred elm, 1989; left of centre: *Two Rough Balls*, oak, 1984, and *Two Ubus*, oak and ash, 1988, and behind them, *Threshold Column*, charred elm, 1990; centre, *Red Flash*, yew, 2003; right foreground: *Black Seed*, charred beech, 2001; to the right, the back of one of the panels of *Millennium Book* is visible.

NOTES

[1] Two exhibitions of modern American art at the Tate Gallery: 'Modern Art in the United States', January-February 1956 and 'The New American Painting', February-March 1959. The first ranged widely over twentieth-century American painting, sculpture and prints; the second, with its polemical title, presented what was becoming known as the New York School in the work of seventeen painters (including Sam Francis, a Californian then working in Paris). Some of these (Still, Pollock, Gorky, Guston, Motherwell, Rothko and De Kooning) had also been represented in the 1956 exhibition by a few works; Pollock had meanwhile had a major exhibition at the Whitechapel Gallery, in 1958. The 1959 exhibition (of paintings only, and therefore excluding the work of David Smith) presented these and other leading painters in quantity, signalling a new chapter in modern art after a century during which the art of Paris had clearly been dominant, and it forced British artists and critics to take a position on their originality and special character.

[2] We reproduce the entire leaflet. It is remarkable how much of the Nash of today is already encapsulated in it.

[3] Julian Andrews, *The Sculpture of David Nash*, Henry Moore Foundation with Lund Humphries, 1996, page 68. This thorough and well illustrated monograph is the first resource for anyone writing about the artist, his work and his thought, and I am much indebted to it.

[4] Richard Mabey's essay, 'An Engagement with Nature', forms the introduction to the catalogue of the exhibition 'David Nash – The Language of Wood', Banque de Luxembourg, 1998; *see* page 20.

[5] Mabey, page 23.

[6] Marina Warner's essay 'Through the Narrow Door' is in the book *David Nash: Forms into Time*, Artmedia Press 2001; a reprint, with the same title, illustrations and contributions by Warner and by the artist, was published by Academy Editions in 1996. In both, Warner's essay is on pages 8–24.

[7] Mabey, page 22.

[8] Mabey, page 20.

[9] Hugh Adams, 'Natural Acts', in the catalogue of the exhibition 'Sixty Seasons', Third Eye Centre, Glasgow, and tour, 1983. On page 20 Adams refers to and quotes from Ashton's article 'Monuments for Nowhere and Anywhere', *L'Art Vivant*, Paris 1970.

[10] Mel Gooding, *Song of the Earth*, Thames & Hudson, 2002, includes five interviews by William Furlong with herman de vries, Chris Drury, Nikolaus Lang, Richard Long, Giuseppe Penone.

[11] Sidney Geist, *Brancusi: A Study of the Sculpture*, Studio Vista, 1968, pages 65-66.

[12] Adams, pages 16 and 18.

[13] 1996: film *Artyfax – From Capel Rhiw to the World*, made by Peter Telfer for Harlech Television. 2003: film *Discovering Heartwood*, recording Nash's residency at the University of North Carolina, of which I say more below.

[14] An excellently illustrated book-catalogue was published by Oriel 31 and Seren, Newtown and Bridgend, in 2001: David Nash, *Twmps*. It includes an informative essay by Sarah Blomfield, as well as a short essay by Nash himself. It is dedicated to Jimmy Hancock, head gardener at Powis during 1971-96, and includes some fine thoughts of his about his role, beginning 'Part of the art of looking after yew trees is letting them do what they want'. Nash never met this man. They would have had a lot to say to each other and much that did not need to be said.

[15] A fifty-minute film, *Discovering Heartwood*, produced by the Blue Ridge Community College, records Nash's residency at the Center. It includes interviews with the artists and students' brief comments about working with him and listening to him, and shows him at work with small groups of them. Nash evidently made a profound impression on them as well as on on Stoney Lamar, a well-known wood carver associated with the Center who acted as Nash's assistant, and spoke with admiration of Nash's emphasis on rhythm and routine in working with wood. I owe Nash's words, quoted in these paragraphs, to this film.

COMING/GROWING

Cae'n-y-Coed (field in the trees) is a 2.5 hectare parcel of land sloping up from the valley floor on the south side of the Ffestiniog Valley in Gwynedd, North Wales. Owned by the Oakeley family (also proprietors of one of the larger slate quarries in Blaenau Ffestiniog at the head of the valley), the land was managed from the late eighteenth century as a supply of timber for the estate, growing oak and ash and beech. In the early 'sixties, when the estate was broken up, my father bought thirty acres, including Cae'n-y-Coed, with the idea of having some cattle when he retired from a business career in London. In time, my mother persuaded him that this was not such a good idea, and the land was sold, with the exception of this small wood, which was retained for the commercial value of its timber.

It was a wonderful place to visit. In spite of the fact that it had not been managed for some time, one could feel the healthy balance of mature and maturing trees carefully nurtured for future timber use.

In about 1970 my father was approached by a local woodman who suggested that some of the larger trees were ready to be felled, and it was agreed that he could buy and extract the mature trees. In the winter of 1970, the woodman (who, we later discovered, was a notorious rogue) cut down virtually everything leaving only the smallest trees and a single stand of birch. Only the trunks of the felled trees were hauled away: all the branches and brush were left and the effect was one of wanton destruction. The valley is part of the Snowdonia National Park and felling of this nature is illegal without permission.

Around this time (1970), I had been to a retrospective exhibition of David Smith's sculpture at the Tate Gallery in London and had been struck by the extraordinary ease with which he handled steel, cutting, heating, pounding and welding it as if it were clay in his hands. David Smith spoke steel. I realised I needed to try to be as fluent with my material, to learn to 'speak' wood and to allow the material to lead me. Hitherto I had been treating wood as a dumb, inert material, using it to invent forms without understanding or taking account of its origin.

The devastation at Cae'n-y-Coed presented me with a significant opportunity. I had just started working with unseasoned wood, and here were 2.5 hectares of branches, some very large. So, it was agreed that in exchange for any wood I could use, I would clean up the mess. For three years I spent time at Cae'n-y-Coed whenever I could. Without chainsaw or tractor, and with only hand tools and block and tackle, the clearing was a big task. I built a small hut where I could shelter from the rain and spent whole

Left: burning bracken during the clearing of Cae'n-y-Coed in the early 1970s.

Right: the first hut, made in 1972.

days simply sorting through the tangle of branches. As I cut them to manageable lengths and stacked them, I became conscious of shapes, diameter and length, bends and forks and the specific form, weight and texture of each tree species.

The growth principles for all trees are the same. Each year their branches divide and lengthen so as to increase the number of leaves and the area of leaf surface, and their girth thickens with a new layer of wood – the annual ring. But each species has different characteristics that are consistent to that particular species throughout the world.

In axing, splitting and sawing by hand I met and had to engage with these qualities: some trees resist splitting – elm, sycamore, yew; some split willingly – willow, beech, chestnut; some resist handling – oak, hornbeam; some seem to welcome being worked – lime, birch, beech. They also smell different: the smell of birch is clean, lime is dry, holly has a strange tang to it. Oak smells of vinegar, elm can be sour and vile. Beech with honey fungus has a smell of honey right through it which will fill the air at a work site.

I started by chopping and splitting fresh, unseasoned wood and deliberately keeping my mind on the physical process rather than on the outcome. Soon I was looking for a way of working the linear shapes of branches into simple, self-supporting structures, searching for a method that followed from the nature of the material. I was using axe and wedge, lever and rope and later saws – methods of handling timber that go back thousands of years. Working continually on one piece of land allowed me to experience at close hand the progress of the seasons through the year and to watch how trees naturally regenerate – some growing from the stumps of felled trees, some from seed; meanwhile the bracken was spreading now that it had more light, and brambles too.

I was in my twenties, and giving up the colour constructions and theories of art I had learnt at art college: finding my art, and letting the land show me the way. The practical work showed me that there was 'thought' in physical movement and physical matter. The contact that my body and mind had with this raw material stimulated new and different ideas. My thinking/feeling senses were meeting the deeper 'thinking' of natural forces. Each branch that I pulled, sawed and stacked contained its journey from being part of a living, growing plant to becoming a separated object paused between life and decomposition. Each branch echoed the character of the species from which it came: a pile of ash branches is so different from a pile of beech, the feeling of ten oak twigs held in the hand is quite different from the feeling of holding ten birch twigs. 'Number' became alive: one branch, two branches, three branches. One = alone, independent; two = balance, even, calm, complete; three = uneven, outward, alive; four = balance again; even number = passive; odd number = active. Maths, Geometry and Algebra had excited me at school; they were the languages I could readily learn. Now at Cae'n-y-Coed these languages became truly alive. Shapes and weights began to demand to be put together, and I followed where they took me. Cae'n-y-Coed became for me an access point into vitality and dynamic thought, enormous in its simplicity.

Once I had started working with wood, it soon became clear to me that when we take wood inside we borrow it from its natural cycle, we remove it from the extremes of the environment that nurture it in growth and break it down in decomposition. My question to myself was how to make viable wood sculpture to exist outside. I began with the assumption that a sculpture outside had to stay the same, to resist change. Clearly I could not change the nature of wood, but I could perhaps change assumptions about it. Engaging with, and celebrating, the potency of the elements (rather than regarding these as a negative force) was a liberation. I quickly saw a distinction between a tree growing or 'coming' and wood decomposing/breaking down or 'going'. The *Ash Dome*, conceived 1976, planted 1977, was my first 'coming' engagement and the *Wooden Boulder*, which began its journey in 1978, became my first 'going' engagement.

Above:
Fork Stack
birch
height: 100 cm
1973

Opposite page, above:
Cae'n-y-Coed, in 1971, with *Split Joined Triangle* visible in the centre.

Opposite page, below:
Left:
Split Joined Triangle
willow and rope
1971

Centre:
Roped Arch
oak and rope
1972
270 x 255 x 107.5 cm

Right:
Roped Bundle Tripod
oak and rope
1972
255 x 180 x 180 cm

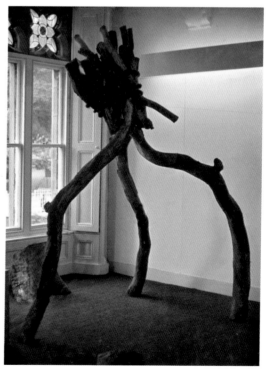

Ash Arcs

Two Lime Towers

Four Ash Corners

Leaning Larches

Celtic Hedge - sycamore -

Blue Ring
1983 → 88

Bramble Ring

Redwood Sentinels

Ash Dome

Serpentine Sycamore

Ash Hedge

seven by seven
49 birches

Box Elder Egg

Oak Bowl

Oak avenue

leaning out of square

Lime Cylinder

sod swap

Coen-y-Coed 2007

Ash Dome, 1977, and other growing works

While I was working through the felling debris at Cae'n-y-Coed, natural regeneration had already started, mostly birch, willow and holly. I felt the need to add other broadleaved trees – oak, ash and beech, much in the spirit of information I had come across about Chinese potters laying down clay in pits for the use of their grandchildren. Another striking story I heard around this time concerned the British Navy during the Napoleonic wars. Finding that they were running out of oak to build ships, they imported Indian teak, but it made ships that were too buoyant. And so, in an extraordinary act of long-term planning, oak was planted all over the south of England to build the fleet in the twenty-first century.

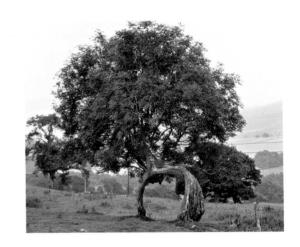

One of the jobs I had when labouring locally for a forestry company was planting Norwegian Sitka spruce in long, straight rows. I was paid six shillings per hundred. It was awful work, but even worse was the result over time of bland, alien plantations taking over the hills and moorlands. They were even replacing mixed deciduous woods which were being felled because of the tax advantage of planting conifers. So when it came to planting trees at Cae'n-y-Coed I knew that I did not want spruce or straight lines.

Not planting in straight lines made me think about the eventual relationship between the trees once they were mature which in turn led to visualising the space between them. Space is a fundamental ingredient of sculpture, and I soon realised the potential of growing a 'shape of space' over a long period of time. This idea answered a small problem I had with the itinerant nature of land art. An intervention in a usually remote area is documented and then abandoned. When I planted the ring of twenty-two ash trees in February 1977 with the intention of growing a domed space, it was a conceptual art

Opposite page, above: an example of the vigorous nature of ash. The centre of this old ash tree had rotted. What remained of the tree was unable to support its weight and had collapsed. A branch supports the remains of the original trunk. There was still enough bark and cambium layer to sustain new growth.

Right:

Ash Dome (detail), in 2002, twenty-five years after planting.

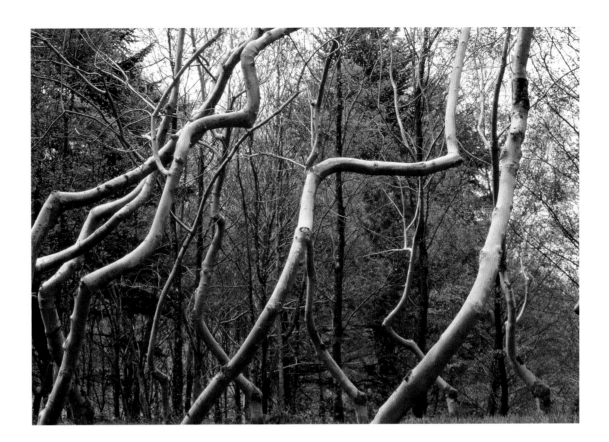

Opposite page, centre, left and right:
Ash Dome in 1980, three years after planting.

Opposite page, below: mulching around *Ash Dome*, 1979 (left); two stages of fletching, the technique used to promote angled growth in *Ash Dome*, photographed in 1983 (centre and right).

work and I presented it as such. However, I reckoned that it would take thirty years to grow the space, and this added a physical commitment to the conceptual action. Taking people there to see the ring of small saplings was asking them to visualise, to conceive of, an intended form. Over thirty years the concept has become a reality.

The idea was untested, but I assumed, optimistically, that both I and the trees would survive the thirty years and that I would have cajoled them into wrapping themselves around and over a domed space. Another Chinese potter story I had heard was that the potter kept his mind on a form of space and coaxed the clay to enclose that 'form of nothing' – the 'something' and the 'nothing' giving virtue to each other.

A dome form seemed most appropriate as it was clearly a human intervention and it reflected forms already in the immediate landscape. There was only one space level enough at Cae'n-y-Coed for this project, and it was itself slightly domed. To the north were the curving foothills of the Moelwyns, and to the east, the dome forms of Manod Mawr and Manod Bach.

My main source for research into which species of tree to use was hedgerows. I noticed that ash was resilient and vigorous and recovered most readily from being pruned or fletched. And in the woods I observed that ash trees could lean a long way from their roots in search of light. (And there was my name Nash, apparently derived from someone living near ash trees Near Ash, N'ash, Nash.)

Twenty-two seemed to be a practical number with no mystical associations; this was sculpture not shamanism. I made a radius with a stake and string and measured twenty-two equal spaces around the circumference. I bought twenty-two ash saplings and planted them. Naively I did not protect them and they were soon gone, eaten by sheep. So I started again with a fence and rabbit guards. It's tough to be a tree with so many predators. Mice, sheep, rabbits, cattle, deer, and squirrels (the latter being the worst) will all nibble the bark off young trees. I also planted birch on the west side as protection from wind as well as inside the circle to stimulate the ash (the trees would compete for light). I took the birch out a few years later when their job was done.

The material and processes involved in the *Ash Dome* are the same as those deployed in making and sustaining a hedge. Interestingly, some people are discomfited by the *Ash Dome* and the controlling interfering nature of my process. There is a sense that it's OK

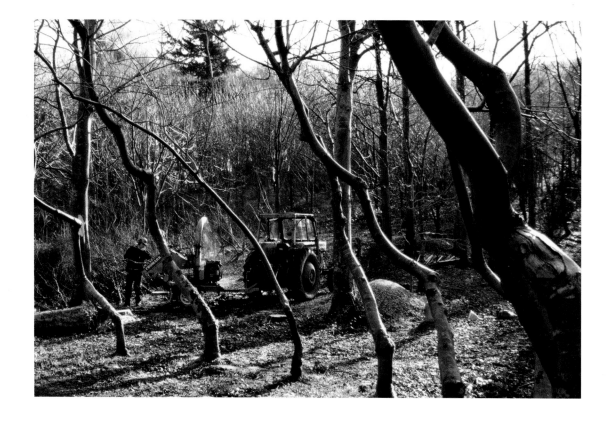

for hedges but not for art. The environmental movement in the 1970s was split between a belief that the human being is an alien parasite and that nature would be better off without us and a conviction that we are an essential part of holistic nature if we can work with it rather than attempting to dominate or conquer it. Forests are healthier for some extraction of trees but suffer grievously if there is over extraction. 'Man gets along better by collaborating with Nature and not dominating it' is one of Lao Tzu's aphorisms.

Left, above: chipping prunings from the *Ash Dome* and adjacent beech trees in February 2001.

Left, below: pruning *Ash Dome* and applying a fluid that contains an artificial smell of fox urine to keep squirrels away. Grey squirrels strip the bark from the upper branches to eat the nutritious cambium layer.

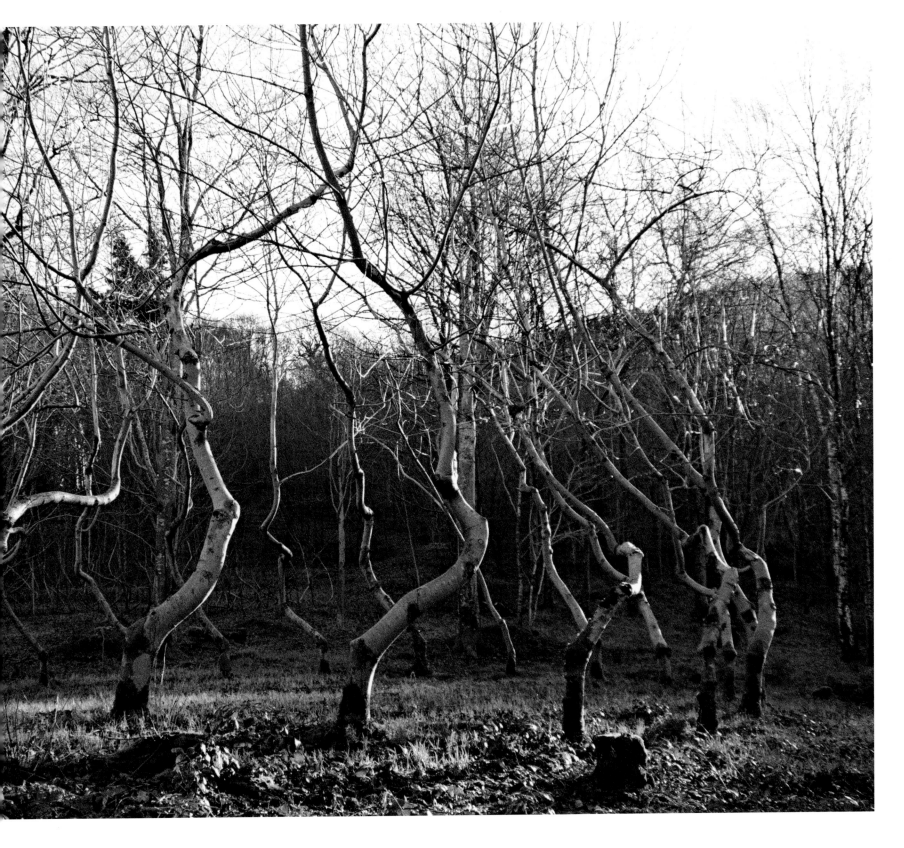

Ash Dome, photographed 2003.

49

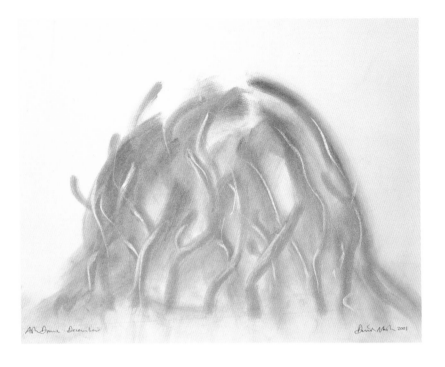

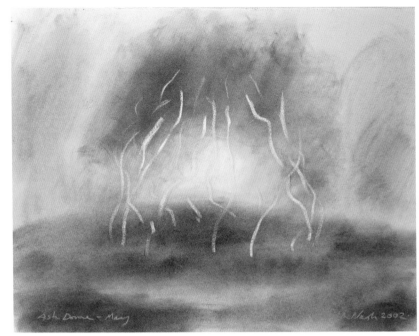

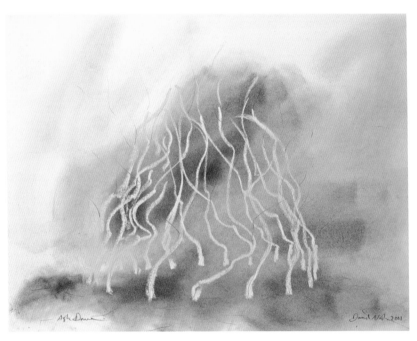

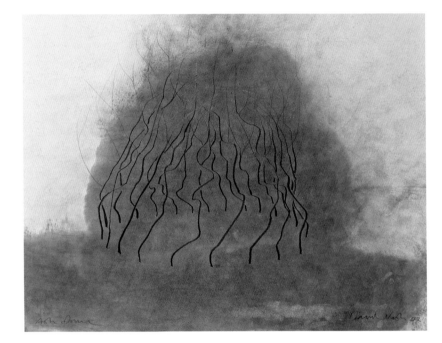

Ash Dome 3
pastel on paper
2001
60 x 80 cm

Ash Dome 4
pastel on paper
2001
66 x 85 cm

Ash Dome 1
pastel on paper
2002
74 x 93 cm

Ash Dome 16
pastel on paper
2002
74 x 94 cm

Ash Dome 12
pastel on paper
2002
69 x 88 cm

Ash Dome 11
pastel on paper
2002
69 x 88 cm

Ash Dome 8
earth and charcoal on paper
2005
42 x 54 cm

Ash Dome 9
earth and charcoal on paper
2005
42 x 54 cm

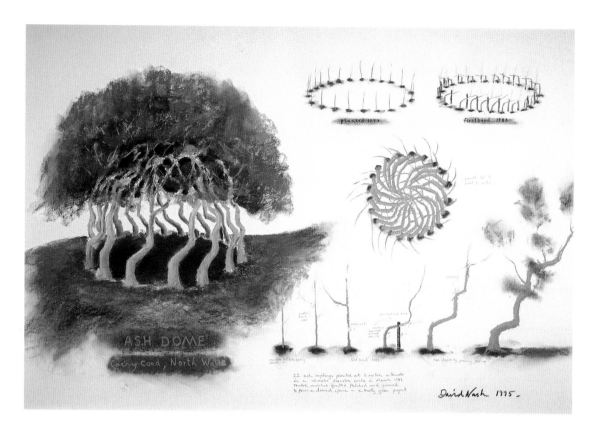

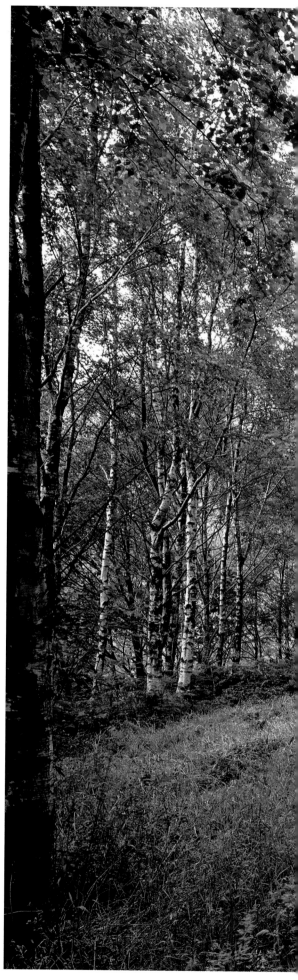

Ash Dome
pastel and graphite on paper
1995
120 x 165 cm

Right: *Ash Dome* photographed in 2004.

Below: *Ash Dome* photographed in 2001 with drawing table in the foreground.

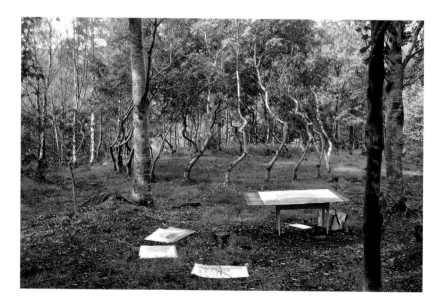

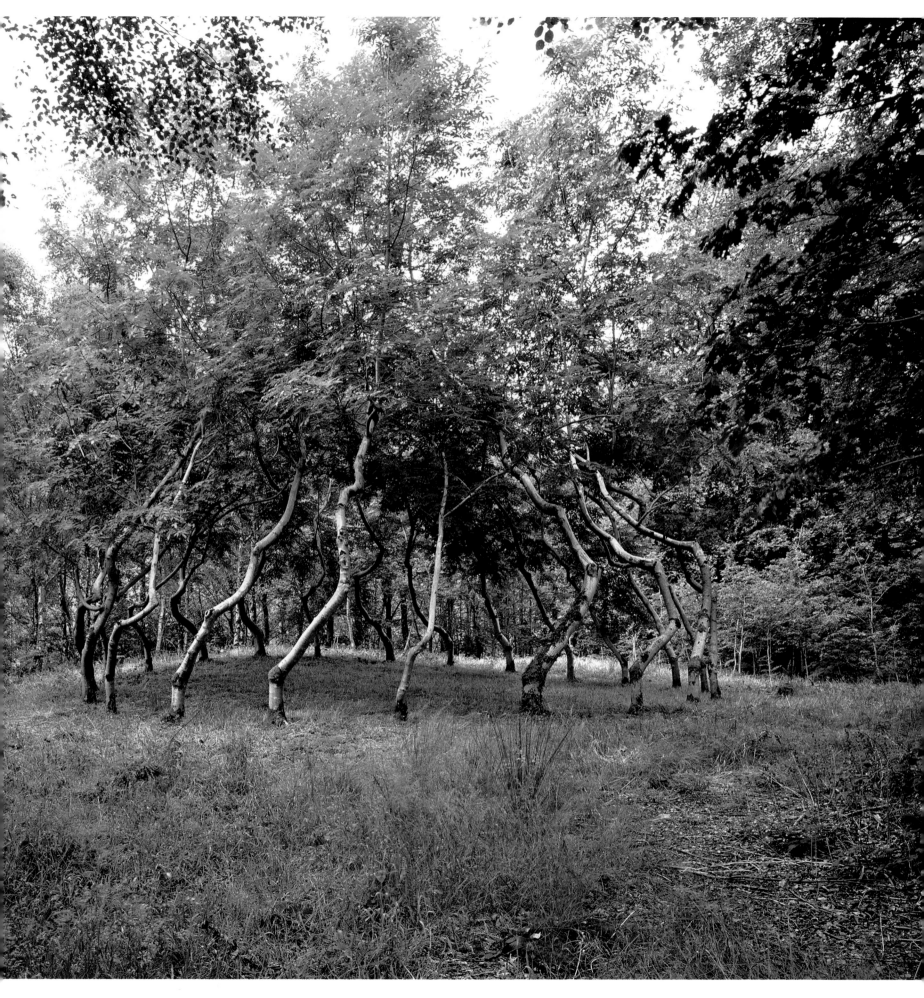

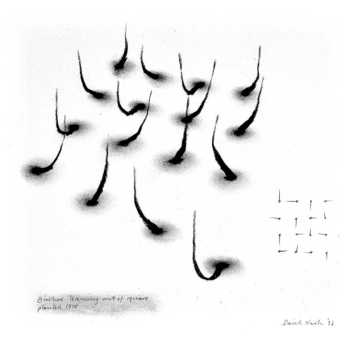

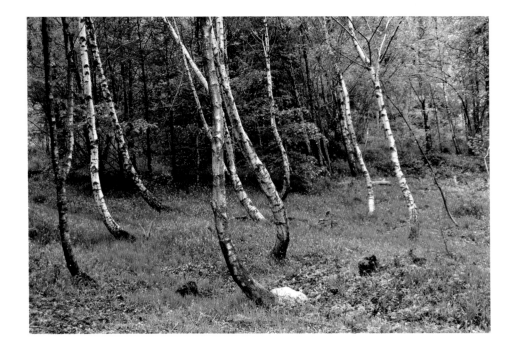

Birches leaning out of square
planted 1978

David Nash '92

Leaning out of Square 1978

Leaning out of Square and *Cracking Box* (*see* page 87), made in the same year, are based on the same concept. One is concerned with the realities of live wood in an outdoor space, and the other with the reality of bringing wood inside. *Cracking Box* is a very simple cubic structure made with unseasoned wood; over time the material cracked and twisted as it dried out, breaking away from the tight geometry of its original form. This process took two years and depended on the object being kept indoors. In *Leaning out of Square* the square form is determined by the planting of sixteen birch trees in four even rows of four. Each tree has been staked at an angle. Over time the resulting curved trunks have broken away from the original imposed square form.

Above left:
Leaning out of Square
pastel on paper
1992
30 x 30 cm

Above right: *Leaning out of Square* in May 2001.

Lime Cylinder 1978

Below: *Four Ash Corners,* photographed 1990.

The original intention was to create a cylindrical space within the woodland, by planting a circle of trees (eleven paces in diameter) and, at regular intervals, pruning all the inner branches, so as to maintain the internal cylindrical space. But at six years old, the trees began to lean in various directions, probably as a result of mice eating at their roots. However, the circular form remains intact, and branches that grow into the internal space of the circle are still being pruned. Attempts to graft branches are being considered.

Four Ash Corners 1980

Four ash trees were planted at the four corners of a square and staked so that they leaned into the centre, with the idea that each lead growth would curve up vertically so that eventually a spire would be formed. Birch trees were planted around them to help to force the ash straight up. By 2004 it was clear that the project had worked, and the trees around it could be thinned out.

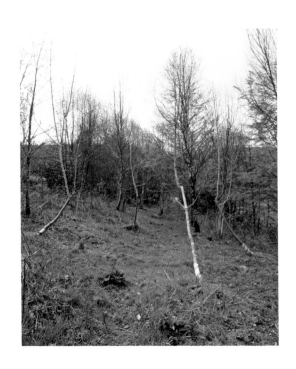

Leaning Larches 1983

The fifty Japanese larches were originally planted in 1983 in preparation for a planted work commissioned by the Modern Art Museum in Edinburgh, but in the event the site changed and different trees were used, so the larches remained at Cae'n-y-Coed. Larch has the characteristic of vigorous lead growth (from the main vertical tip). Saplings are

30 Leaning Larches
graphite and pastel on paper
1982
76 x 56 cm

Drawing relating to an earlier project with
staked larches.

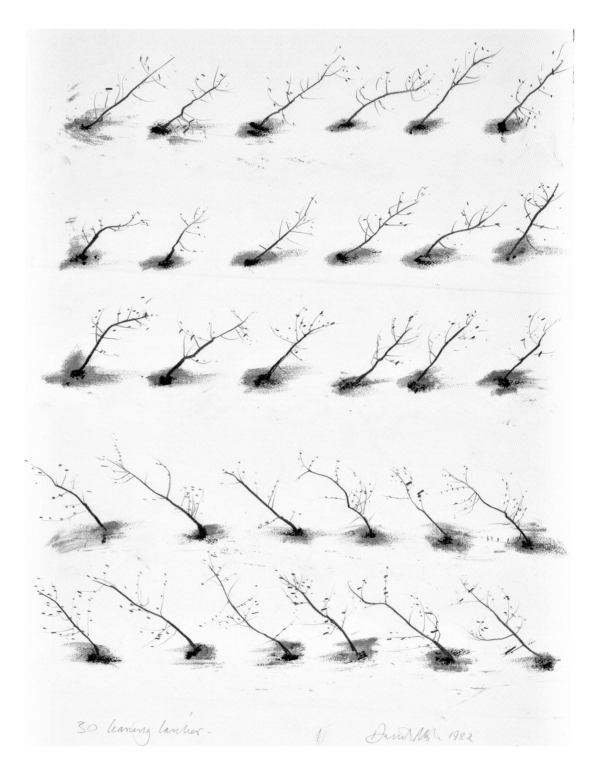

One of the larches staked for *Leaning Larches*,
photographed 1989

very easily dragged down in winter by collapsing bracken and brambles or snow, but then
straighten up again in spring as the old bracken rots away; over several years of this re-
peated action what is known as sabre growth is produced. Commercial growers work hard
– by weeding in summer – to stop this happening.

In *Leaning Larches*, this process was recreated by staking young trees at an angle for
five years and then, in 1988, transplanting them into groups and releasing them from
their stakes. The trees not only immediately began to correct themselves, they over-
compensated, bending right back and twisting and turning in their attempts to return to
an upright stance. According to a botanist I know, tree cells, in particular those of larch,
have what might appear to be a strong 'sense of balance' which makes the tree always
strive to stay vertical, and thus to right itself if it grows at too acute an angle.

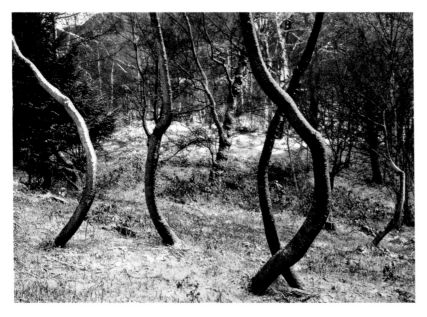 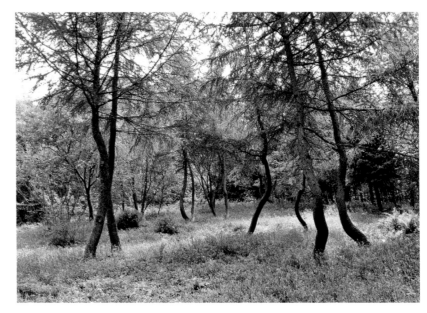

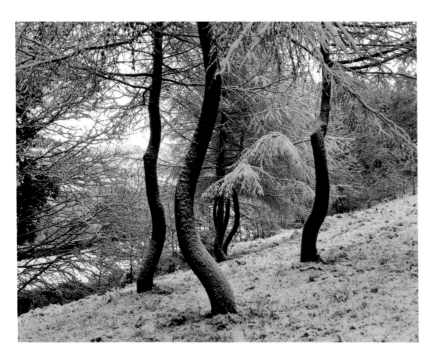 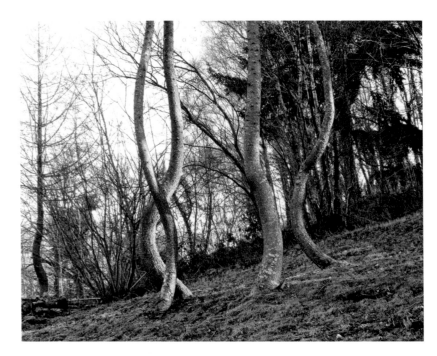

Opposite page: *Leaning Larches* photographed in 1995 (top left and top right), 1999 (centre left), 2001 (bottom left and right) and 2002 (centre right).

Right: *Bluebell Ring* photographed in 1985.

Bluebell Ring 1983

Bluebell Ring resulted from a desire to create a work about the colour blue (*see* page 151). Thousands of bluebell bulbs were moved from around Cae'n-y-Coed to an open slope and planted in a ring thirty metres in diameter. When in bloom, the flowers formed a discernible ring. After four years, the form dispersed into the general bluebell carpet of the woodland floor.

Sod Swap 1983

Cae'n-y-Coed, North Wales, to Kensington Gardens, London

Sod Swap
Left: Welsh sods in Kensington Gardens, London, winter 1983 (above), and London sods at Cae'n-y-Coed, summer 1983 (below).

Right: London sods at Cae'n-y-Coed, still mown as they had been in Kensington Gardens, photographed in 2004.

Sod Swap was a response to an invitation to exhibit a temporary work in Kensington Gardens in London as part of the British Sculpture show in the summer of 1983. My experience of group sculpture exhibitions in urban 'parkscape' settings is that they tend to look as though a group of unrelated UFOs has arrived, with no indication of origin or destination; they linger uncomfortably in this alien environment, only to vanish some

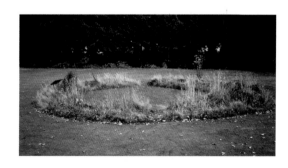

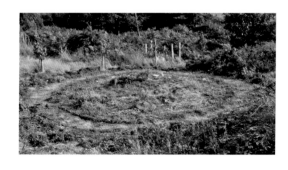

six weeks or so later as suddenly as they came. With this in mind I decided to work towards a solution to the problem of making an outdoor sculpture appropriate to a temporary placement.

At the time it was important to me that the sculpture should be living and visually unobtrusive, but with a clear indication of origin to overcome the UFO problem. Practical circumstances also had to be considered – time of year, size of site, and transport. The resulting idea was to exchange soil and plants (sods) between my home environment, the land at Cae'n-y-Coed, and the exhibition venue, Kensington Gardens.

Eighty-three strips of Cae'n-y-Coed sod measuring 90 x 30 centimetres were cut from a ring six metres in diameter, put in a truck and driven to London. The displaced Kensington turf was put in the returning truck and laid in the vacated space at Cae'n-y-Coed, so half the work was in London, half in North Wales. A botanist identified twenty-six plant species in the Welsh sod and five species in the London sod. The swapped sods were to be treated in the same manner as they had been in their original environment, thus the Welsh turf was to be left unmanaged and unmown, and the London turf was to be mown and cared for.

The plan was to swap the sods back again after the exhibition, but lack of funds prevented this. A new location for the Welsh turf was arranged in the centre of one of the formal lawns at Kenwood House, through the intervention of Common Ground. The turf remained untouched and the species were listed on a plaque, whilst the surrounding lawn was tended as usual. It stayed there for the next ten years, until English Heritage took over Kenwood House in 1993 and discarded it. Once again, Common Ground tried to intervene but it was too late, the turf had been thrown away.

The London turf has remained at Cae'n-y-Coed, where it has continued to be maintained as though it were still in London. The growth of surrounding trees, however, has altered the ecology of the area, and almost all the turf has turned to moss. But there is still, after twenty-five years, a faint vestige of the original circle.

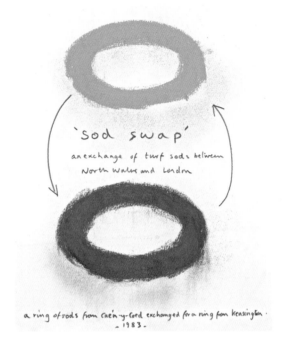

Sod Swap
graphite and pastel on paper
1983
70 x 50 cm

In 1983, daisy, rye grass and common mouse-ear chickweed were recorded in the London sods, while thin-runner willow herb, moss, common mouse-ear chickweed, bluebell, thyme-leaved speedwell, bracken, common St John's wort, bramble, procumbent cinquefoil, ragwort, common hemp nettle, soft rush, scented vernal grass, hogweed, creeping soft grass, cocksfoot, common catsear, hardheads, lesser stitchwort, white clover, ribwort plantain, common bent, common sorrel, birdsfoot trefoil, sheep sorrel, red campion and Yorkshire fog were recorded in the Welsh sods.

Bramble Ring 1985-1994

Brambles native to the wood were woven into a controlled, plaited ring. As new shoots developed, they were plaited into a ring form, which grew to approximately a metre high. Left to themselves, brambles' new shoots spread along the ground; weaving them into a ring limits the plant's ability to source new nutrients. The *Bramble Ring* lasted four years and produced a good crop of berries.

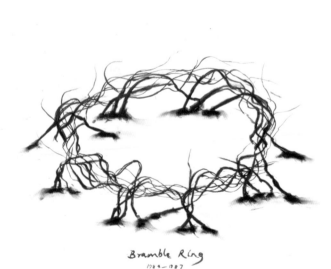

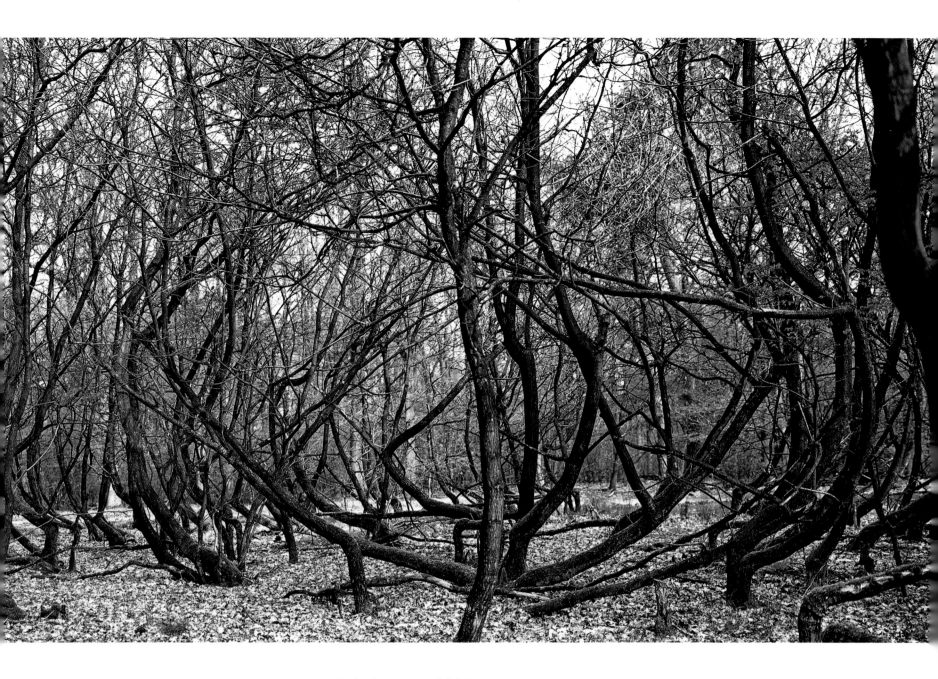

Divided Oaks, Hoge Veluwe, The Netherlands, 1984
The Kröller Müller museum commissioned a
growing sculpture for the Hoge Veluwe, a national
park surrounding the museum. I was told that a
quarter acre of small oaks was to be cleared
because the trees were not growing well. Over a
few weeks in early 1984 I carefully fletched and
staked over 150, so that half leaned west and half
leaned east with some criss-crossing in the centre.
For eight years, I returned regularly to tend these
trees, eventually removing the stakes.

Opposite page, below left:
Bramble Ring
pastel and charcoal on paper
1992
57 x 63 xm

Opposite page, below right: *Bramble Ring*
photographed in 1985.

Oak Avenue 1987

Originally, the plan was to use different species of tree to create a series of gateways into
the wood, but this was not realised. As the planted oaks grow, the width of the avenue
will become narrower, creating obvious thresholds as you walk up the hill into the wood.
Oak Avenue leads to the *Ash Dome*.

 The bark on the third tree up on the right has been eaten by squirrels, and the crown
of the tree is dead. The affected area will be pruned, and the rest of the tree retained. The
fourth tree up on the left died and was replaced by another one in 2000.

Serpentine Sycamore 1988

Wild sycamore saplings were taken from Abergynant wood and each planted at an angle
so that together they form a serpentine line. Sycamore, however, does not respond well
to transplanting and it took a long time to get going. It began to work as a form, but
then suffered serious damage by squirrels, and was removed in 2000.

Oak Bowl 1989

Twelve oaks were planted on a slope in a circle, each one staked to lean outwards so that a bowl from would gradually be created. Rowan and birch trees (which grow faster than oak) were planted in the centre of the circle to encourage the oak to lean out towards the light. But it didn't work because the oaks grew straight up. One oak died and was replaced. Various trees around the form needed to be thinned to give more light to the oaks. The method is working to a degree but the form is so far not as distinct as was hoped for.

Celtic Hedge 1989

Originally, in 1989, thirty-three groups of three trees each were planted – more than were needed so that if some failed the original intention would not be affected. There is no geometric pattern in the planting of *Celtic Hedge*, unlike the *Ash Dome*. As the trees grew, their young branches were woven and bent to encourage them to curve around each other – the beginnings of a woven hedge. Sycamores graft readily into each other, and in March 2003, twenty-two grafts were made – by rasping off the bark layer of the two branches to be joined, exposing the cambium layer (the growing layer of the tree) and screwing the two branches together. The cambium layers of the two branches gradually fused, and the screws have been slowly engulfed by the tree as it grows. Sizes of branches and their relative positions suggest where to graft. Initially many of the trees were badly affected by squirrels eating their bark, until a latex solution (with an added ingredient: a synthetically produced odour of fox urine) was applied to their trunks to discourage the squirrels, which would eventually have killed the trees. In 2005, a further seventeen grafts were made. The trees are now physically joined together.

In 1994, *Lime Wall*, composed originally of thirty-two limes, now thirty-one, was planted to stand as a replacement for *Celtic Hedge*, should that fail (limes also graft well, and squirrels are not attracted to them).

Ash Hedge 1990

The same process has been used as for the *Ash Dome*, but *Ash Hedge* is randomly shaped, with no geometric form other than that of a straight line. The *Ash Dome* showed that

Right: *Celtic Hedge* photographed in 1996.

Below: detail of *Celtic Hedge* in 2004, two years after grafting.

ash trees are very amenable to bending, and this hedge has been bent, staked and pruned into an ornate zigzag form. The fence behind the hedge had to be raised to stop the neighbour's horses from eating the trees.

Ash Arcs 1990

While bracken and brambles were being cleared, a natural hollow in the ground revealed itself. It prompted the planting of a piece which would be the opposite of the *Ash Dome* in which the trees compete with each other and surrounding trees for light; the *Ash Arcs* have been situated where light and space are abundant. They were staked so that they would grow curving away from the centre, following the edge of the naturally occurring bowl form to create two arcs. With no lip, the bowl implies part of a sphere.

Ash was used because it is able to lean a long way from its roots without falling over. While the two arcs are composed of the same number of trees, the piece can cope with the loss of some of them, and the form will still remain. The only maintenance is cutting off lower branches to stimulate height.

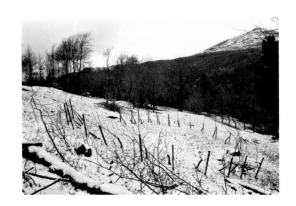

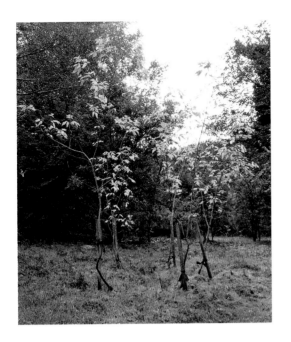

Above: *Box Elder Eggs* in progress in 2006.

Below left:
Ash Arcs
pastel on paper
1990
100 x 70 cm

Below right: *Ash Arcs* photographed in 2006.

Box Elder Eggs 1994

The idea was to create two egg forms by planting the trees at an angle, then grafting the branches together to create the forms. (Axel Erlenson in Santa Cruz, USA, used box elders for his tree pieces in the early 'fifties, because of the trees' grafting ability.) While these box elders did not grow well initially (and so are still not ready for grafting), they have started to grow more vigorously since 2002.

Two Lime Towers 1994, transplanted 1998

Originally lime trees had been planted where *Seven by Seven* is now growing to become *Lime Ladders*, but this project did not succeed, and the remaining healthy trees were transplanted to a new site to form *Two Lime Towers*. As the trees grow (they are still in their infancy), branches will be grafted together and new branches grafted continuously up the tree, to create two lime towers.

Redwood Sentinels 1996

These two redwoods, which arrived in pots as a gift in the early 1990s, have been planted and left to grow naturally: two tall sentinels which can be sighted from the road by visitors.

Seven by Seven 2001

The trees were planted seven feet apart in seven rows of seven, and the approximate height of each tree is estimated at forty-nine feet (seven times seven). This particular species of birch (which is hardy enough for the North Wales climate) was chosen for the strong matt white of the mature tree's bark. The fully grown form will appear as a white cube on a slope. A commercially planted birch wood in Hokkaido, Japan, inspired this piece (*see* page 99). Maintenance involves cutting weeds away around the base of the trees and pruning lower branches to encourage straight growth.

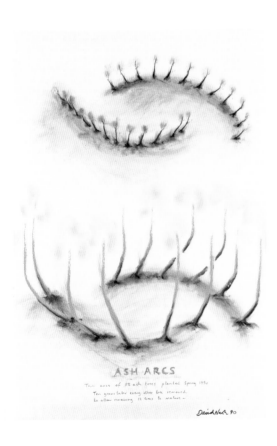

ASH ARCS

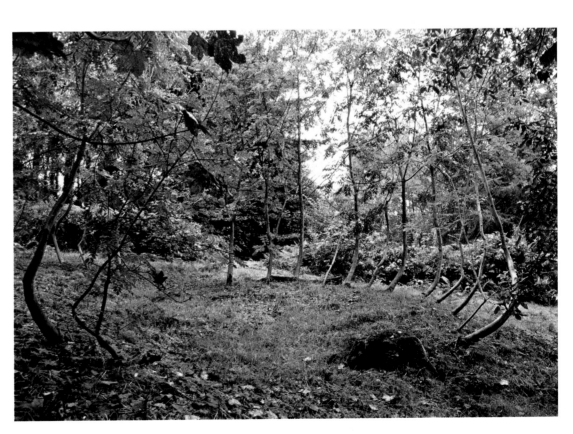

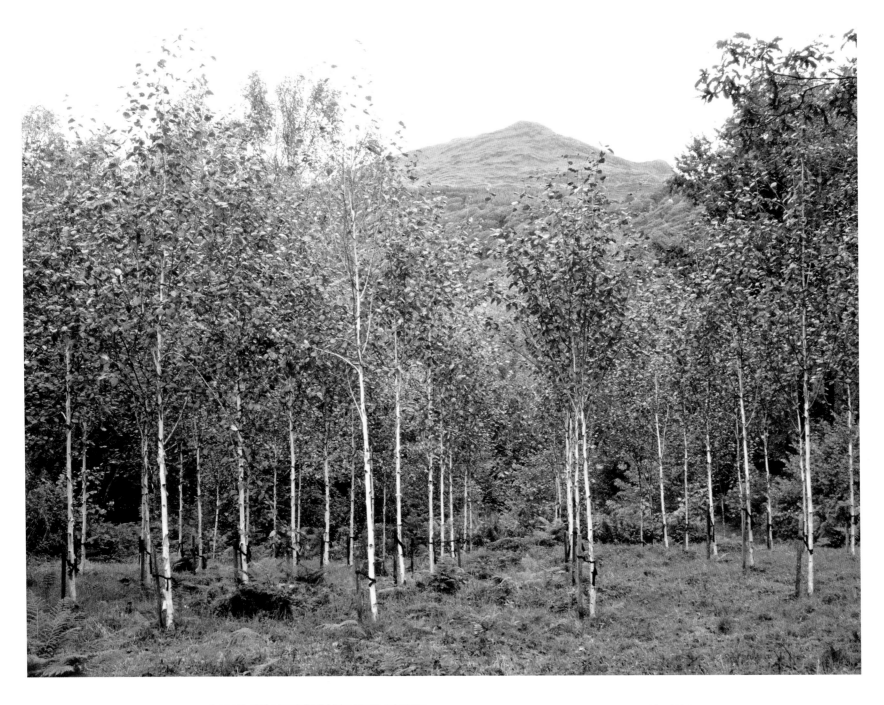

Above: *Seven by Seven* photographed in 2006,
five years after planting.

Left:
Seven by Seven
pastel on paper
2007
76 x 56 cm

GOING

As a student, I jumped into a sea of theories, histories and identities and floundered about with great eagerness, seeming for brief moments to glimpse some sense, but mainly finding myself in a confusion of complexity. I needed to concentrate on three fundamental aspects of the material objects I was confronting:

origin – how an object came into being
place – how it exists in space
change – how it progresses/changes over time

As an artist I am motivated to begin the life of an object. I work a material that already exists into a new beginning. In that beginning I'm aware of the material's origin and of how it will stand in the world – how it will occupy space. I am also aware that from the start elements within its material and in its surrounding environment will, over time, change it.

I wanted to make objects that would be completely revealing about themselves, so that what each one is made of, and where it is going are clear. My intention was that such sculptures would also be robust and self-sufficient, welcoming weathering and change, bearing the marks of their journeys through time. The material that I found to be a trusted partner in this activity was wood. As a tree it has its direct origin in the earth, growing and 'coming'. Once dead, it begins to reintegrate into the origin from which it sprang: 'going'. Taken inside, protected from the elements, it dries and settles down: it has been borrowed from the cycle of coming and going.

Below:
Placing – Going
charcoal on paper
1989
100 x 185 cm

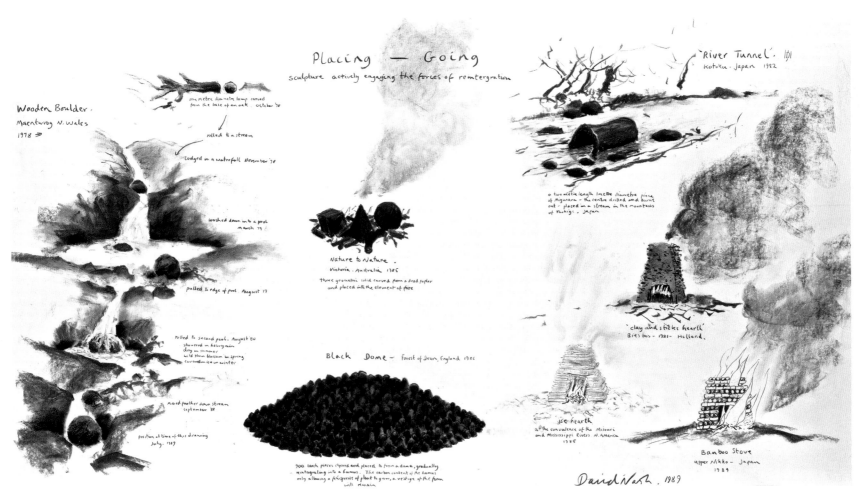

Wooden Boulder and other going works

High up on the other side of the valley opposite Cae'n-y-Coed, an oak, possibly 200 years old, lost a large limb in a storm, which made the whole tree unstable. As it was a danger to users of a footpath, its owners decided to have it cut down. They agreed to let me have the wood in exchange for felling and wood clearing. This was in the summer of 1978, a year after the *Ash Dome* had been planted. My studio work around that time had been with thin hazel and willow branches plaited and woven into structures. This oak tree gave me the opportunity to tackle some real weight and volume and, over two years, became my first 'wood quarry' (*see* page 87).

Wanting just raw volume and having acquired a larger chainsaw, I cut a rough sphere from the base of the trunk with the intention of getting it to my studio to dry and crack (a large version of one of the *Nine Cracked Balls* made in 1970-71). The two possible routes were getting it down a very steep slope and then down a track which would need careful control, or rolling it down a nearby stream, in the hope that the rock banks would slow its momentum. We chose the latter route, but the sphere jammed halfway down a narrow waterfall. I had no option but to leave it there. It looked good in the streaming water, and I started photographing it. Within a week the iron in the water had reacted with the tannin in the fresh oak turning the surface a very dark indigo blue. In winter a cap of ice formed on it.

This placement became more and more interesting as it revealed the potential of wood strategically positioned outside to react to the changing, eroding, effects of the elements – engaging with change. The following March the sphere changed position when heavy rainfall swelled the stream and freed it from the waterfall allowing it to plunge into the pool below, where only a fraction of it now showed above the water. The sphere looked more and more like a rock, a wood sculpture of a rock, a *Wooden Boulder*.

My intention at this time was to continue to move the *Boulder* down the stream to the road but over several years so that I could document the changes in varying weathers, seasons and flows of water in the stream. The object could then be exhibited along with the documentation. This plan was followed until 1981 when the *Boulder* was photographed and filmed being netted, winched and then dragged out of the pool to the shallows. Shortly after this, passers-by, youngsters perhaps, pushed it back into the pool (the sphere form invites rolling). It was winched out again and rolled further downstream to sit among big river stones for a while before being rolled down to the next pool.

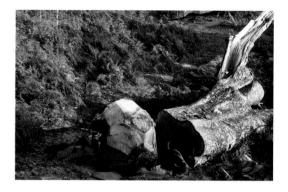

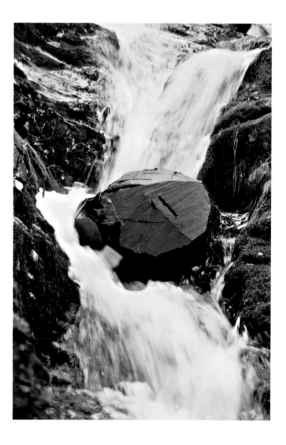

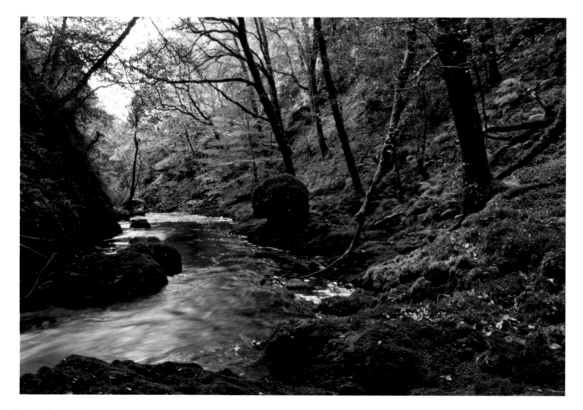

Above: *Wooden Boulder* with the oak trunk from which it was carved, Bronturnor Uchaf, Vale of Ffestiniog, 1978.

Below: *Wooden Boulder* stuck halfway down the waterfall into which it was pushed; the original intention was to transport it back to Nash's studio.

Left: stone boulder in Cynfal Valley known by Nash since childhood holidays in the Vale of Ffestiniog.

Over the following year it sat in a peaceful trickle of water in dry periods and was pounded by water in wet ones; I observed wild plum blossom on it in the spring, leaves piling up behind it to be flushed away by a storm in autumn, and then in winter, a cap of snow followed by it being completely encased in ice. The inert *Boulder* drew attention to the varying events and activities taking place around it, and gradually the thought of taking it out of the water faded. Material, environment and position change, and so too do intentions. If the *Ash Dome* was a 'coming' sculpture, then the *Wooden Boulder* was a 'going' sculpture – both pieces kept alive and spontaneous by their engagement with the elements. They were partners, on opposite sides of the valley and on opposite sides of the natural cycle of trees and wood.

I decided not to touch the *Boulder* any more, just to observe, though I did intervene on two more occasions. In 1988 there was a change of ownership of the land which raised the interesting issue of ownership of the *Boulder* (it seemed the real owner was the stream). If I had left it where it was, it would have legally belonged to the new owner of the land who was still an unknown quantity. My access to it might be prohibited, and the new owner would be free to remove it from the stream. So I rolled it twenty metres down-stream across the property line, still in the stream but now on the land of farmer Evan Jones, whom I had known since childhood.

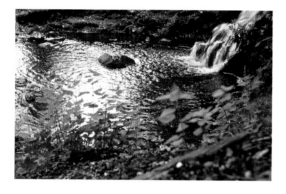
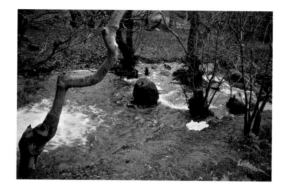
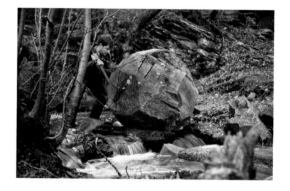

Above left: *Wooden Boulder* at the foot of the waterfall, March 1979.

Above centre: poised at the edge of the pool beyond the waterfall, 1980.

Above right and below: in 1980, being rolled towards the next pool, where it was to rest for the following eight years.

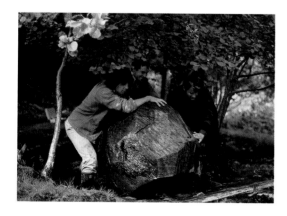

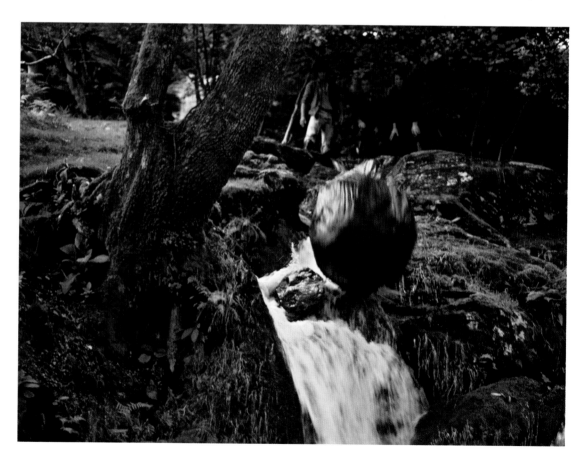

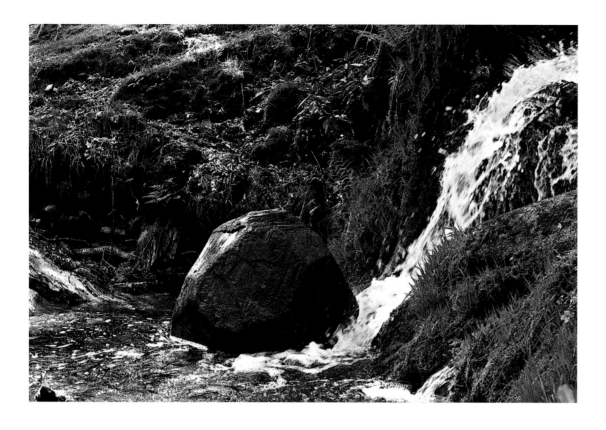

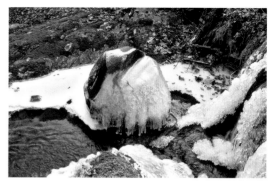

Wooden Boulder, 1981; in summer (left) and in winter (above).

Opposite page, top left and centre: *Wooden Boulder* stuck under a bridge in 1994; top right: being winched out in 1995 before being safely deposited on the other side of the bridge.

Below: *Wooden Boulder*, 150 metres further downstream after a storm in 1990.

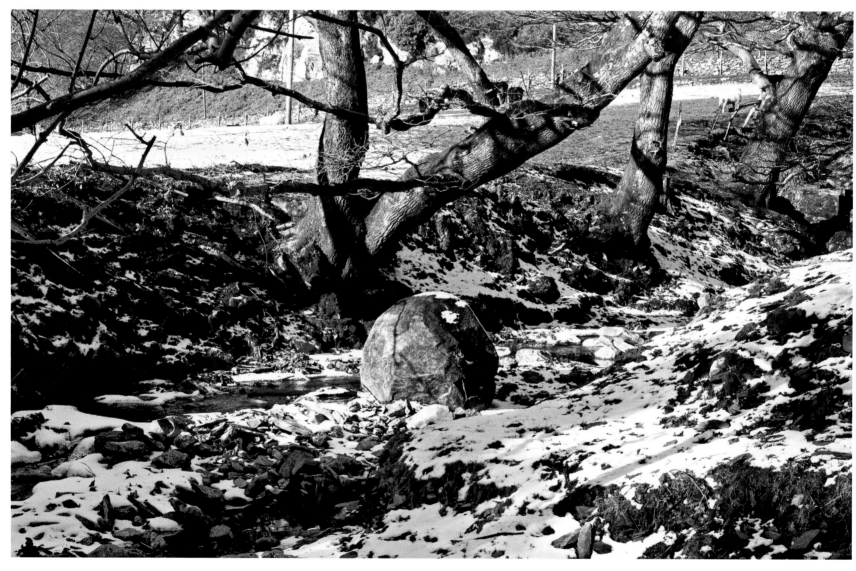

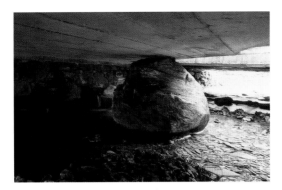
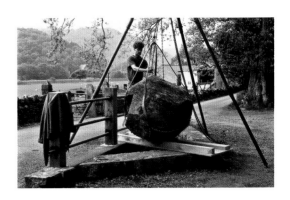

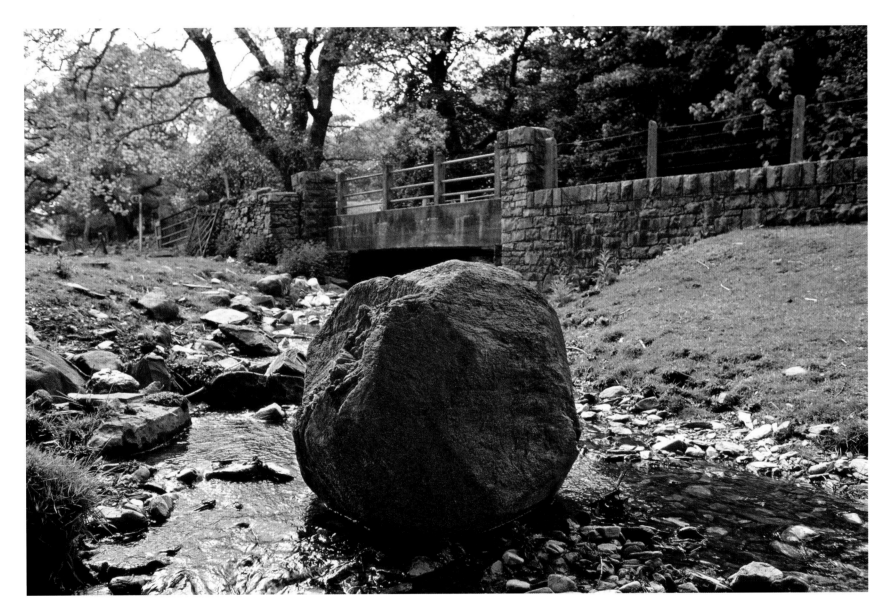

Above: *Wooden Boulder* becalmed in the Bronturnor stream in 1996.

Overleaf: *Wooden Boulder* in the Bronturnor stream in 2001, where it had lain virtually unmoving for six years (left); and (right, above and below) resisting stormwater in 1999 and eventually being propelled by high water into the river Dwyryd in November 2002.

Two years later a storm carried it a further 150 metres depositing it in a wider, calmer and more level stretch of the stream. In late 1994 another storm jammed it under a small bridge on an old drovers' road that runs along the edge of the valley. If left there, it would have been removed by the highways department to prevent a blockage building up which would then cause serious flood damage to the road and Evan Jones's farm. So I intervened, moving it beyond the bridge; this was early in 1995.

Seven years later, in November 2002, having withstood many storms, it was finally propelled out of its familiar parish of the Bronturnor stream into the river Dwyryd, the main watercourse of the Ffestiniog valley. It took me a while to find it – becalmed on a

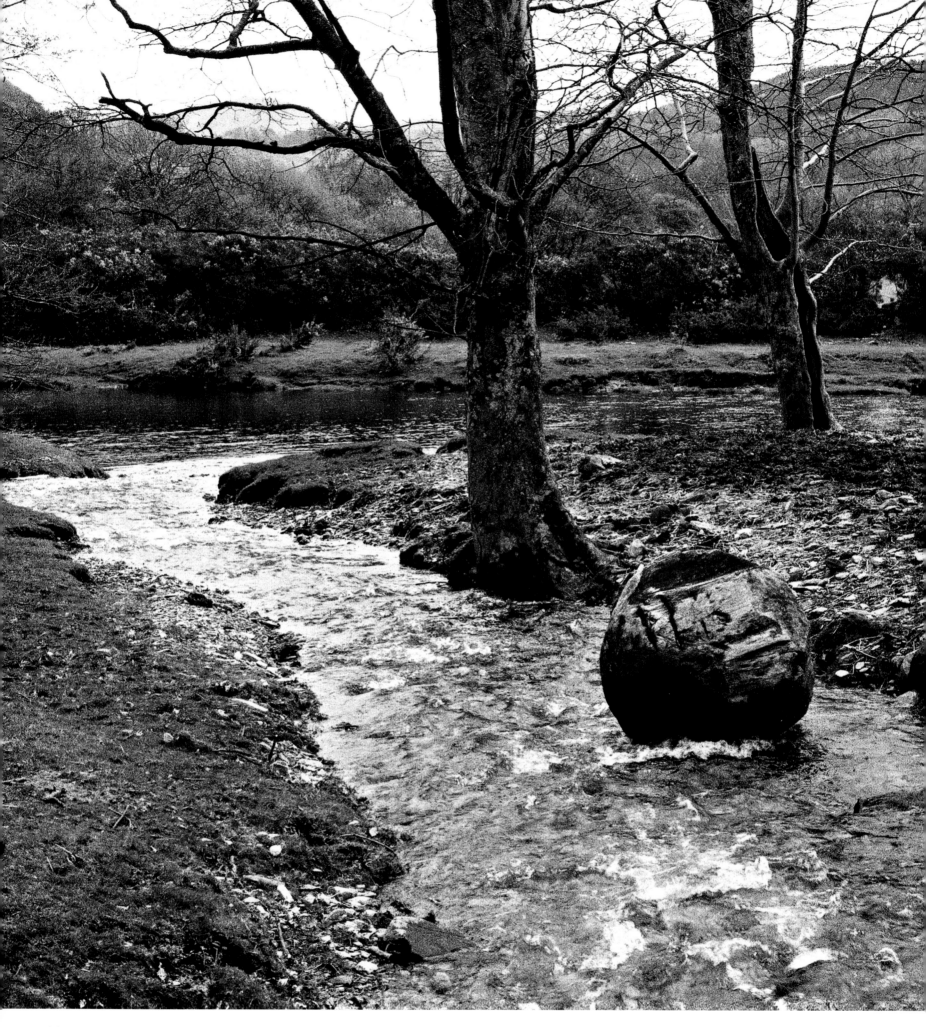

sandbank in the Dwyryd estuary eight kilometres from Bronturnor. Here it was in a very different environment. Each time it had moved during the twenty-four years that it had been in the stream, it had bedded into its new position for years at a time. Now it was in tidal waters and very mobile.

The high tides around each new and full moon would float it back up the river where it would sit, its position determined entirely by how much rainfall there had been, the height of the incoming tide, and the wind. The next incoming tide would then float it back down the estuary towards the sea. This perambulation in and out continued until the summer of 2003. The last sighting of the *Boulder* was close by an island near Portmeirion.

For several months after that, I searched the estuary, checking every creek meandering across the hundreds of acres of estuary flood plain, every ditch, every cove, every group of rocks. It was like looking for a body. I was not desperate to find the *Boulder*, but I needed to be confident that it really had gone out to sea, into the Tremadog Bay, and around the Ilyn Peninsula to be carried north by the Gulf Stream – a 'going' sculpture that had taken twenty-five years to go.

Wooden Boulder in the Dwyryd Estuary where it floated on the tides from
March 2003 until it finally disappeared in June of the same year.

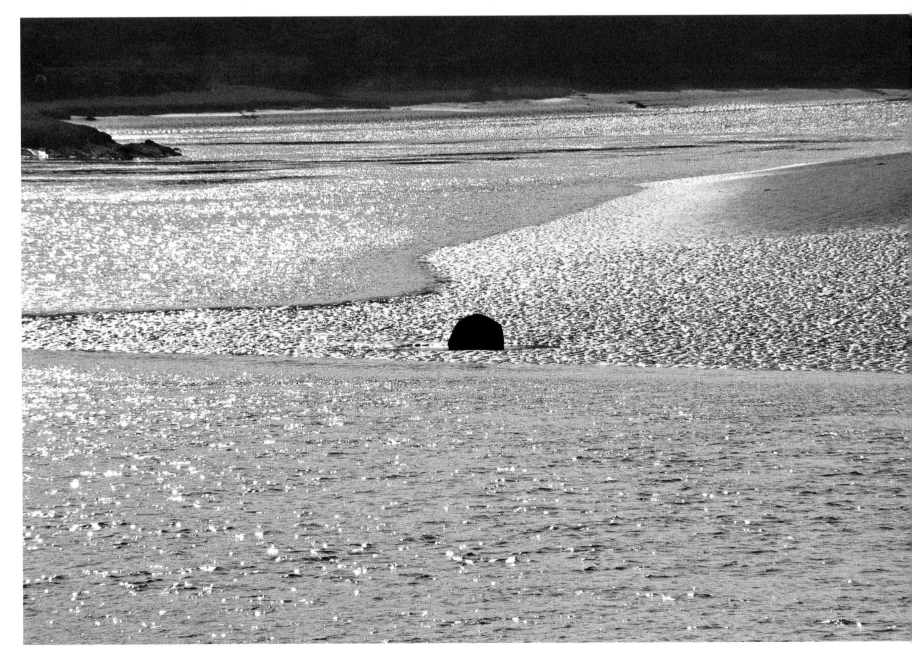

Tremadog Bay

into the sea

lastsighted
June 2003

March 2003
Equinox tide floats
Boulder back on to Dwyryd

Railway bridge

Tides move
Boulder around
on sand bank

Tyddyn Isa

Jan 2003 High tide
and wind floats
Boulder into
marsh

November 2002
Boulder floats 8 kilometres
stops on sand bank

Gelli Grin

Bryn Dwyryd

Bryn Mawr

Wooden Boulder 1978 → 2003

David Nash

Maentwrog

Rolled to Waterfall
November 1978

Sept 1978
Wooden Boulder
Carved

March 1979
Storm washed Boulder
into pool

Summer 1979 pulled out of pool
with ropes, sits in
shallows

Summer 1980

Rolled down into
second pool
Stays in pool for 8 years.

March 1988

Rolled into gulley.

Bronturnor
Ffestiniog Valley

1990. Storm moves Boulder 150 m.

Spring 1994
Storms jams Boulder
under bridge

November 1995
River Authority
puts Boulder on
bank

Summer 1994 extract Boulder from under bridge

March 1996 students push Boulder back into stream

Drovers Road

November 2002
Storm propells Boulder
in Dwyryd

Afon Dwyryd

River Tunnel

In 1982, in Tochigi, northern Japan, I had my first opportunity to work on a wood quarry abroad (*see* page 88). The fallen tree that had been found for me was a mizunara, a water oak, and starting work on it was something of a challenge as it was lying 2,000 metres up in the mountains under two metres of snow. In the early morning of the first day there, it was bitterly cold, and we soon got a fire going. Tending the fire developed into (among other things) hollowing out a big log with fire which took many days of carefully controlled burning. There was no space for the 'tunnel' in the exhibition, and it seemed more appropriate to leave it where it had been made as a local marker for that particular wood quarry.

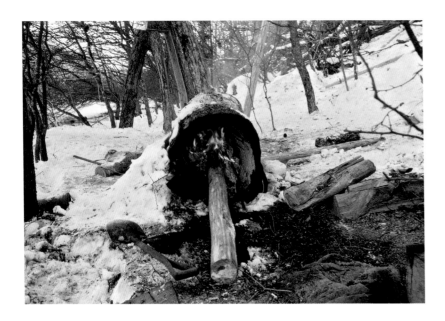

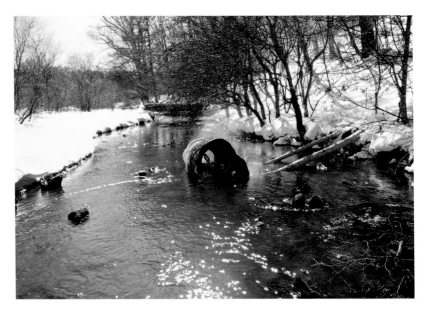

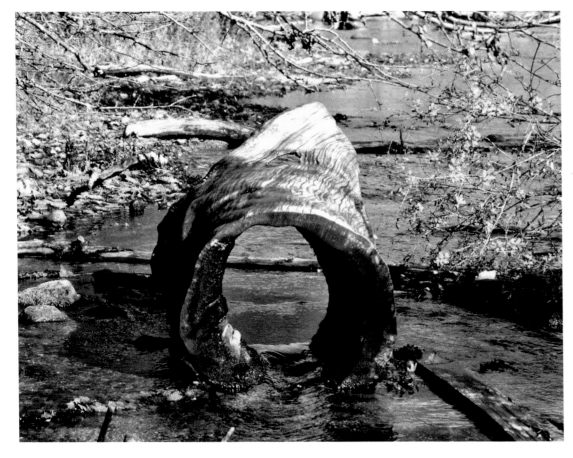

River Tunnel
mizunara
Tochigi, 1982

Above left and right: the section of trunk being hollowed out by fire, after which it was rolled into the river.

Below: *River Tunnel* as it was left in the river once work at the wood quarry had been completed, photographed in 1984.

Stoves and Hearths

Gathering stones, large logs or digging a small pit has for thousands of years been the way travellers have made a temporary hearth. Each place has materials particular to its geography, flora and geology. Each moment in that place is also particular: determined by the seasonal cycle and local weather. Each hearth is thus an encapsulation both of a fleeting moment in and the physical constancy of a particular environment.

Wood Stove, Maentwrog, North Wales, 1979
The first wood stove was suggested by an Irish student who observed that since I made Tables, Ladders and Bowls I could make a 'wooden hearth'. The ironical image of a self-consuming wooden woodstove was an idea to realise. Using a large fork of oak still remaining at the Bronturnor wood quarry, I pushed the saw into the face of the wood, made four cuts (which produced a square) and cut the back loose with a cut plunged down from the top. This cut also created a chimney.

Wood Stove, Tan-y-Bwlch, North Wales, 1980
A two-inch hand auger was used to drill a chimney down the length of an oak log and then a fire box was sawed out at the base. The original intention was to exhibit the stove alongside a photo of it burning, but in the event the idea did not seem to require the object, and only the photograph was exhibited. The stove project became a documentation of 'moments-of-land'.

Capitol Stove, Washington DC, USA, 1980
I was invited by the International Sculpture Conference to make a temporary structure in the Mall leading up to the Capitol Building in Washington DC, as part of the conference activities. I asked for two cords of firewood and built a large circular hut.

Right:
Wood Stove
Tan-y-Bwlch, 1980

Below:
Wood Stove
Maentwrog, 1979

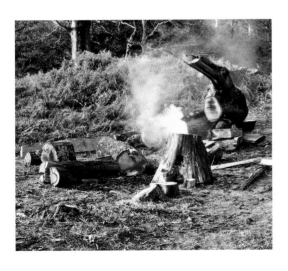

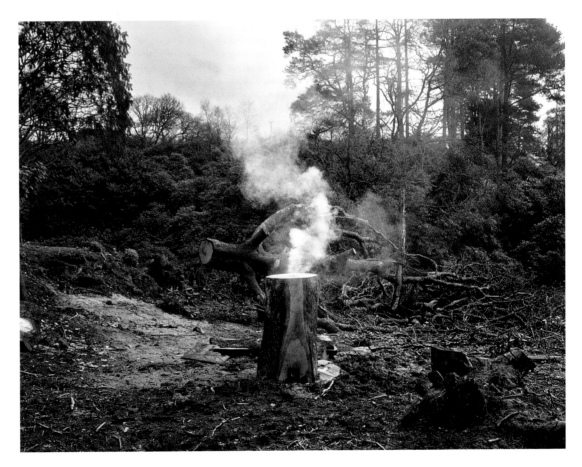

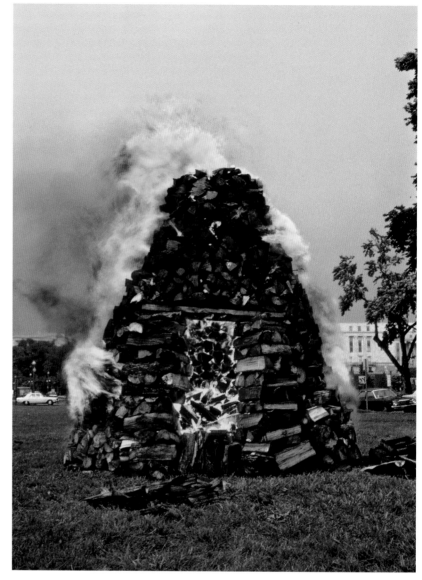

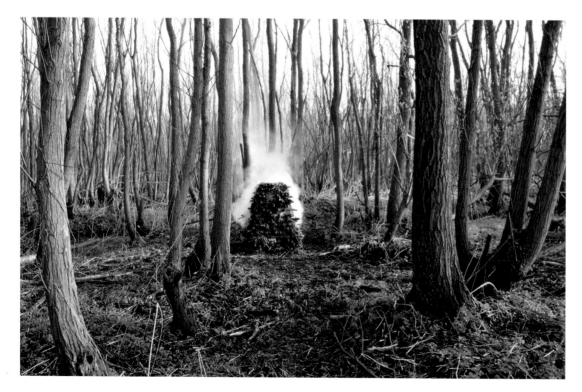

Above:
Capitol Stove
firewood
Washington, USA, 1980

Left:
Biesbos Stove
sticks and clay
Biesbos, The Netherlands, 1981

From one angle it would appear capped by the distant dome of the Capitol. After the conference, the structure had to be removed. Several passers-by remarked that it would make a great fire, and that did seem a good way for the piece to 'go'. We invited the fire service to attend on standby; I was hoping to put the fire out while the structure was still intact so that I could photograph the black form capped by the white dome of the Capitol, but they said that they were an emergency service and could not make appointments. At six o'clock on the final conference evening, just as I set the stove alight the heavens opened and there was a tremendous rainstorm with spectacular thunder and lightning. Spectators ran for the marquee. The blazing stack defied the rain, the fire service was called and, as soon as they arrived, they started hosing and pulling it down. I tried to intervene to ask for it to be left standing for my photograph but was told, 'Move over buddy, this is an emergency'.

Biesbos Stove, The Netherlands, 1981
Made in the delta of the river Maas on low, flat tidal land from wet clay and willow sticks. Visiting the site two years later, I found the stove collapsed to a thirty-centimetre-high mound covered in rabbit droppings; the highest point in the area, it was being used as a look-out.

Below left:
Clay Cliff Stove
Aberdavon, North Wales, 1982

Clay Cliff Stove, Aberdavon, North Wales, 1982
Made where a section of cliff had been ripped away by a storm, leaving deep fissures.

Below right:
Snow Stove
Kotoku, Japan, 1982

Snow Stove, Kotoku, Japan, 1982
Pile of shovelled dry snow splashed with water to freeze and bind the form, then hollowed out. Fire burned for four days before the form melted and evaporated.

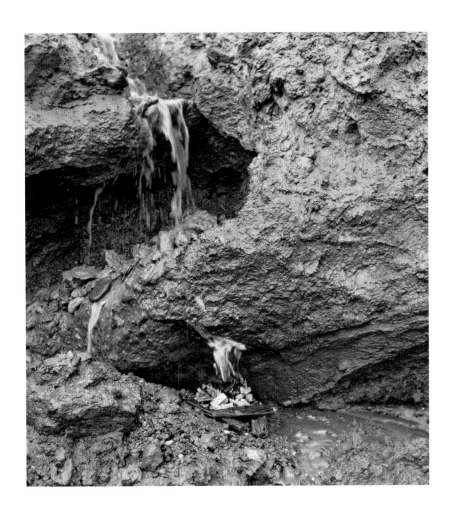

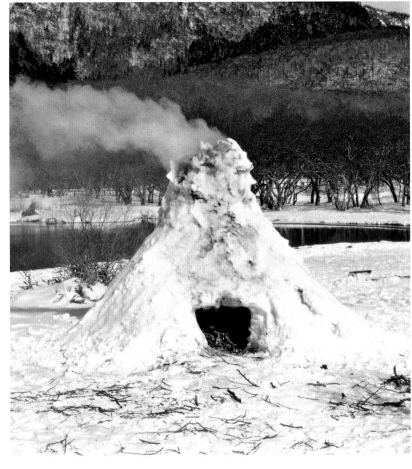

Bamboo Stove, Yumoto, Japan, 1984
When bamboo burns, air trapped in the separate chambers inside the stems expands, and the bamboo explodes, bursting like a thunderflash. Lengths of bamboo were cut to and wired together in an attempt to stop the explosions blowing the form apart. The event was witnessed by twenty local farmers and their wives, who had arrived on fire watch, each armed with two buckets of water.

Ice Stove, St Louis, Missouri, USA, 1985
January 1985. The flowing ice in the Mississippi and Missouri rivers converges near St Louis with a thundering roar. Ice stove built with ice spillage on the bank.

Above:
Bamboo Stove
Yumoto; Japan, 1984

Below:
Ice Stove
St Louis, Missouri, USA, 1985

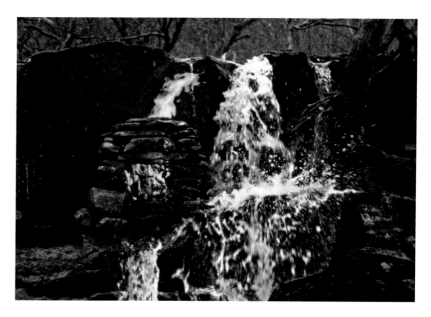

Above: *Stone and Moss Stove*, Cymerau, near Blaenau Ffestiniog,
North Wales, 1988

Below: *Slate Stove*, Blaenau Ffestiniog, North Wales, 1988
Shards of slate built into a stove on a slate tip behind Capel Rhiw.

Above: *River Stove*, Bronturnor, North Wales, 1988
Wet stones on a ledge and then dry sticks. Flames rise, water falls, two
elements passing. (Beware: wet stones can explode when heated.)

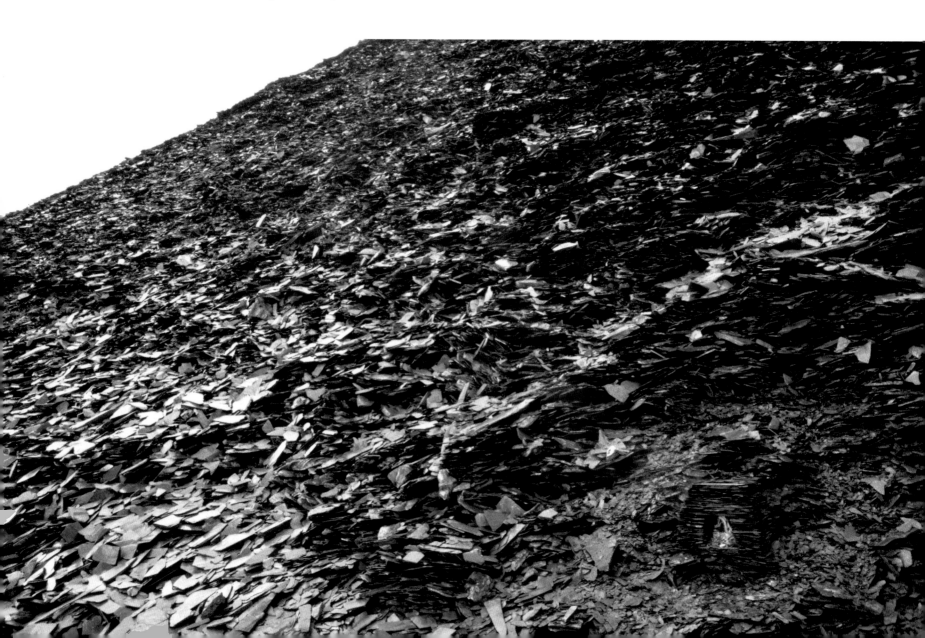

Alder Bark Stove
Hokkaido, Japan, 1993

Ice Stove
Hokkaido, Japan, 1994

Black Dome

While working as a resident sculptor in the Grizedale Forest in 1978, I often came across level oval spaces, barely discernible on the hillside, always with the same combination of plants; they were old charcoal-burning sites. Presumably the carbon residue from the charcoaling process had leached into the soil, allowing only certain species to flourish. These spaces, although nearly invisible, bore a sense of human presence, an echo of ancient activity in the forest.

Eight years later I was one of a group of artists invited by the Forestry Commission to consider making sculptures in the Forest of Dean. The works had to be: based on our response to the forest, sensitive to the environment and accessible to the public. The Forest of Dean has a history of charcoal manufacture and remembering my experience in Grizedale, I chose to make *Black Dome*. Ideally the sculpture would have been a mound of charcoal – its brittleness would not have survived public accessibility. I therefore opted for charring sharpened sections of larch trunks.

To make a dome eight metres in diameter and one metre high required 900 pieces of wood. Even working with an assistant, after the first day we had achieved only fifteen pieces. However, our technique improved and our daily rate had soon increased to over a hundred. A hole was dug, fifty centimetres deep and eight metres in diameter, and partly filled with gravel for drainage. The 900 charred stakes were graded to form a dome, each piece wired to the next to prevent them from being pulled out. I had envisaged the sculpture re-integrating with its environment, rotting down gradually into a humus, combining with fungus and leaf-mould; plants would add to the process of 'return'. Eventually, after thirty or forty years, only a vestige of its original form would be left, a slight hump. I had also imagined grass and bracken growing around the dome: in summer, one would see (from the public footpath) the top of the dome rising above the bracken – black to green; in autumn, when the bracken had collapsed and turned amber, the whole *Black Dome* would be visible; in the snow yet another variation would be experienced.

The sculpture trail quickly became far more popular than anyone had foreseen, radically changing the *Dome*'s environment. A new path was made right up to the *Dome* and beyond it to the next sculpture to cope with the erosion caused by so many visitors ranging freely through the forest. The *Black Dome* was transformed from a quiet reclusive object into a busy roundabout.

Something else that I had not anticipated was the public's delight in walking over the *Dome*. This initially produced a polished effect like a stroked cat but later the stakes began to shift, the form was disturbed.

New Health and Safety regulations came into effect, and the *Black Dome* was deemed a hazard. To stabilise the stakes, charcoal was poured into the spaces between them, but turned to a mush in the rain, so crushed coal, another material from the forest, was used. This is a sculpture that has undergone huge changes – from human reaction and intervention as well as from natural processes and the elements.

Charring larch logs for *Black Dome*, Forest of Dean, 1986.

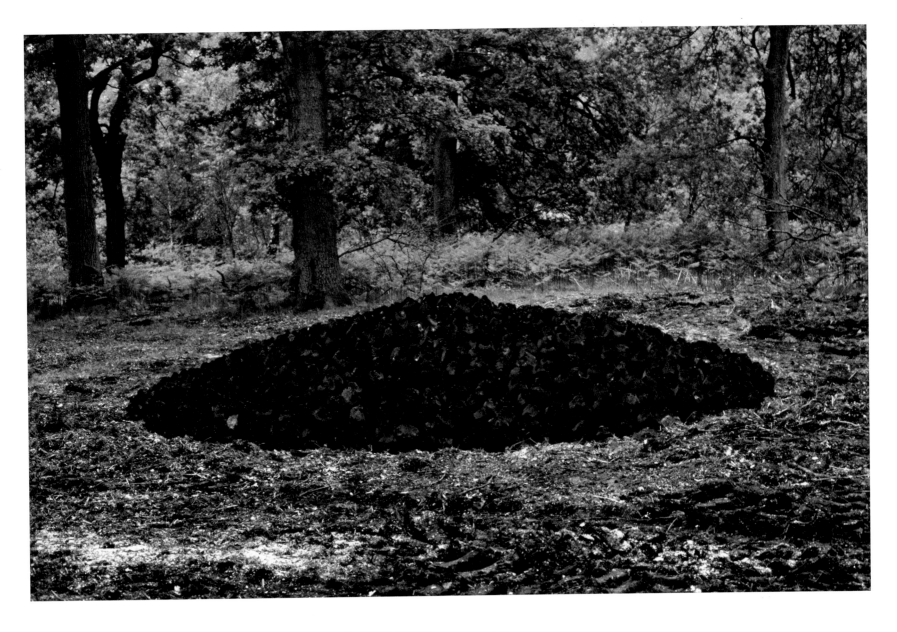

Black Dome
charred larch
Forest of Dean, 1986
100 x 800 cm

Opposite page, above: *Black Dome* in 1995.

Opposite page, below: details showing gradual erosion, 1995 and 1999.

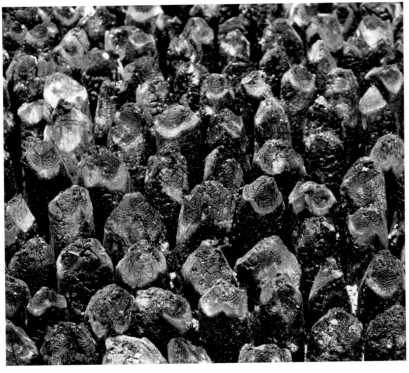

Left: detail of *Black Dome*, 1986.

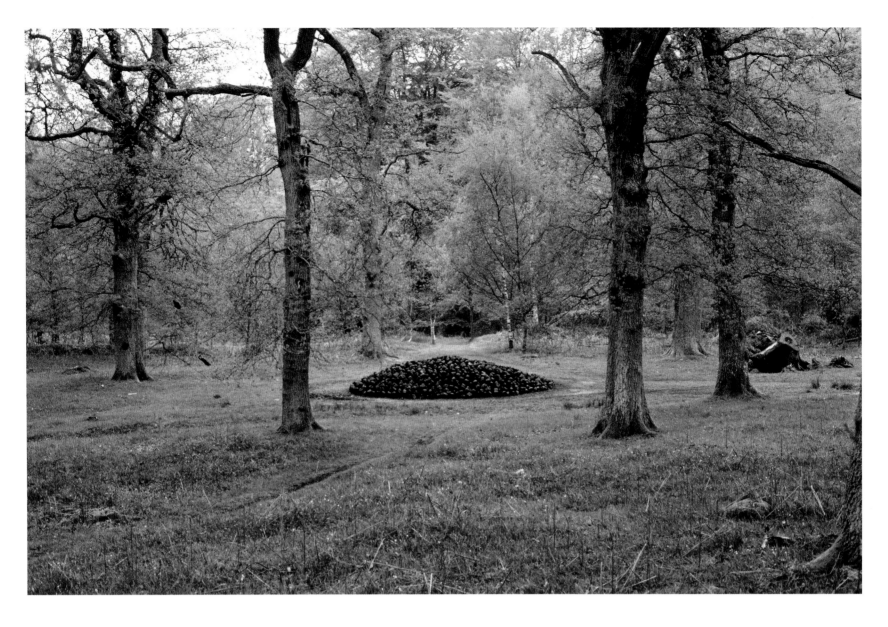

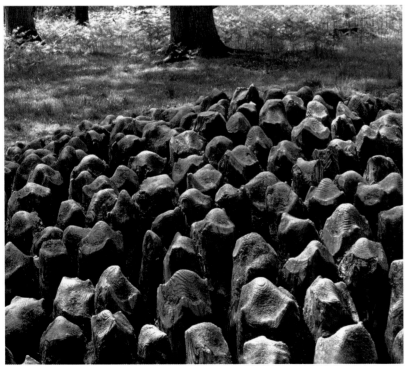

WOOD QUARRIES

The source of my material is a tree – a fallen tree or a tree standing dead – usually in a quite inaccessible place and weighing several tons. (As a rule, the more inaccessible it is, the less, if anything, I have to pay for it.)

Each species of tree has a different behaviour in its cycle of life and death, a different pace and character of growth as it spreads up and out from its roots, and eventually re-integrates with the earth as humus or ash. When I use wood I am borrowing it from that cycle; if I discard it, it returns to the cycle. The slower growing trees such as oak tend to have a greater resistance to decay. Faster growth trees like birch decay quickly. When an oak falls, its outer layer of bark and sapwood rots off in a few years, but its main body of heartwood can take over a century to decay. Californian redwood is the same; pieces of 'first growth' logged over 150 years ago and left in the forest are still sound timber. Birch, beech, lime and hornbeam, if left outside, decay from the inside out and after a five- to six-year period become an unusable pulp. But if their bark is removed and the wood is kept sheltered, it dries to a hard condition with no decay.

Whatever is made from a tree, indeed whether anything can be made at all, is con-ditioned by a host of practical facts, including whether it is possible to divide the tree into manageable parts, and the need to reduce the weight of each piece by carving so that it can be moved to a place where it can be picked up by a truck. The sequence of events in-volved in deciding whether I can work on a tree is generally as follows:

– Hearing about a tree, finding out where it is and who owns it.
– Going to see the tree which also reveals its accessibility.
– Checking the condition of the tree, its species, how long it has been down or dead. If it is beech and has been down for over four years, for example, the interior will already have deteriorated. If it is oak, how long it has been down matters far less because the wood is so durable. I also check the tree for any damage sustained in its fall and for any sign of rot spots.
– Ascertaining how the tree has fallen and assessing the risk that sawing may disturb its balance (which can be very dangerous).
– Sizing up the immediate site in terms of how easy or difficult it will be to move pieces around for carving.
– Finding out how safe it is to leave unfinished work and equipment on site overnight.
– Assessing the thickness and length of the trunk and major branches and noting any distinct features such as a curving trunk, so as to work out the possible yield of shapes.

From all of these purely factual observations I will know whether it is worth committing attention and resources to the transformation of this tree into what is almost always a group of sculptures. Once I am installed with all my equipment and the sawdust starts

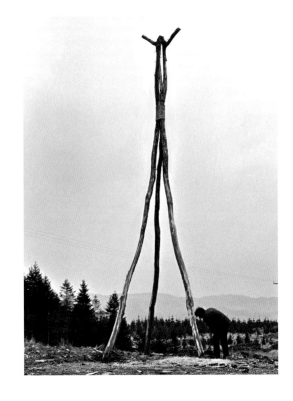

Above:
Horned Tripod
wood and rope
Grizedale Forest, Cumbria, 1978
600 x 200 x 200 cm

Below left:
Waterway
fallen oak trunk and fallen sycamore trunk
linked by oak branch troughs
Grizedale Forest, Cumbria, 1978
approximately 50 metres long

Below right:
Running Table II
oak and steel
Grizedale Forest, Cumbria, 1982
165 x 300 x 120 cm

First Wood Quarry, Maentwrog 1978-80
charcoal and graphite on paper
2003
56 x 76 cm

to fly, a dynamic chain of possibilities begins to reveal itself. The tree becomes a vein of material which I can excavate, the site becomes a quarry, vibrant with sawdust, big wood shapes, offcuts, branches, and the working tools – saws, levers, chain hoist, winch: a wood quarry.

In the early 1970s, I worked alone, using only hand tools and a block and tackle. I could only manage smaller trees or branches, assembling parts into larger sculptures by binding or pegging. The first whole trees I had access to were fallen oaks in Grizedale Forest, Cumbria, when I was funded to go there on an art residency in 1978. By then I had started using a chainsaw and needed to haul larger branches out of the forest to assemble on site where a sculpture could be seen by the public walking the Silurian Way. The first *Running Table* and *Big Tripod* were made there.

This experience gave me the confidence to tackle the oak that became available later that same year at Maentwrog in the Ffestiniog Valley, a big tree probably 200 years old, growing next to a path. A large branch had broken off, making the tree unstable, dangerous to users of the path, and the owners had decided to cut it down. It was agreed that I could have the timber if I organised the felling and cleared away. This was in June 1978 and over two years I worked through the tree making eight sculptures:

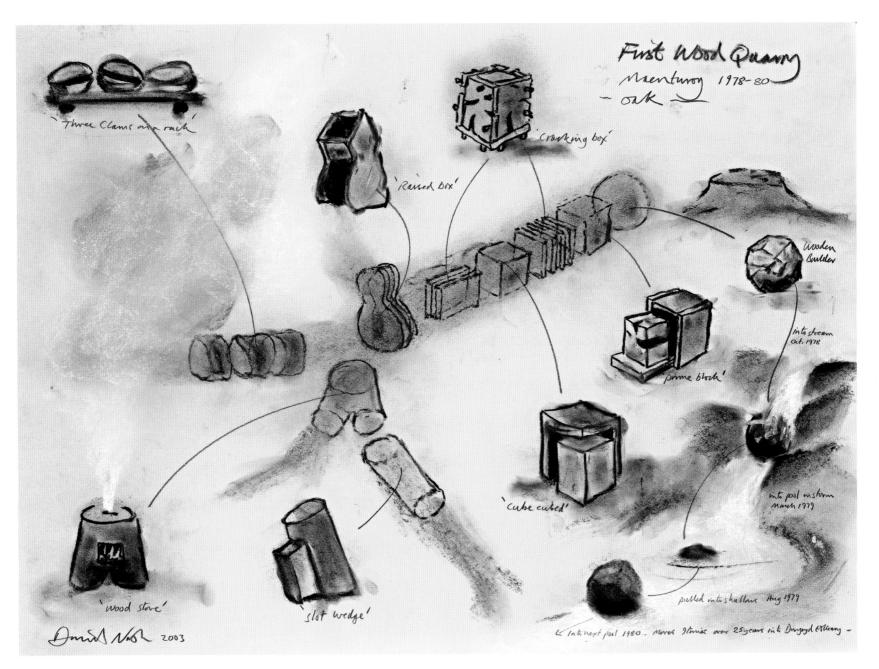

Wooden Boulder (the largest piece from the base of the trunk)
Prime Block (the first piece of my work to go to America)
Cracking Box (the first of several versions in different woods)
Cube Cubed
Three Clams on a Rack
Woodstove (the first of several)
Raised Box
Slot Wedge

In 1979 another oak tree came down in the valley at Tan-y-Bwlch, and the National Park authorities gave me permission to work it where it fell. These trees were truly like quarries. The material just lay there dormant, and when I had an idea I would go and carve it at one of the two sites.

In 1980, my work was included in a show of seven British artists at the Guggenheim Museum in New York. Sculpture was selected from my studio, trucked to London, crated by the British Council and sent over the Atlantic. I followed. This was my first long-haul flight and first time in America; it was very exciting to be included in a show in this spiralling building, and exciting to be in New York. We opened the crates – so strange to see these rough objects in a museum environment – and arranged the pieces around half a spiral. The experience was one of 'visiting' and 'talking', the only people I met were from the art world. I soon became aware that I was not meeting America as a land. It would have been more interesting for me to have been able to make new work in a rural area, to meet regular Americans, to confront the elements, to breathe the air, to haul American wood – to experience a more physical meeting with the continent. I resolved then that if another opportunity to exhibit my work overseas occurred, I would propose that all the work be made in the host country.

Quite soon, in 1982, an opportunity did arise, in Japan. A 'British Art Show', supported by the British Council would involve around thirty artists, each with an independent space for a group of work, in a tour of four museums starting in Tokyo, I made my proposal and a museum in Tochigi was enthusiastic to support such a project. America had been thrilling and foreign, the idea of working in Japan was even more exciting, and foreign but also somewhat daunting. The project was scheduled for February 1982 with the exhibition opening an early March.

Anxious that I might have bitten off more than I could chew, I needed a trial run, as this would be the first time that a coherent group of work would be made from a single tree in one continuous working period to be exhibited immediately. I started a residency at the Yorkshire Sculpture Park working with a dying elm. The tree was felled, and it took twenty-one days to work through it, from its roots to its twigs, making a group of sculptures and wall-mounted pieces As I dismantled the tree, I noticed a continuity of 'V' shapes made by the roots and the dividing branches and that became the theme of the elm project. The results 'Pyramids and Catapults' were shown at St Paul's Gallery in Leeds.

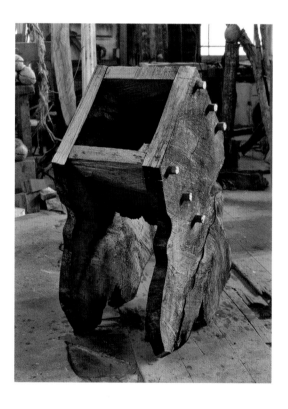

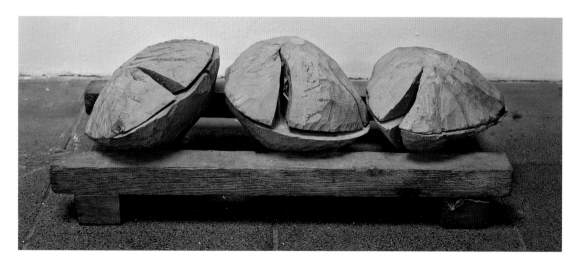

Left:
Three Clams on a Rack
beech and oak
1974
32.5 x 85 x 35 cm

A precursor to the *Three Clams on a Rack* made at the Maentwrog wood quarry.

88

Opposite page, above: *Prime Block*, cut from
the trunk of the oak at the Maentwrog wood
quarry, 1978.

Opposite page, centre: making *Extended Length*,
one of the pieces made at the oak wood quarry at
Tan-y-Bwlch, 1981.

Opposite page, below:
Raised Box
oak
1979
122 x 58 x 94 cm

Made at the Maentwrog wood quarry.

Right:
Slot Wedge
oak
1979
125 x 83 x 43 cm

Made at the Maentwrog wood quarry.

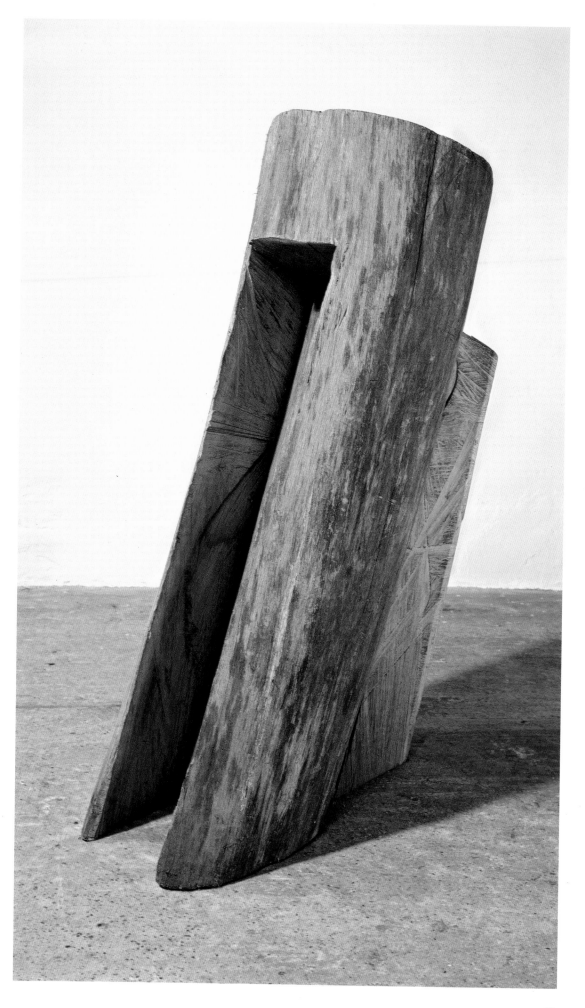

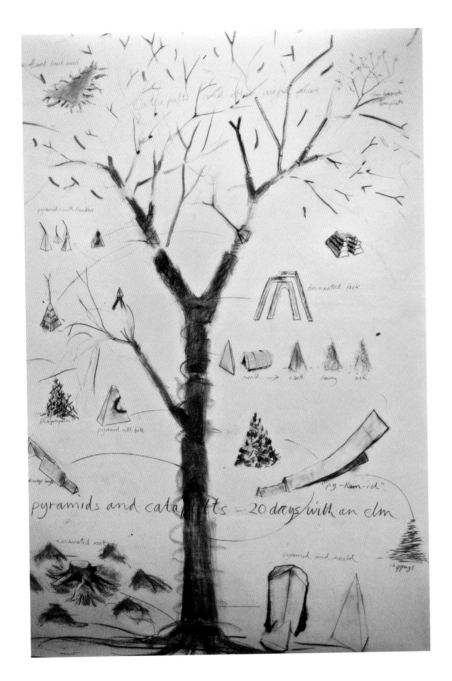

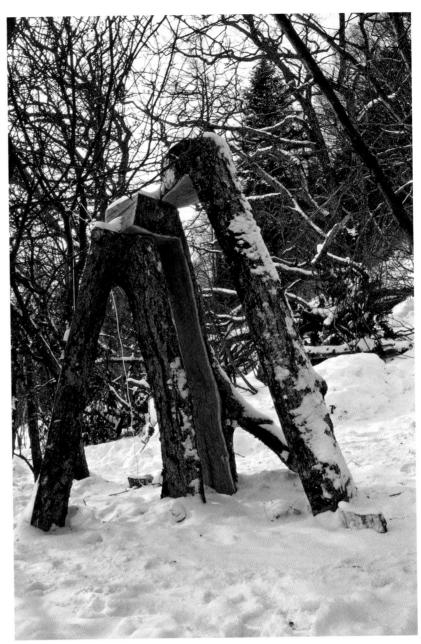

The Tochigi Museum asked for a list of my requirements. These were:

- twenty-one working days
- a fallen deciduous tree one metre thick in the main trunk (it was not to be cut down for the purpose)
- local woodmen to help me, plus their usual forestry equipment
- an interpreter
- local accommodation within ten minutes' drive of the worksite (to avoid lengthy commuting)

Ian Barker of the British Council and David Brown of the Tate, curators of the exhibition, made the preliminary visits to the area to explain the requirements. The Tochigi project proved to be as near perfect as I could have hoped for. There were a few initial problems, but nothing that could not be turned round to advantage.

The only fallen tree that fitted my specification was in a National Park, 2,000 metres up in the mountains under two metres of snow, a long hike from the nearest road. The interpreter, Norio, was a student of political science from the city with no experience of rural life. The woodman, Mr Gomita and his three crew were all local. The accommodation was in a café, quite rough and homemade in the village of Yumoto.

Above left:
Pyramid and Catapults – 20 days with an elm
earth, charcoal and graphite on paper
1981
140 x 100 cm

Above right:
Capped Arch
mizunara
Kotoku, Japan, 1982
approximately 270 x 215 x 215 cm

The tree had two trunks, both of which had fallen down a slope just above a small stream. On one bank of the stream was a level area perfect for a work site. The stream, fed by a hot spring, did not freeze over in spite of very low temperatures, The tree was a mizunara (wateroak), and its beautiful close-grained wood was in excellent condition. We started each day at first light and it was bitterly cold: -20°C until the sun appeared at 10 am; it set around 3 pm. I marked the trunks for cutting and Mr Gomita and his men quickly understood what was required. The compacted snow made it easy to move the sections of trunk down the slope; the woodsmen worked quickly and carefully, deftly avoiding any damage to young saplings.

Norio and Mr Shioda, a young curator from the museum, stood watching and shivering, and looked so miserable that we got a fire going. Tending the fire developed into managing the hollowing out of a big log with fire, and heating up iron bars and rods for scorching some of the sculptures, which kept them busy and cheerful. Mr Gomita worked so quickly that he was getting ahead of me, anticipating the next move. We both spoke 'wood' so communication was very clear.

The manager of the cafe, Mr Wataru, was a very unusual Japanese in that he was very forward with making fun. He and his young family were unusually open in letting me see into their private life. It was so good to experience the rural life of a Japanese mountain village before meeting the pace of bewildering Tokyo.

On a deeper level, the physical work took me into the elements and allowed me to experience their particular character in Japan. Physical engagement with a Japanese tree – cutting, moving, chopping, burning – confirmed the experience at Cae'n-y-Coed ten years before of finding 'thought', external to my thought, in the material. Here were 'other' thoughts/senses. It took three days for me to become aware of this silent dialogue. The light, the water, the air are all clearer, sharper and harder in Japan. The land is very young compared to North Wales, and the elements felt young, quick, enthusiastic, unpredictable. The physical work made these qualities a body/mind experience and brought new tones and resonances to my ideas.

At the Tochigi museum I had noticed a water feature starting from a marble plinth above some steps and flowing diagonally across a courtyard. It was tempting to think about making a 'waterway' installation. Towards the end of the project in Yumoto there was a big pile of thick branches left over. I asked Mr Gomita if he and his crew could come to the city for three days and help me make an installation in the museum courtyard, and they agreed. Everything was moved from the work site to the road on a sledge made by the woodmen. After the first run across the valley, the tracks were watered to freeze so a layer of ice formed, which would reduce friction on the runners – so clever. (They also made a bridge across the river.) All the sculptures and branches were moved to two big trucks, one to go to Tokyo for the first venue of the 'British Art Exhibition' and one to take the branches to Tochigi. The burnt-through hollow log we rolled into the stream to be a *River Tunnel* (a relative for the *Wooden Boulder* in North Wales – *see* pages 66-73).

We made the waterway over two days. It was such a happy working event, drawing deeply on the experience and momentum we had developed over the previous three weeks. The aesthetic of the waterway was determined by the forms of the branches and the need for each trough to slope down slightly. I had arranged for thirty per cent more branches than I thought would be needed to be brought; we used every one. When the 'British Art Exhibition' moved to Tochigi in the spring, the mizunara branches forming the waterway had sprouted small branches and leaves all along its fifty-metre length, and birds were flocking to it for the grubs in the bark. The museum thought I had planned this – I was as surprised as they were.

It seemed as though everything I had done before had been a preparation for this first wood quarry in Japan. The project also marked the beginning of a new way of working. I had never had assistants before. My approach had been to be totally independent, making the work on my own and generating my own resources to do so. I had assumed that I would lose spontaneity if I had people to help me (and I would also have to pay them). But in Yumoto, I found that there was more spontaneity: other people brought unexpected stimulation. My reaction to Norio being so cold and miserable resulted in the *River Tunnel*. More people brought with them more strength to tackle much

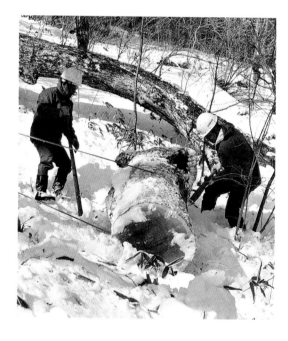

Below: moving section of mizunara trunk down to the worksite, Kotoku, Japan, 1982.

Above: moving sculptures by sledge from the wood quarry in Kotoku to the nearest road, where they were loaded on to a truck and taken to Tochigi Museum, 1982.

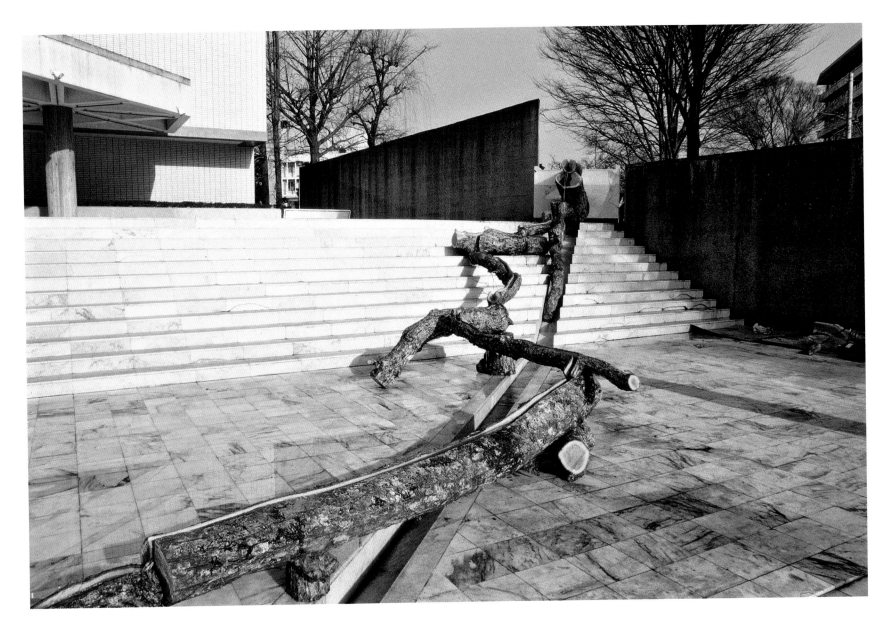

Waterway
mizunara
Tochigi Museum, 1982
4000 x 300 x 350 cm

larger trees than I could deal with alone; ideas I had avoided because of time constraints could now be realised quickly. More people also brought with them more information, more stories and local knowledge and the binding together that happened in the course of the project produced a dynamic of intention, the social side of which was also stimulating and heartening.

Also important here was the cultural/educational element that the museum ethos brings to a project. Eventual sales of sculpture made in such a project are neither the target, nor the measure of success. Museums are publicly funded so the project focus is on creativity and philosophy – made viewable by the exhibition for the interest of the museum's public.

My working practice evolved in this cultural ethos. What I made was a gesture towards 'everyman'. When I make a project with a museum or any other public institution the goodwill that gravitates towards it is given in a spirit of creativity. The funding is public money which covers the costs and perhaps a small fee. The motivation and mood are subtly different in the context of a commercial gallery where the work tends to be targeted, strategically aimed, at a particular sensibility of collectors and needs to be sold to make the show financially viable.

The wood quarry method of generating a new group of work became through the 1980s and early 1990s my main way of working, and the technique evolved. The start of any 'quarry' is an invitation to have an exhibition: the first step towards accepting is trying to get a sense of the people from whom the invitation was coming. If that feels good then I go to see the space for the exhibition and get a general idea of the funding and

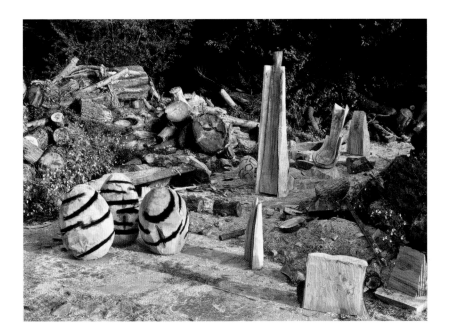

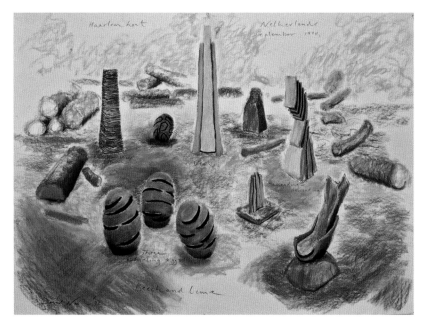

Left: Haarlem hout wood quarry,
The Netherlands, 1990, with (in the left
foreground) *Whirling Eggs*, lime and beech, and
(right of centre) *Veil*, lime.

Right:
Haarlem hout
pastel on paper
1990
50 x 70 cm

timing. Also crucial to discover are any facts that will condition what is possible: height, width, length of the room or rooms, how much weight the floor can take, the width of access doors. Each space has its quirks: mobile internal walls that cannot be removed from the room, for example. One public gallery I worked in was a multi-functional community space, and it still had to be available for a ballet class, a brass band practice and T'ai Chi. The most stimulating part of this process is engaging with the space, entering into a dialogue of possibilities with what for me is like a theatre. Each space is unique, with a certain age, history and personality, and will suggest particular shapes. In another museum in Japan, there were metal discs at regular intervals all over a big marble wall; when pulled forward these turned out to be hooks which prompted a huge wall installation of offcuts called *Autumn Leaves*.

Having assessed the space, I can then proceed to sourcing the wood, equipment and assistants. To find the wood, we leave the art world and enter the regular world. My requirement that the wood be ethically sourced (i.e. that the trees should be thinnings, fallen, dead or felled because they have become dangerous) leads to visits to public parks, local tree surgeons, private estates and farms. The space and funding are fixed facts, the wood is the variable that can be adjusted to suit those facts.

Usually I need a preliminary visit a year before the exhibition date and then an intensive period of three to four weeks before the opening to make the sculpture and drawings and to install them. As in theatre, the show must open so the work has to be done. This is a great stimulus and focuses both my mind and that of my host. Spontaneity and openness to possibility are of paramount importance; problems have to be turned around to be opportunities. Decisions and instructions have to be crisp and clear. It takes three days to get everything up and running with a proper momentum. I start with a known form, something I'm confident in making; the activity of making it opens up the 'quarry', offcuts start appearing, assistants' skills and are revealed, as are the tasks with which they have difficulty. Three days working, three nights sleeping and then the project itself becomes a 'being' in momentum. Usually very dynamic and exciting, this stage often brings the media who effectively announce the upcoming show with their coverage.

The show is tailor-made for the space and fresh from the field of action. The newness of the wood gleams full of the light it is made from, the smell of the wood is welcoming, the dynamism of the making carries over into the installation. Over the years the most fascinating and rewarding aspect of a wood quarry for me has been the community of people that evolves around the project. Much of my attention is on building and maintaining the goodwill, humour and energy of the group. If that goodwill is lost (which it has been on two occasions) the project becomes very difficult. If the human spirit is withdrawn, then all I have is a load of heavy, dormant lumps of wood.

Chêne et Frêne (Oak and Ash), Tournus Abbey, France 1988

I was invited by Marie Lapalus, director of the museums of the Macon region, to make an exhibition in the Refectory space at Tournus Abbey. Funding was provided by various local authorities and arts funding bodies and included a £500 fee for the artist from a fund to support arts events in rural areas.

My first visit (with my wife Claire and ten-year-old son Jack) was arranged for 17th October 1987, which turned out to be the day of the great storm that hit south-east England. The trains south were cancelled, so we got a lift to London with an art handler whose journey to Blaenau with such a tail wind had been very fast. Because of the chaos, we had to stay in London for three days. We eventually arrived at Tournus Abbey, a beautiful thirteenth-century building, and saw the space. The Refectory was long, and very tall with a vaulted ceiling, windows high up along one side and a floor of large flag-stones. It would be a 'shoe-string' project, poorly funded, but the space was so wonderful that it felt worth the extra effort to see a new group of my sculptures there.

On a second visit I met students at Macon School of Art who would be able to help me on the project and found two available trees and a worksite in the village of Pierre de Bresse.

It is a small village with one main street and a square, two bars and a hotel. In his enthusiasm for the project, the mayor suggested that I had the magnificent oak tree growing in the village square, a tree that is the heart of the village. I refused it, of course, but word got round that it was to be cut down for the art project and this naturally stirred strong (and very vocal) resistance. Unfortunately a negative feeling towards the project from the village in general remained throughout the time we worked there. Also, the villagers didn't like the students because they were from the city.

My assistants were Alan Mantle, a woodman and artist from North Wales who was skilled in tree-felling and very skilled with the chainsaw, and Eric and Sabine, two students from Macon Art School who were very good cooks as well as great general assistants. Eric also photographed the project for the museum and for a hoped-for publication.

The wood was to come from a storm-damaged oak (*chêne*) in the grounds of an old *château*, now an ecological museum, and an ash (*frêne*) near the village in an area fenced for a herd of deer which had eaten the bark off the tree and killed it.

The Refectory space, with its high, arching ceiling, called for forms to reach up into it. I imagined the monks eating in the Refectory – wooden tables, wooden bowls, spoons. The project began with these impressions in the back of my mind, although the forms were neither drawn nor designed. What was made came from the shapes and volumes of the two trees – I was also interested to contrast the two different woods, oak and ash.

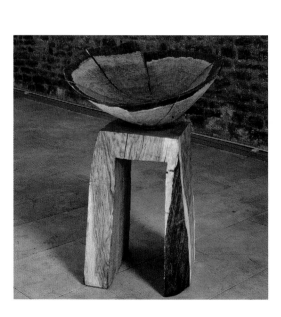

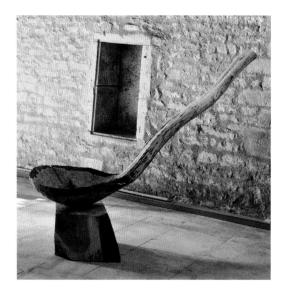

Above:
Chêne et Frêne
watercolour on paper
1988
left: 119 x 90 cm; centre: 95 x 213 cm;
right: 213 x 60 cm

Far left:
Oak Bowl
1988
120 x 87 x 35 cm

Left:
Spoon
oak
1988
154 x 227 x 57 cm

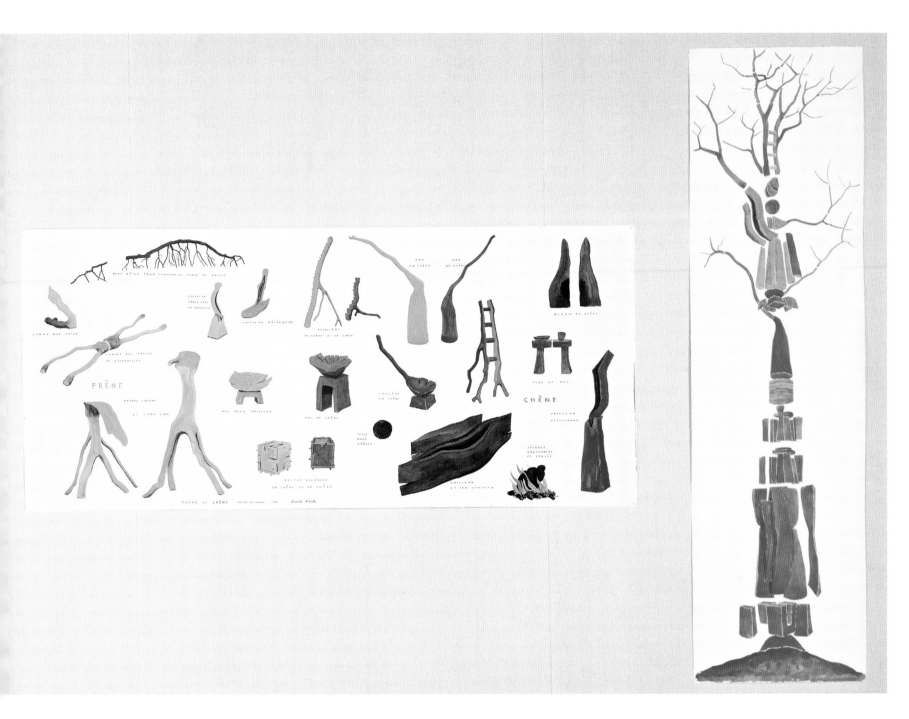

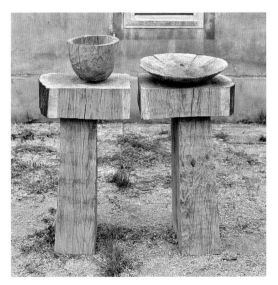

Right:
Ash Stairway
ash
1988
278 x 114 x 76 cm

Far right:
Platter and Bowl
oak
1988
111 x 116 x 50 cm

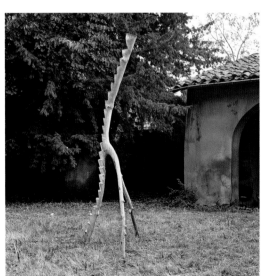

Alan felled the ash in the deer park, and we dismantled it into parts; then he felled the oak. We were working through the fallen oak when a young woman, the area arts officer, arrived. She and Alan caught sight of each other and were instantly in love. I saw it happen. Alan stopped his saw, and Chantal picked her way through the tangle of branches. That neither spoke each other's language was no obstacle. I didn't see much of Alan after that. They married and are now living in France with a daughter.

The project was fraught with distractions. We all developed a painful rash from a parasite in the woods, except for Alan who was forest-hardened and in any case otherwise engaged. A third student had his own agenda and was quite a menace. The Venice Biennale and Basel Art Fair were opening, and one of the galleries representing me thought it a good idea to divert visitors to Tournus to see some action – a well-intentioned idea but very annoying. The villagers continued to feel negatively towards the project which was particularly distressing as one of the pleasures of these on-site projects is usually local engagement. It was not be on this one. Had it not been for the support of Marie Lapalus, the museum director, and Eric and Sabine, the work would not have succeeded as it did.

The weather was dry and hot: the oak baked to a golden tan, the ash gleamed white and clean. The plan was for the pieces to be stored immediately so that their surfaces were protected. I left assuming that this was to be done the following day. In fact, the volunteer truck driver disappeared for two weeks during which time it rained heavily. All the pieces were stained and mud-splattered. I didn't discover this until August when I took my family back to the area for a holiday and went to see the sculptures which had all been herded into a small chapel. I was horrified. Everything would have to be resurfaced which would mean at least ten days' work before the installation in October.

This was arranged. Eric and Sabine came to help again, the sculptures were taken (appropriately enough), to an deserted old hospital for reworking, and the show was rejuvenated and installed.

Left:
Big Tongue
ash
1988
280 x 212 x 155 cm

Right:
Descending Vessel
oak
1988
406 x 51 x 51 cm

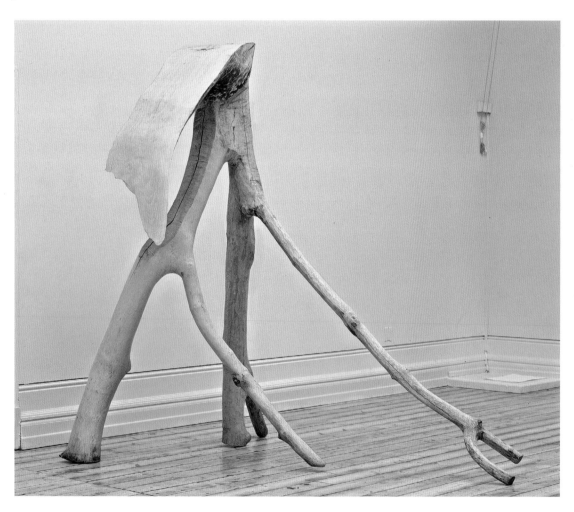

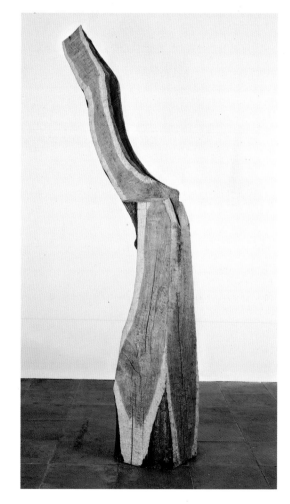

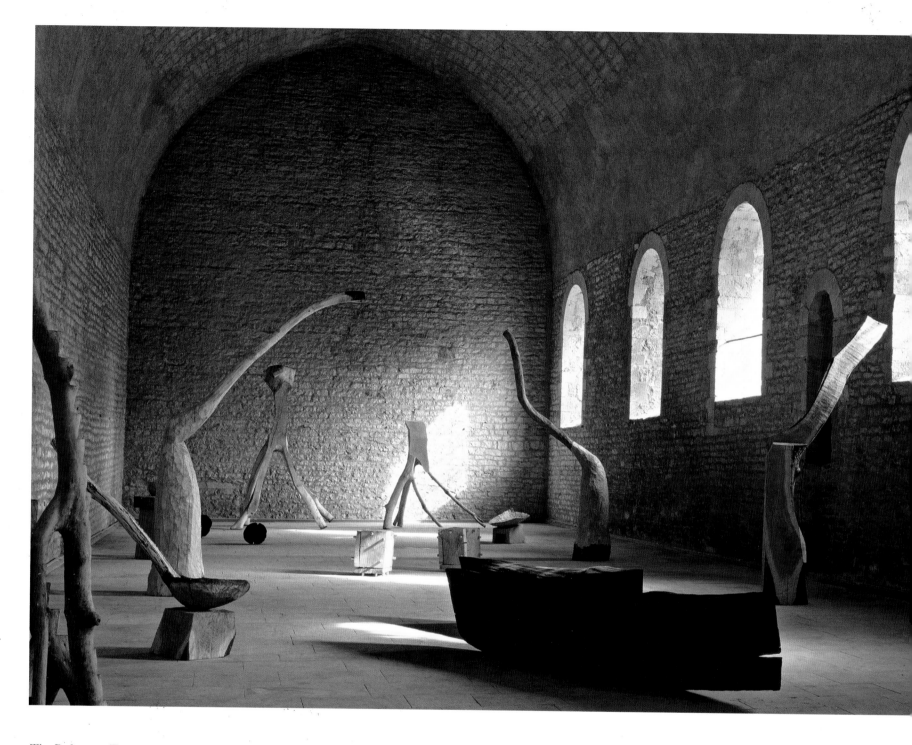

The Refectory, Tournus Abbey, 1988.

Against the rear wall, *Long Neck* and *Big Tongue*, both ash. The tree's crown divided evenly into four big branches, which invited a large four-legged object – *Long Neck*. *Big Tongue* started as an offcut from *Long Neck*.

The oak trunk was just thick enough to make a 'vessel' and its extracted interior volume to sit alongside it. *Vessel and Volume* (visible in the foreground) were then charred. Offcuts from the *Vessel* were used as walls for a fire pit to char the *Celtic Bead* (*see* page 98), and themselves became *Four Menhirs* (not illustrated).

In the centre of the floor are two *Cracking Boxes*, one of oak, one of ash – a chance to make a pair of boxes in different woods to see how differently they behave over time.

The *Ubus* reached up into the height, *Vessel and Volume* stretched along the length. The curve and angle of the bowls reflected the curve of the vaulted ceiling. Tables, Bowls and Spoons echoed the space's original function. *Long Neck* and *Big Tongue*, two big gawky animated pieces, were placed at the far end as senior characters. All stood on a stone floor against amber-coloured walls made of small stones. The only light was from the windows, so the atmosphere changed dramatically with the weather and time of day.

The pieces were later shown in the art museum in Calais where a catalogue was produced, and later still they formed the basis for a solo show at the Serpentine Gallery in London. Over the years the oak and ash pieces from Tournus have found their way individually into public and private collections around the world. *Long Neck* was too big to house and was reduced and recycled as smaller sculptures. *Big Tongue* remains in Capel Rhiw. It had to be outside for eight years until I made bigger doors into the chapel. Now it is inside with a mottled grey surface from the snails that fed on the algae which grew while it waited outside.

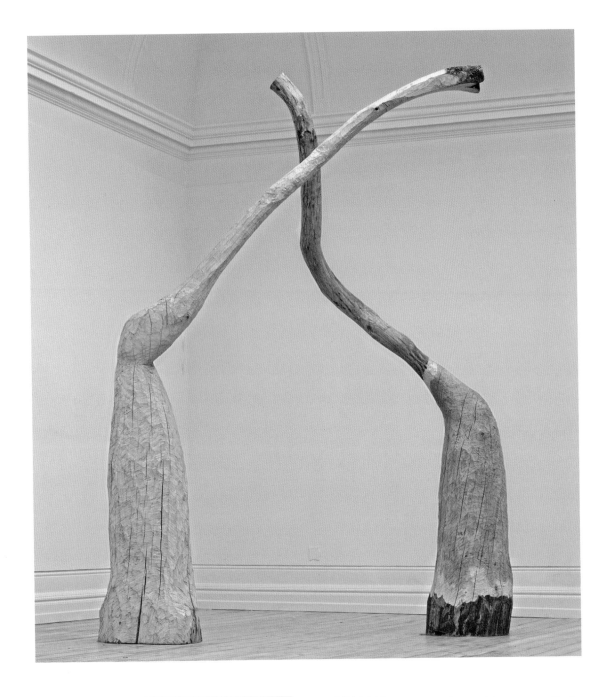

Two Ubus
oak and ash
1988
ash (left): 340 x 240 x 72 cm
oak (right): 343 x 180 x 74 cm

The thickness of the oak trunk was tapered to the thickness of the branch springing from it. One of the students nicknamed the sculpture 'Ubu' after a character in Alfred Jarry's Dada play. The name stuck – good onomatopoeia, sound for shape. Following the illogic of the Ubu drama in which there is a Mrs Ubu, I carved another in ash. They have been together ever since.

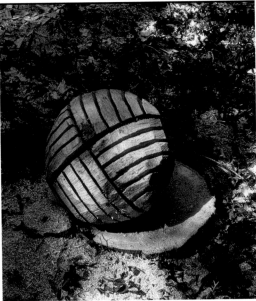

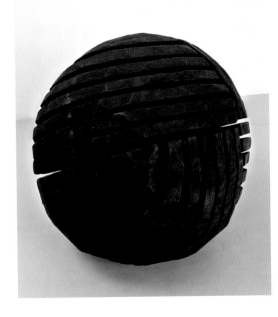

Far left: *Celtic Bead* before charring.

Left:
Celtic Bead
charred oak
1988
42 cm in diameter

On a rest day during the project, I visited a small local museum and saw some beads reputed to be Celtic. One tiny round black bead was inscribed with cuts quartering the sphere into four striped segments. I made a drawing and carved a larger version the following day.

Spirit of Three Seasons, Otoineppu, Hokkaido, Japan 1993-94

Asahikawa Museum, in Hokkaido, invited me to originate an exhibition of wood sculpture to tour six venues in Japan, starting at their museum in June 1994. The sponsor was Tokyo Shimbum, a major Japanese newspaper. The wood was to come from an experimental forest managed by Hokkaido University at Otoineppu (at the northern tip of Hokkaido). Because of its latitude, Hokkaido has very extreme seasons. I proposed that I make the work over a period of a year making four visits, one in each season. The show was to be called 'Spirit of Four Seasons', but the Japanese economy took a plunge so one season was pulled, hence the title, 'Spirit of Three Seasons'.

Otoineppu is a village of 1500 people which has developed a tradition of wood carving. A local timber mill owner, Mr Kawakami, had championed the work of an Ainu wood carver called Bikki who had subsequently become renowned across Japan for his sculpture. (The Ainu are the original native people of Hokkaido, traditionally hunter-gatherers.) Mr Kawakami and Bikki persuaded the village council to propose that the local state high school, threatened with closure, become a specialist school for wood craft. The proposal was successful and so is the school, with children now being sent there from all over Japan.

Carving is everywhere in the village: the pillars and railings of the railway station are all carved, the post office is full of relief and free-standing sculpture. All the public buildings are decorated inside and out with carvings. My project was embraced by the whole village. There was a regular stream of visitors to the worksite and during the periods between my visits the work was carefully stored at the school, a service garage, and the emergency fire station.

My main assistant and interpreter was an American artist called Stan Anderson. A self-styled 'lapsed Mormon', he had learnt Japanese when he was a young man on a Mormon mission in Japan; he spoke English, Japanese and 'wood' fluently, and was very good company.

For our spring visit, we were accommodated in a large modern hot spring hotel a few miles from Otoineppu; in the summer, we stayed in an empty farmhouse very near to the worksite, but three metres of snow made the farmhouse inaccessible in winter, and for my final visit I stayed at Mr Kawakami's house.

Birch plantation, Hokkaido, Japan, Spring 1993.

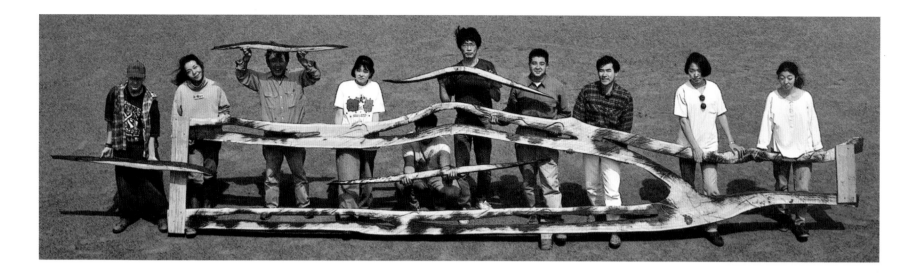

Tokyo Shimbum commissioned Mr Anzai, a renowned photographer, to document the project for the exhibition catalogue. At my suggestion, we agreed to feature the village as much as possible so that the publication would also promote Otoineppu as a place to visit.

The various woods I was given to work with were:
 – tamo, a commercially grown deciduous tree most like ash in its structure and shape;
 – Hokkaido birch, which grows very slowly, has a close, silk-like grain and is surprisingly heavy – as tough as oak. This was the most rewarding wood on this project.
 – hana, a species of alder, which is very similar to European alder except that its orange-red colour is more intense in Japan.
 – elm, which was the same as European elm. This was a big trunk with a big area of rot up one side and a few snow-damaged limbs.
 – mizunara (water oak). I was given one whole tree from the forest, and two mighty trunks from a woodyard where they had been languishing unsold for years because they had too many faults for commercial use.

Spring

After the long frozen winter and slow thaw, the spring is a short intense period that starts in May. Unlike Europe where there is a sequence of plants appearing, in Hokkaido everything grows at once at an astonishing pace. The birdsong was new to me too: nightingales

This page and opposite page, top:
Two Streams
tamo
1993
640 x 117 x 18 cm

This pair of shapes had a strong feeling of direction which was emphasised by lines cut along their length and then charred.

Arriving/Receiving – Opening/Scattering
tamo
1993
240 x 265 x 15 cm

Left: freshly carved at work site; and right: wall-mounted in a Nagoya gallery.

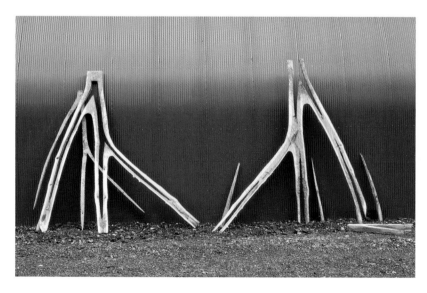

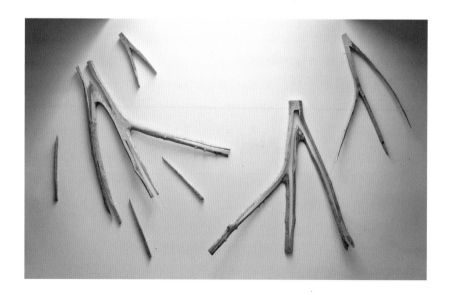

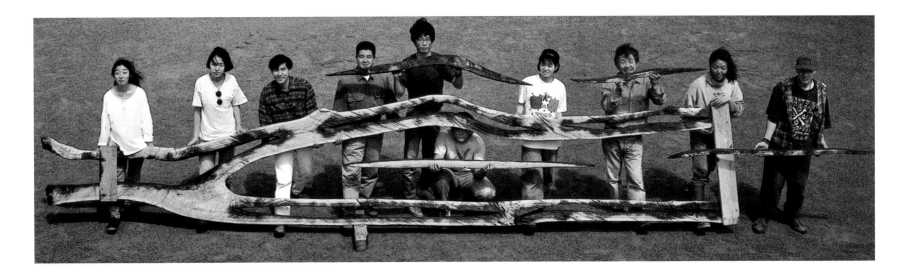

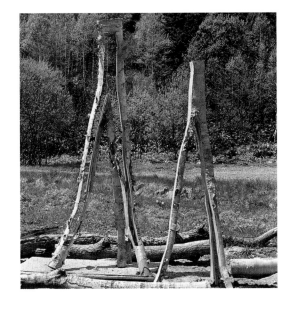

had arrived, the older ones with clear, mature song and the younger ones still learning the phrases.

In the forest a bird made a beautiful, timeless sound like a heartbeat – perhaps a bittern? – which made it very hard to start the chainsaw. Two crows visited the site each day at seven in the morning and again in the evening, clattering about in the birch trees and on the roof of our tin work hut. We worked through mixed weather, a cold wind and rain then bright hot sun; nightingales sang, insects bit us, and fish spawned in shoals in the nearby stream.

Working through the trunks and branches that had been extracted from the forest and laid out at our muddy worksite, I started with a crack and warp column. The birch was like dense silk with a trunk of an unusually large diameter, thick enough to make a vessel form – *Three Vessels*; the offcuts were kept for later. The other trees provided – tamo – were not so big and consisted mostly of branches. I found two pieces that could be cut in half along their length and hung on a wall as reliefs: *Arriving/Receiving – Opening/Scattering* and *Two Streams*.

Right:
Banzai
birch
1993
130 x 45 x 30 cm

A section of birch trunk and limb that reminded me of a Japanese gesture of enthusiasm: an arm and fist are raised with a cry of 'banzai!'.
I carefully peeled through the layers of colour from the white outer bark through the red beneath to the light, silky surface of the wood.

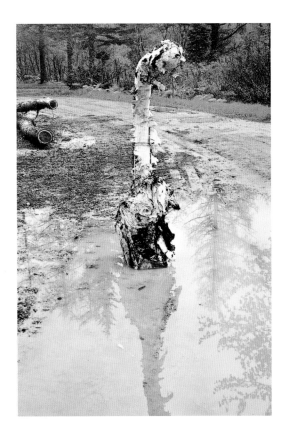

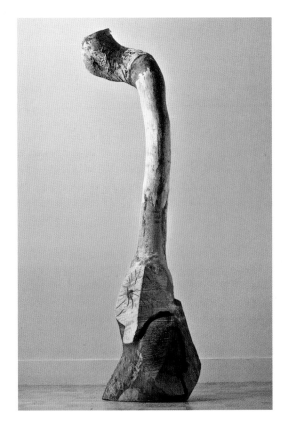

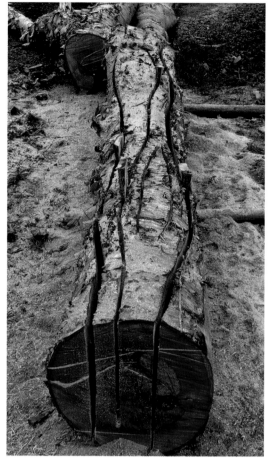

The spring visit was a beginning. We were opening up the wood and discovering the characteristics and qualities of the environment and the kind of support we could call on, and testing the equipment. We went looking for more dead, broken or over-mature trees: I needed greater volume for larger works. In our search we walked into a birch plantation of trees that were about forty years old and planted in rows. This experience of the benign, gentle personality of birch left a deep and lasting impression on me. It was a damp, misty day which could have been any moment over the last ten thousand years, a moment that allowed one to step out of human history and into the timeless cycle of plants, land and weather.

Hearing that we were looking for more wood, some of the villagers were keen for me to see the big logs they had seen washed up on nearby beaches. I was sceptical about the usefulness of the wood – beach wood is usually waterlogged and eaten by sea bugs – but thought it would be nice to see the sea, so I agreed on an early start for the one-hour drive the following morning. Word got around, and at seven am half the village was ready, forming a convoy of twenty or more vehicles including two flat bed trucks.

The wood was, as I suspected, rotten and bug-eaten, but the enthusiasm of the villagers prevailed and big logs were rolled several hundred metres up over the dunes and man-handled onto the trucks. On the shore of black volcanic sand, with the island of Rishiri on the horizon, I made some 'stove' pieces with some beach wood.

The logs were delivered to the worksite and the continuing interest in them made me feel obliged to do something with them. I charred hollow pieces stacked one on the other, though this was not something that I could take into a museum environment. That and the other lumps remained on the edge of the site and were soon forgotten. On the next visit, in summer, we were to revisit these hollowed, blackened logs.

Summer

Returning to the worksite in late July, we found that the undergrowth had become a jungle. The weather was hotter, but there was still a Siberian chill hidden in the wind. There were more types of biting insect, each favouring subtle variations of weather and different times of day. My sixteen-year-old son, Jack, accompanied me. He had been with us on a three-month project in Japan when he was seven. That experience had grown in him and he was eager to return. With a group of helpers, we lived for three weeks in an old farmhouse, with only the barest amenities, close to the worksite.

A group of Nagoya art students came for a weekend workshop, and there were many

Top left:
Three Birch Vessels
1993
63 x 415 x 32 cm; 57 x 411 x 34; 62 x 330 x 30 cm

Companions to *Two Oak Vessels* (*see* opposite page).

Top right: birch trunk with the first cuts for *Birch Vessels*.

Above: *Birch Vessels* in progress.

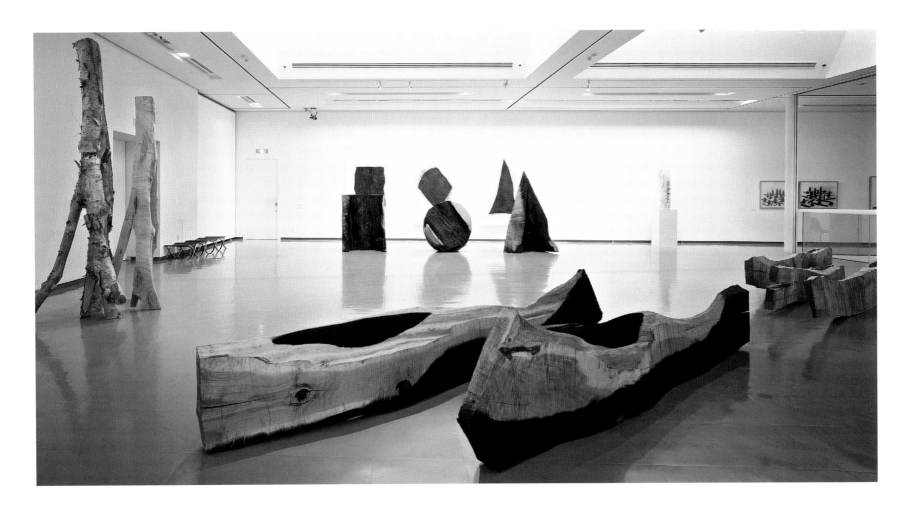

'Otoineppu: Spirit of Three Seasons', Nagoya City Art Gallery, 1994. In the foreground, *Two Oak Vessels*, 1993, and behind them *Birch Vessels*; left, *Inside Outside*, birch, 1993; against the rear wall, *Cube Sphere Pyramid*, elm, 1993.

Below:
Red and Black
alder (left) and charred tamo (right)
1993
106 x 500 x 500 cm (left); 135 x 700 x 700 cm (right)

people wanting to help; sometimes there were more than twenty people at the worksite. During this second visit the coherence of the group of work began to appear and at the end it was clear what else was needed. Wood not yet carved and two big oak trunks found unwanted at a local woodmill were taken to another site in the village in preparation for the winter session.

When I mentioned to Mr Kawakami that in Europe freshly cut alder, once exposed to the air, changes from white to red in twenty-four hours, he said they also had trees like that, called hana. He took me to see one: it was alder and it did change colour – even more dramatically than the alder I had worked with in Poland. Colour in nature in Japan is extraordinarily vivid. I continued my theme of Red and Black charring domes and lengths of tamo and carving domes and skinning branches of alder which I left to redden in the sun.

Another continuing theme was the contrasting relationship of birch and oak. European oak is slow-growing and has a durable heartwood: hard, heavy and determined. European birch is fast-growing, has no heartwood and is soft, light and yielding. Here in Japan the contrast was not so extreme because the birch is so heavy and dense. I carved *Two Oak Vessels* to be juxtaposed with the *Three Birch Vessels* made in the spring.

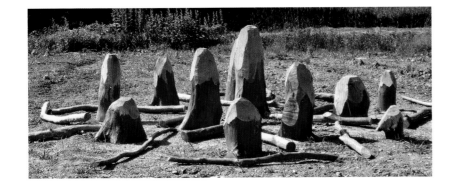

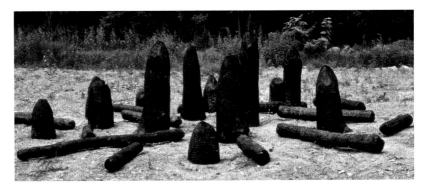

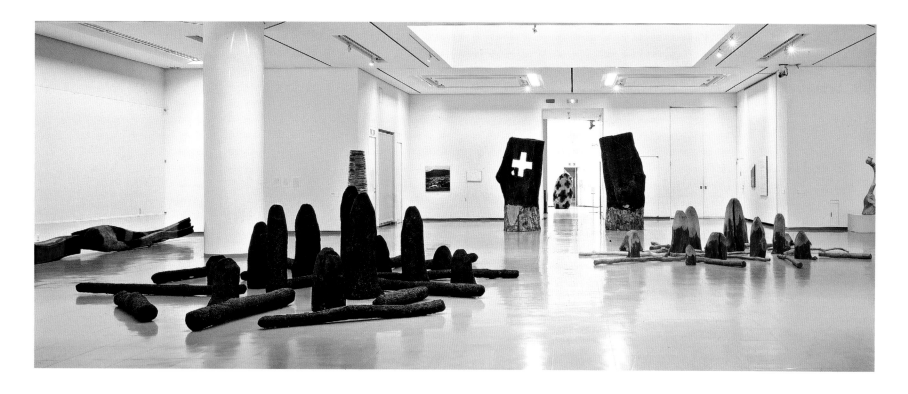

As in *Banzai*, I found a sense of muscular gesture in three mizunara trunks and branches, and made *Trunks and Limbs*. (Put together they looked like the Chippendales.)

We extracted a huge hollow elm trunk from the forest which turned out not to be as hollow as we thought and too heavy to move. A road crew working nearby helped us to load the truck. I carved a *Cube Sphere Pyramid*, cut out the rotten areas and purged the hollows with fire. Another part of the elm I carved into a very tall *Mountain and Cloud* which broke in two when being moved. In spite of the distress of those transporting it, this proved a positive development which resulted in two pieces being made: *Mountain in Japan* and *Rising Mountain*. Other smaller pieces included *Elm Song*, *Table with Two Pots* (birch) and *Three Stoves* (birch) – females for the Chippendales.

At the end of the visit, when we were cleaning up and deciding where finished pieces could be stored, the two hollow charred logs that had been made in the spring from wood washed up on the beach came to everyone's attention again, and, once more, the desire not to disappoint my hosts led me to work on them, this time to make a 'stove' piece. We celebrated the end of the visit with a beach party: another convoy with even more villagers rolled the hollow lumps back to the beach and set them up, again with Rishiri Island in the background. A bundle of red alder sticks that had been discarded along with the beach wood at the work site also found its way into a truck and unexpectedly appeared on a villager's shoulder, so they joined the tableau, orange-red on the black sand, orange-red flame in the black sand – *Red and Black Stove*.

'Otoineppu: Spirit of Three Seasons', Nagoya City Art Gallery, 1994. In the foreground, *Red and Black*, alder and charred tamo, 1993; behind them, *Black and Light Gate*, partly charred oak, 1994; in next room, *Charred Cross Egg*, oak, 1994.

Below left:
Trunk and Limbs
oak
Otoineppu, 1993
left to right: 106 x 97 x 85 cm; 80 x 70 x 125; 100 x 180 x 70 cm

Below right: *Birch Bowl*, *Table with Two Pots* (birch) and *Small Birch Throne*, Otoineppu, Japan, 1993.

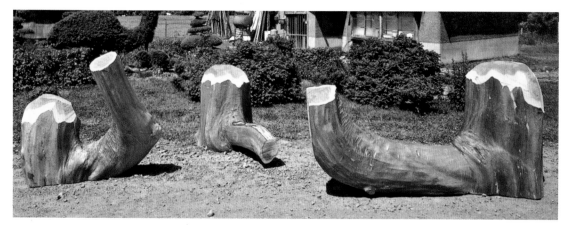

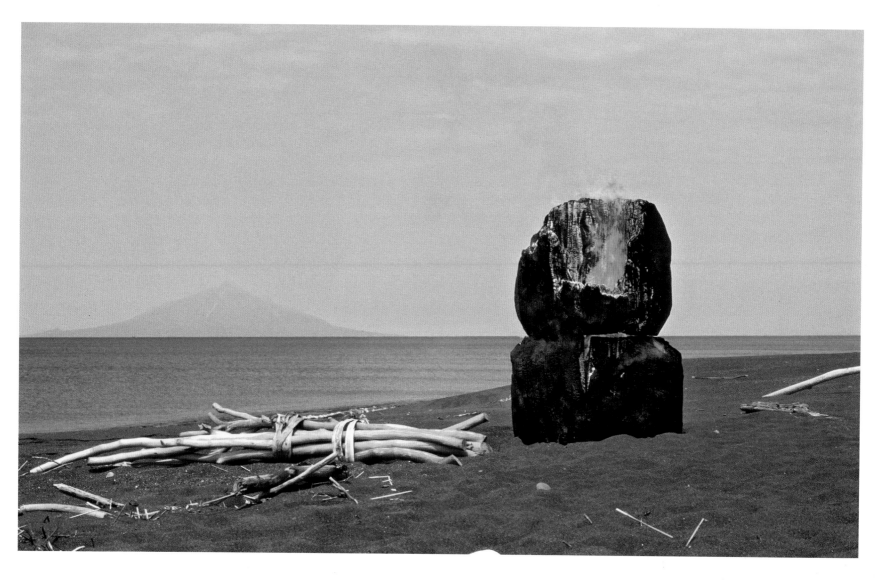

Red and Black Stove
Teshio, Japan, 1993

Right:
Mountain in Japan and *Rising Mountain*
elm
1993-94
321 x 117 x 85 cm and 177 x 65 x 25 cm

Far right:
Fins
partly charred tamo
1993
tallest: 242.5 x 51.5 x 57.5 cm

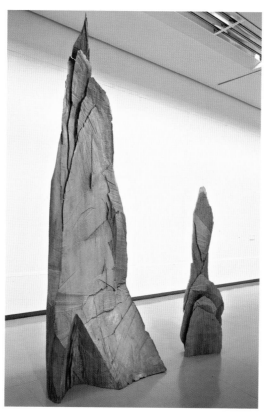

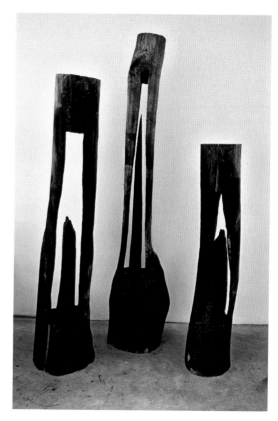

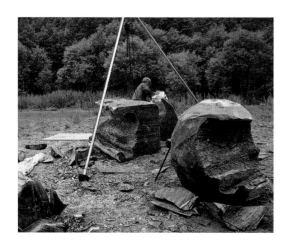

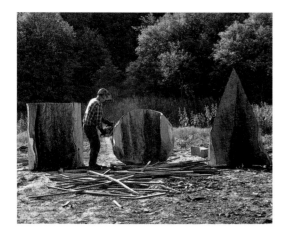

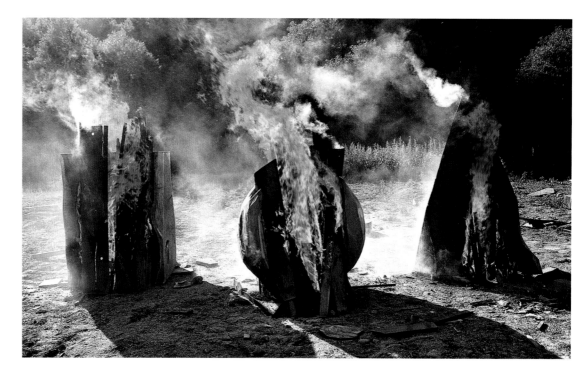

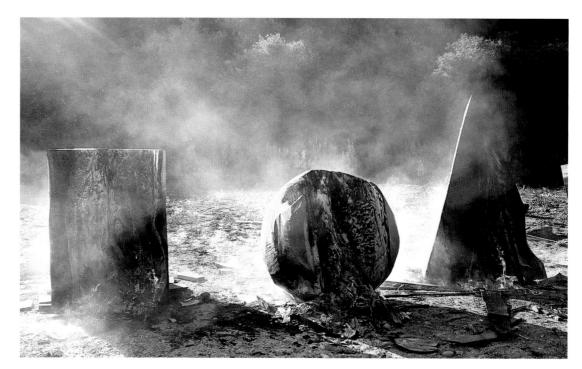

Preparing, charring and transporting *Cube Sphere Pyramid*, elm, Otoineppu, Japan, 1993.

Winter

I returned in February when Hokkaido was at its coldest and under its usual three metres of snow. It seemed to snow continually, not heavy falls, but a consistent gentle falling of white flakes. It was dangerous to walk in the forest: the snow collected in the trees, froze and condensed into big, concrete-like lumps weighing 100 kilos or more which tended suddenly to fall.

In preparation for this session, an area had been dug out, like a quarry with three-metre-high white walls protecting us from the deadly wind: a snow quarry. With fires burning, and some sheds to shelter in it made an excellent work place. We dug out the wood stored back in the summer, positioned the two huge mizunara trunks and made the sawdust fly. One trunk I cross-cut into two parts, one to be *Charred Cross Egg* and the other *Big Bowl*. The second trunk was split down its length to open out symmetrically, using the same process as for the tamo branches in the spring. When these two mighty trunks had been stood up they looked like an entrance gate for the exhibition. There was some rot two-thirds of the way up one of the pieces, which when cut out led to a hollowed-out cross shape. I cut the same cross shape right through the other gate pillar and charred them both, a black cross in one and a light cross in the other, *Black and Light Gate*.

The offcuts from *Birch Vessels* made in the spring had been brought to the site and – now weathered to a silver-grey – leant against the three-metre snow wall. Shadows fell across them in a rare moment of sunshine and suggesting a contrast between weathered surface and the bright wood revealed by a fresh saw cut: *Light in Shadows*.

Visiting villagers were now rather less interested in the shapes I was making than in offcuts for their fires. By the end of three sessions there were twenty-one sculptures and sixteen graphic works. The sculptures were once more squirrelled away around the village until the summer when I went out again to the installation and opening.

Light in Shadows
birch
Hokkaido, 1994

– Hokkaido Asahikawa Museum of Art, 18th June–17th July 1994
– Nagoya City Art Museum, 30th July–25th September 1994
– Ashiya City Museum of Art and History, 19th November 1994–22 January 1995 (the terrible Kobe earthquake struck at this time. Ashiya was close to the epicentre. The museum was very new and built to hold together in a quake, but the sculpture was thrown around like shaken dice. Some pieces were damaged but all could be repaired, but there was awful loss of life in the old city around the museum.)
– The Museum of Modern Art Saitama, 4th April–5th May 1995
– The Museum of Modern Art Kamakura, 20th May–18th June 1995
– Tsukuba Museum of Art, Ibaraki, 24th June–30th July 1995

Each museum acquired one or more works and at the end of the tour in July 1995 everything else was put in two forty-foot containers and sent by sea to Blaenau Ffestiniog.

Opposite page, above:
Charred Cross Egg
partly charred oak
1994
height: 178 cm; 93 cm in diameter at widest point

Opposite page, below left: preparing *Black and Light Gate* (top); the sculpture, partly buried in snow, with firewood stacked around it in readiness for charring (bottom).

Opposite page, below right:
Black and Light Gate
oak
1994
260 x 127 x 60 cm (left)
250 x 134 x 83 cm (right)

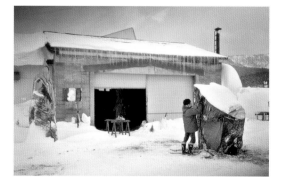

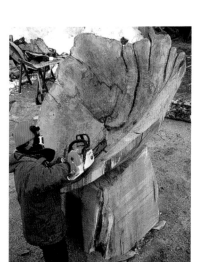

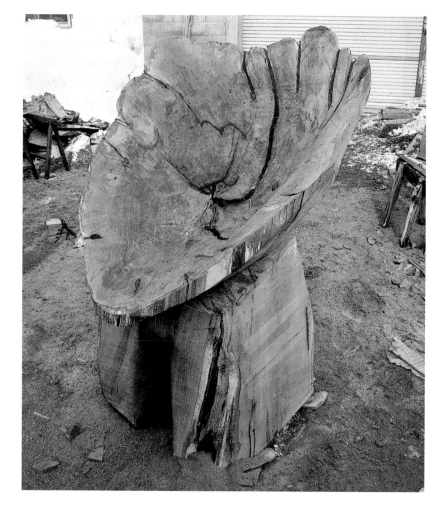

Above: workshop and site, Otoineppu, Japan, winter 1994.

Below: *Big Bowl*, made of mizunara, in progress, Hokkaido, Japan, February 1994.

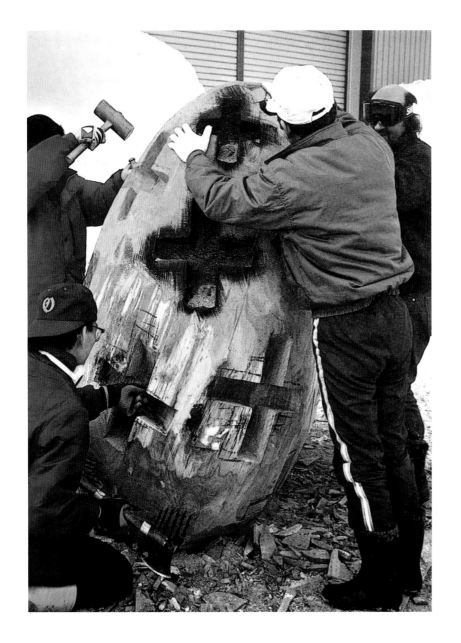

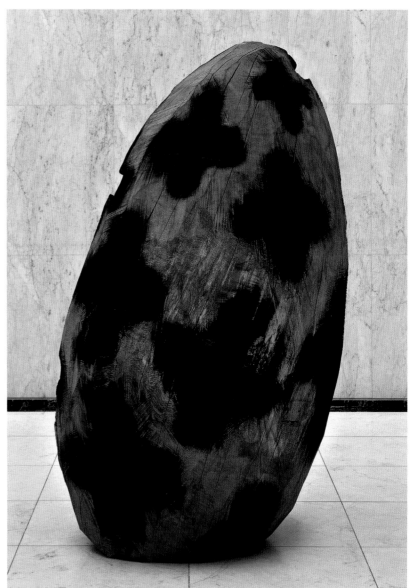

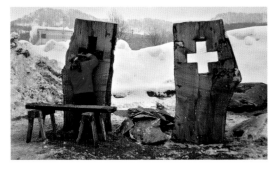

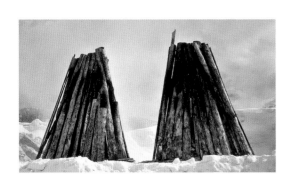

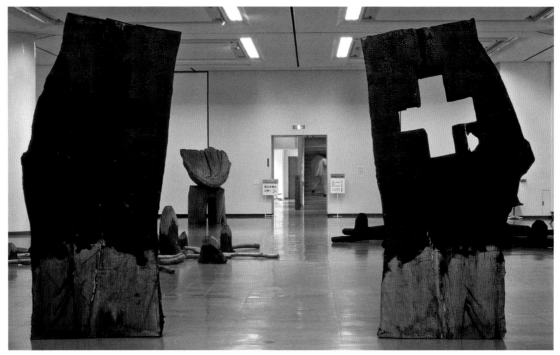

Més enllà del bosc (Beyond the forest), Barcelona, Spain 1995

Early in 1994, the Palau de la Virreina, a public arts venue in Barcelona, invited me to make an exhibition composed of some works from my studio and some to be made in Barcelona, as part of a year of cultural exchange between Wales and Catalonia. It was to be sponsored by the local authority of Barcelona (Ajuntament de Barcelona) and the British Council.

On my preliminary visit in early 1995, I was taken to visit the Parks Department of Barcelona where various trees were available, and at a tree dump there we saw a cedar trunk and some acacia – not very appetising. The staff said there were more trees at their 'tree hospital'. I was not sure of the translation and it was explained that the city had an area where ailing trees were nursed back to health. Any street tree in the city showing signs of stress was severely pruned, dug out with a special machine and taken to this 'intensive care unit' as they called it. We drove to the city limits and behind an enormous supermarket was a ten-acre area of ground with rows of pruned trees, some quite big. There was apparently an eighty-per-cent success rate, and as one tree was brought in, so it was replaced in the city by one that had recovered. I could have any of the twenty per cent that didn't make it. Walking along the rows I marked the ones to keep for the project – plane, olive, Australian pine (new to me) and palm, an unexpected opportunity.

The Palau de la Virreina is an old palace on the Ramblas next to the famous covered market. The ground-floor rooms have arched ceilings and uneven flagstone floors. Across a courtyard are several arched alcoves which were also part of the exhibition space. The museum commissioned Liliana Albertazzi to curate the show, and she came to Blaenau to select work and to make an interview for the catalogue text. My assistant was my elder son William, then a student at Middlesex University.

The project took twenty days including travel. We drove with all my tools, saws, burners, etc. from Blaenau to Plymouth, then took the boat to Santander, and drove across northern Spain to Barcelona. Our accommodation was a small apartment overlooking the city.

At the 'tree hospital' we started with an Australian pine, a southern hemisphere tree, one of the 'ironwoods' of the world. Planted in Barcelona in the 1930s, at sixty years old all the Australian pines had started ailing, and only a very few recovered. Most of the

Municipal 'tree hospital' for Barcelona, El Prat de Llobregat, northern Spain.

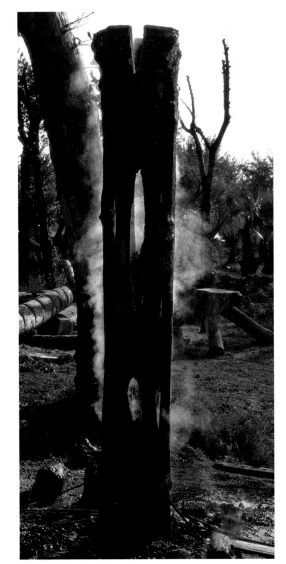

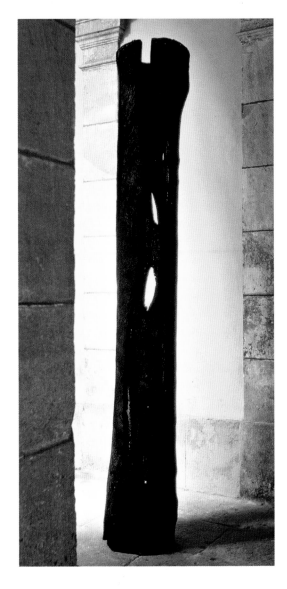

Above:
Charred Lace Pillar
plane
1995
254 x 40 x 40 cm

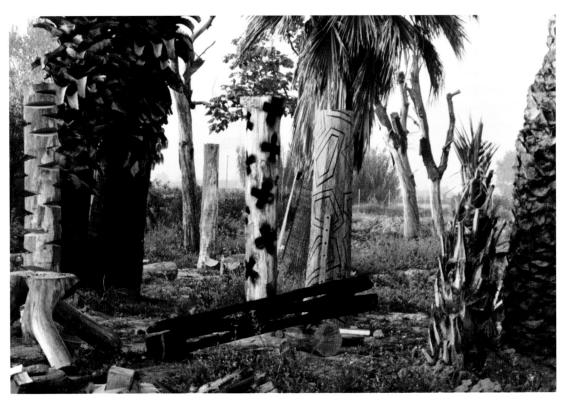

Right: *Barcelona Pillars* in progress at
El Prat de Llobregat, Barcelona, Spain.

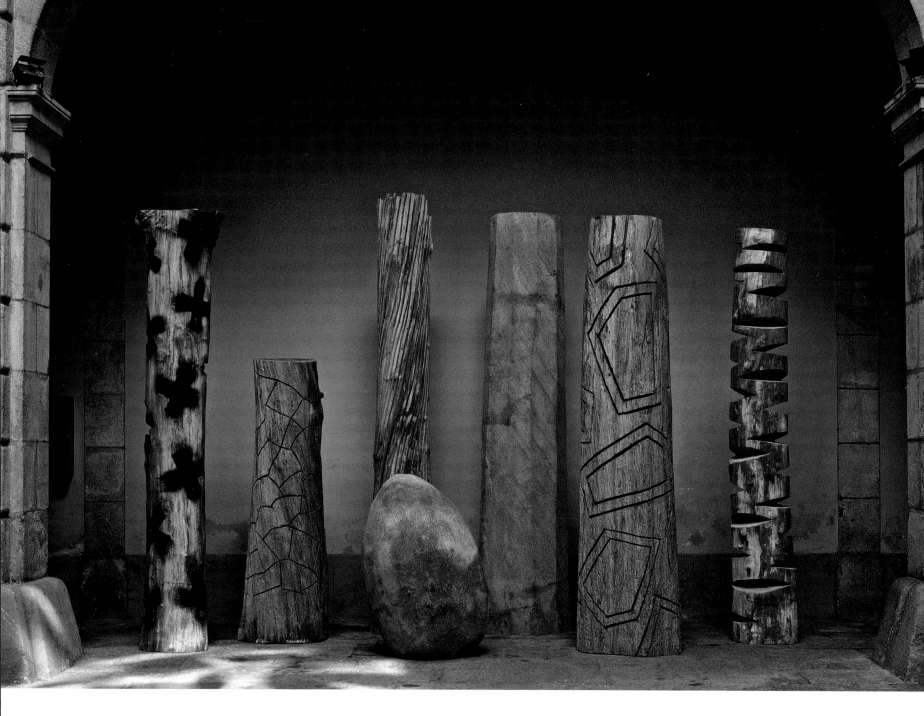

dead ones had been left standing for a long time, and their bark had fallen off leaving a marvellous spiky silver surface. They were as hard as concrete and resisted cutting. Heavy, hard and resistant – I opted to use them for a group of pillars relating to the pillars with strikingly lively decorative surfaces in the late-nineteenth-century Barcelona architecture of Gaudí and others.

The planes had spreading crowns which made supporting legs when the trees were inverted – two Descending Vessels, descending into a tangle of limbs; an offcut from a Vessel became the first Downpour. The palm cut like rolled-up carpet – the saw roared through with no resistance, and the amount of dust reminded me of beating a carpet. Palm is not a tree. It's a big plant with no annual rings, very fibrous. It rots very quickly. I was lucky to have one that had just died. Made *Leaning Egg* – heavy, wet and hairy, a very friendly object – and a column for the pillar group.

With the offcuts I made twenty-one smaller pieces for an installation called *Market Stall*. I had noticed local people using the courtyard at the Palau de la Virreina as a shortcut into the covered market and returning with bags of produce. I wanted to make something for these people who would probably not visit the exhibition, being more concerned with going to the market. The familiar form of a market stall might catch their attention.

Barcelona Pillars and an Egg, 1995
Left to right:
Charred Cross Pillar, plane, 262 x 40 cm
Mosaic Pillar, Australian pine, 181 x 60 cm
Spiral Striped Pillar, plane, 288 x 43 cm
Pillar and Egg, palm, pillar 280 x 70 cm, egg 107 x 78 cm
Pentagram Pillar, Australian pine, 258 x 68 cm
Side-sliced Pillar, plane, 260 x 43 cm

In a market one scans the mass of contents for what might be needed, maybe for a moment they might scan my stall in the same way. It was also a way of showing a group of disparate, unrelated and some unfinished pieces together in a manner relevant to the venue. Some did stop, gave it a glance, and walked on, usually with a shake of the head.

Most of my projects are rural, and it was curious working in a city. The four gardeners/nurses at the tree hospital were quite bemused by this different incarnation of some of their patients. They let us use their canteen and lock-up to store the tools overnight, but otherwise they kept their distance until the end when they inquired about whether they could have the offcuts for firewood.

We installed the new work in the alcoves; the other works arrived by truck from Wales, were wrestled into the Virreina rooms and placed in position. The show opened some two weeks later on 27th October 1995.

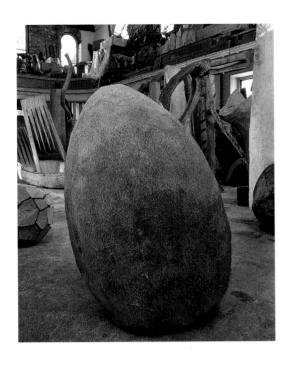

Left:
Leaning Egg
1995
height: 107 cm
photographed in Capel Rhiw, 1997

Below:
Market Stall
Australian pine, plane and olive
Barcelona, 1995

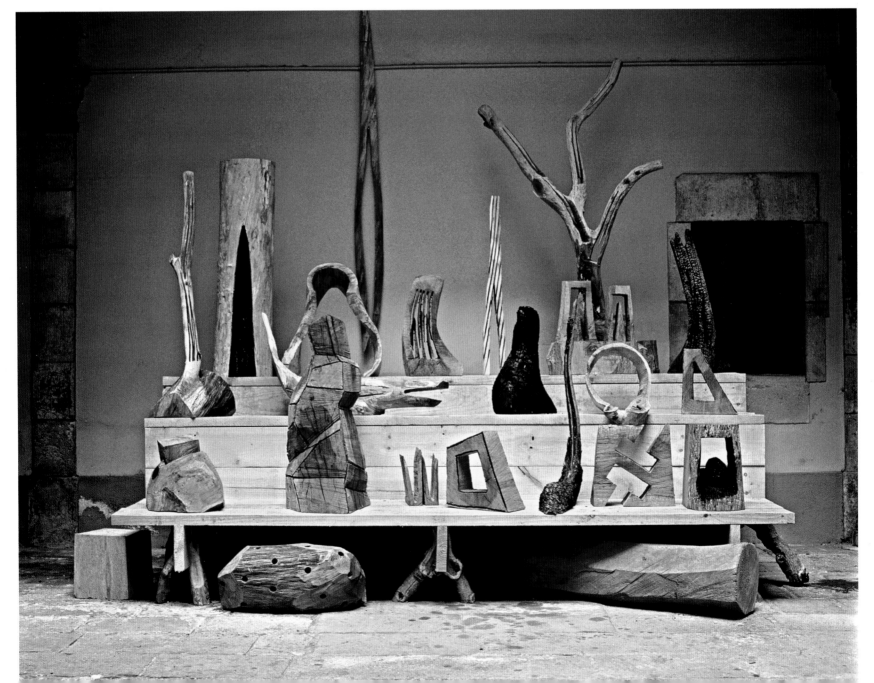

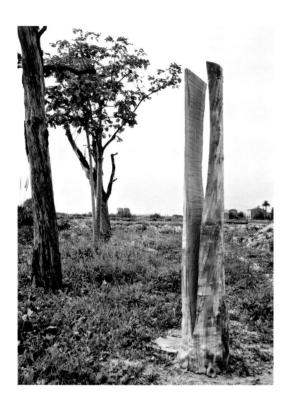

Plane tree with first stage of carving for
Downpour, El Prat de Llobregat,
northern Spain, 1995.

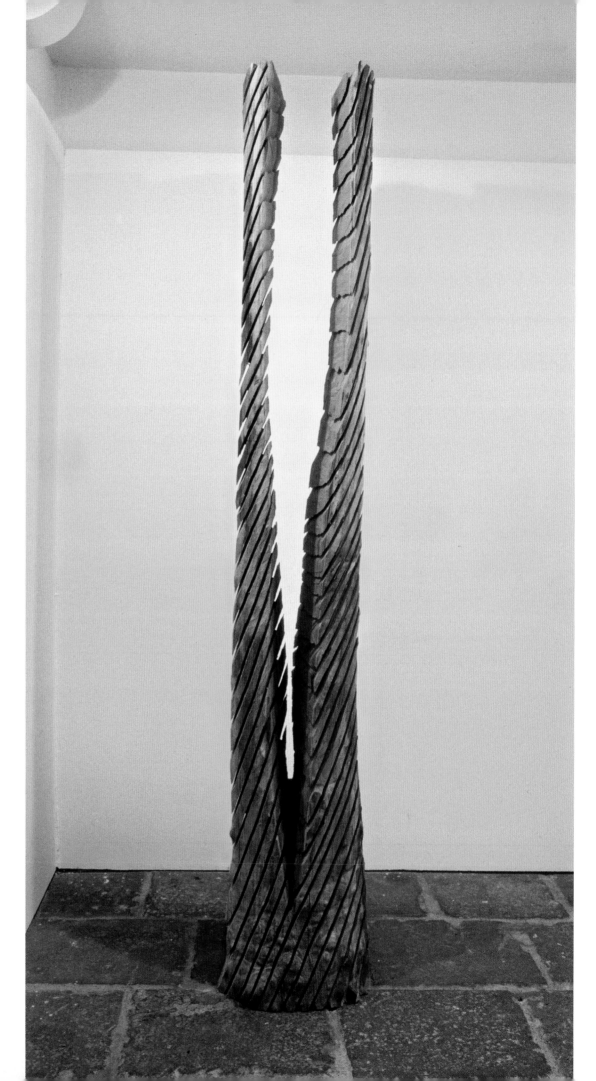

Downpour
plane
1995
243 x 45 cm (at base)

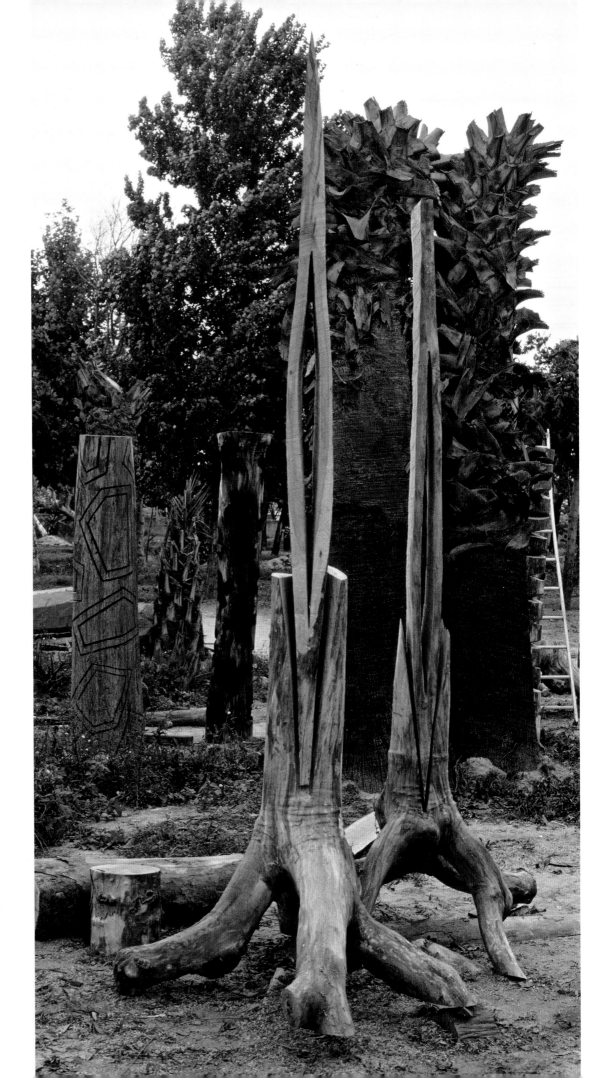

Below and right: work in progress on dead plane trees for *Two Descending Vessels*, 1995; 368 x 137 x 169 cm (left); 338 x 136 x 147 cm (right).

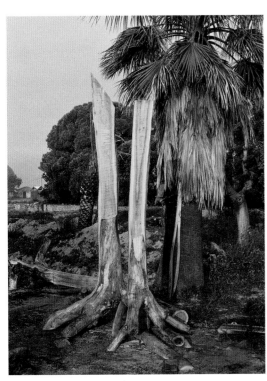

INSIDE

If someone asked what material I was using when I was first making wood sculptures, I would say 'I'm working with wood'. This was usually just planks and beams from demolition sites. When I no longer had access to that, the only available wood was fallen trees. Then I realised that I was working not just with wood, but with where the wood came from – the tree. I was experiencing the trees by carving at first exclusively by hand. (I didn't have a chainsaw for ten years). When you carve oak, for example, it really bites back at you; it's got a lot of resistance. Carving lime – a soft, yielding wood – on the other hand, is a very different experience. I was learning the languages, the dialects of these different woods.

Once I started looking more into living trees and began to plant them, I saw how they are a weave of the four elements. The trees are seeded in the earth, which is full of minerals. That's a world of matter and solids. They need light and warmth (which is the fire element) and they need water and air. I realise that wood is a very balanced amalgam of these four elemental forces.

The particular character of wood comes from the way in which the tree grows. This material has subtle variations depending on the species, environment and latitude. As I work mainly in northern temperate zones, the trees that I have access to are principally broadleaved trees like oak, beech, ash, lime, cherry, elm and birch. I have tended to avoid pine trees because the grain is too pronounced and it's a pithy wood. The hardwood trees are much more interesting with particular qualities about each.

Oak and Birch

Oak is a very slow-growing wood and it rots slowly, but birch is a fast-growing wood with a short life cycle and rots quickly. Its waterproof bark (which has been used for canoes and roofs) holds the water in a fallen trunk and hastens decomposition; its leaves, twigs and trunk all make good humus. Oak has a dense canopy of leaves, and lets little grow beneath it, while birch, often the first species to colonise a cleared woodland or abandoned fields, is a bright, pretty tree whose small fluttering leaves allow light through for other plants and slower-growing trees. It is sometimes known as the mother of oak, for its

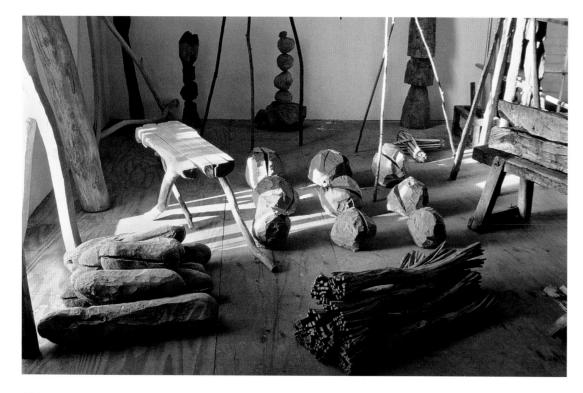

Capel Rhiw gallery, photographed 2006.

Against the middle of the rear wall is *Bonk Pile 1* ash and pine, 1971. In the centre are *Running Table,* beech, 1977, *Nine Cracked Balls*, ash, 1970-71. In the foreground are (left) *Stack of Pods,* beech, 1974, and (right) *Loosely Held Grain,* willow, 1975. Just visible to the right is half of *Two Squared Lengths on a Bench,* holly and oak on pine, 1975.

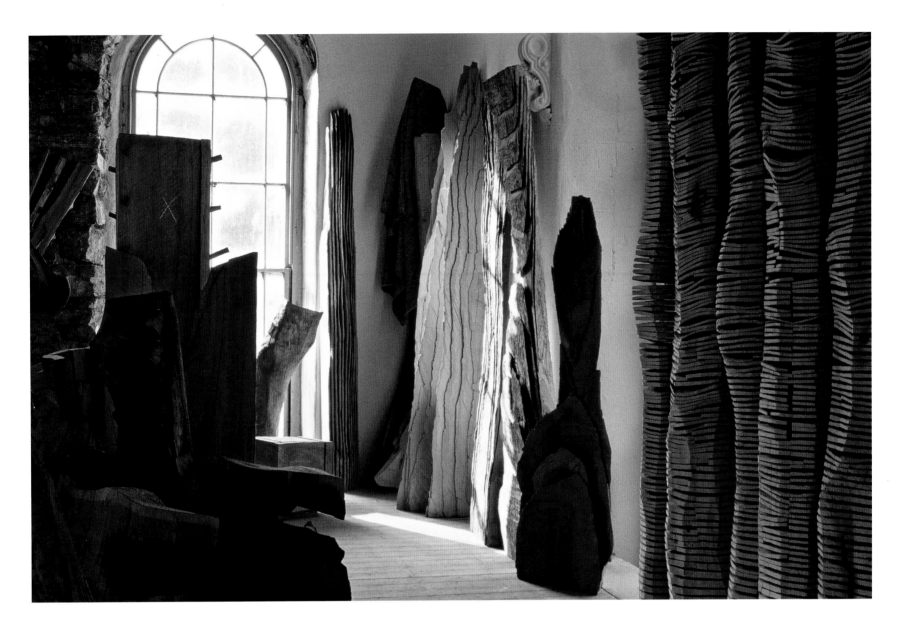

Corner of balcony, Capel Rhiw gallery, photographed 2006.

From the right hand side of the window towards the foreground: *Sheave*, oak, 1995; *Wall of Sheaves*, beech, 1993; *Cuts Up, Cuts Down*, red oak, 1993; *Landscape in Japan*, elm, 1993; *Crack and Warp Wall*, lime and sycamore, 2003.

nurturing characteristics. Its wood is white, all sapwood, and its sweet sap makes a drinkable alcohol. The properties you find in birch are beautiful, benign (feminine) yielding qualities. It is called the loving wood, and the oak is a keos – very male, hard, resistant. When I'm carving or hitting it with an axe, it answers me back. Birch wood dries light (in weight) and burns quickly – a soft, kind wood. Oak, when dry, makes good firewood, burning hot and for a long time.

If you look at a tree, its life and its circumstances, the personality of each individual is consistent to that species. Oaks are ugly trees when they are young. They grow slowly and continuously, gradually developing a secure centre in the lower trunk. Unusually for deciduous trees, they leaf twice each year: in spring the lead buds push forward with new growth, then there is a pause before another push in midsummer with new red leaves that mature green and have a leathery texture. Each tree evolves like an independent state and supports a huge variety of wildlife, including birds, insects and fungi.

Two hundred years to grow, two hundred to mature, two hundred to die, is a general maxim for the oak. As it dies, it retreats down into its lower trunk. As hollow squat hulks, oaks may continue to live to a thousand years and more. Interestingly, the massive oaks with forty-foot-high trunks that we all admire are in fact unnatural. The oak's tendency is to form a cover low down and to spread its branches to gain access to as much light as possible. Over generations magnificent trees have been formed by continual pruning. The ponderous growth of oak makes its wood good for foundations, pillars, beams and ships. The bark is thick and full of tannin that may be used to cure leather.

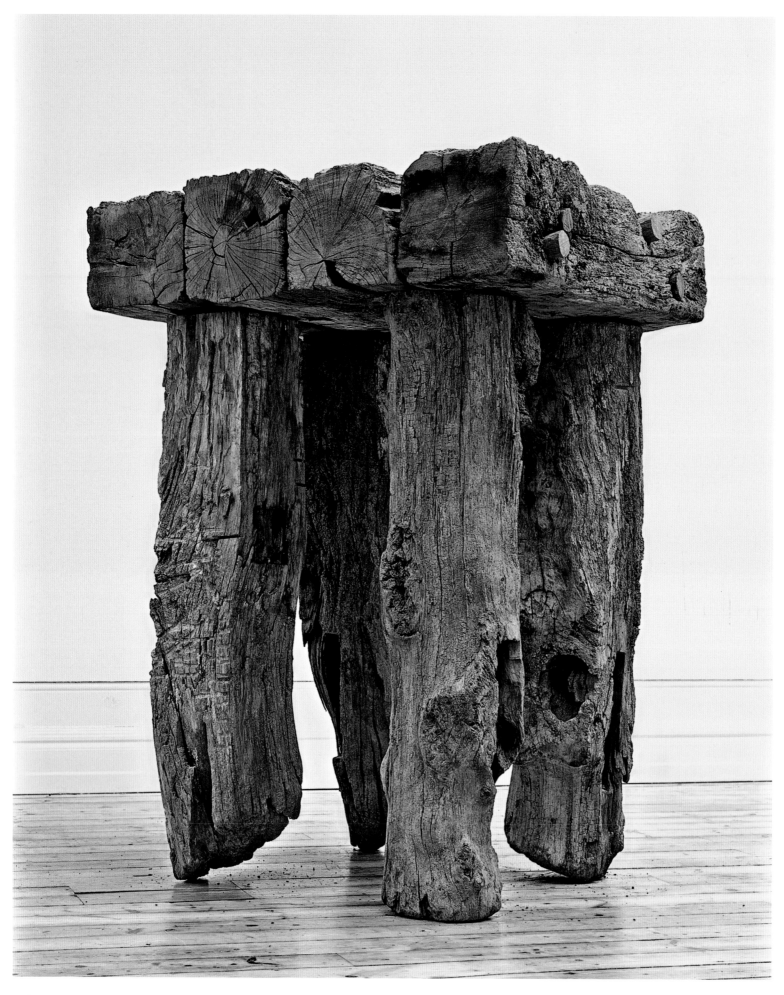

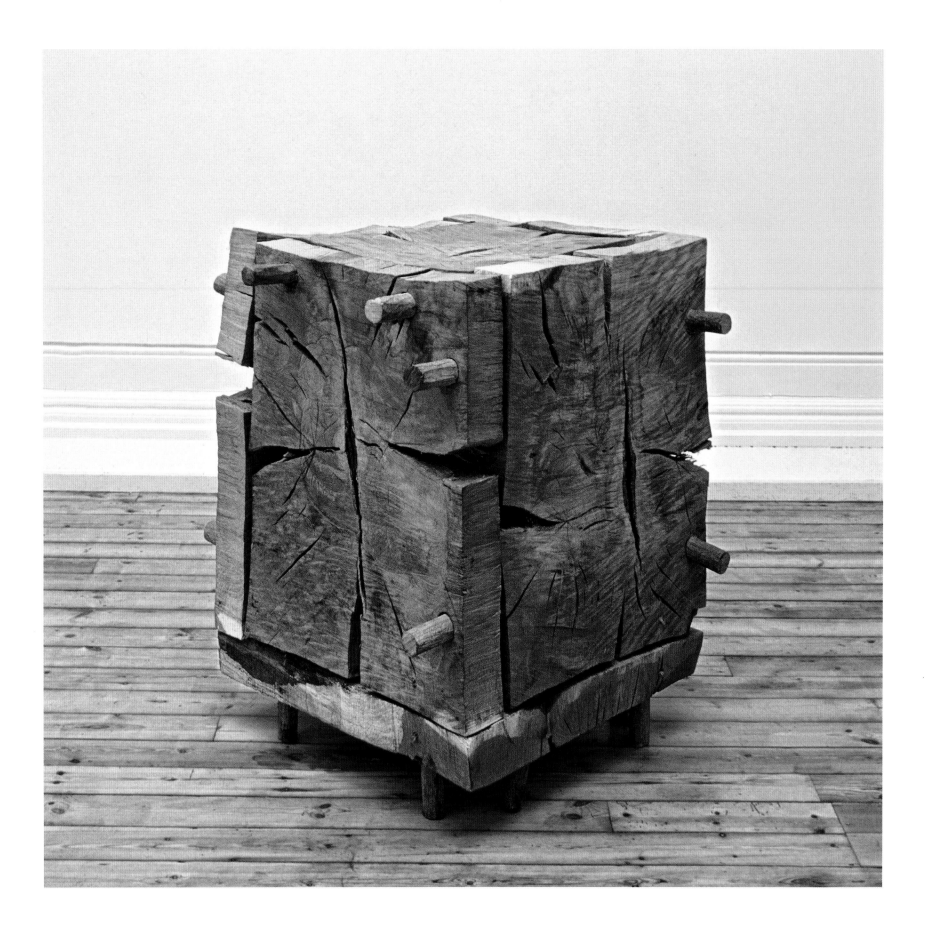

Opposite page:
Ancient Table
oak
1983
165 x 120 x 100 cm

Above:
Cracking Box
oak
1990
93 x 100 97 cm

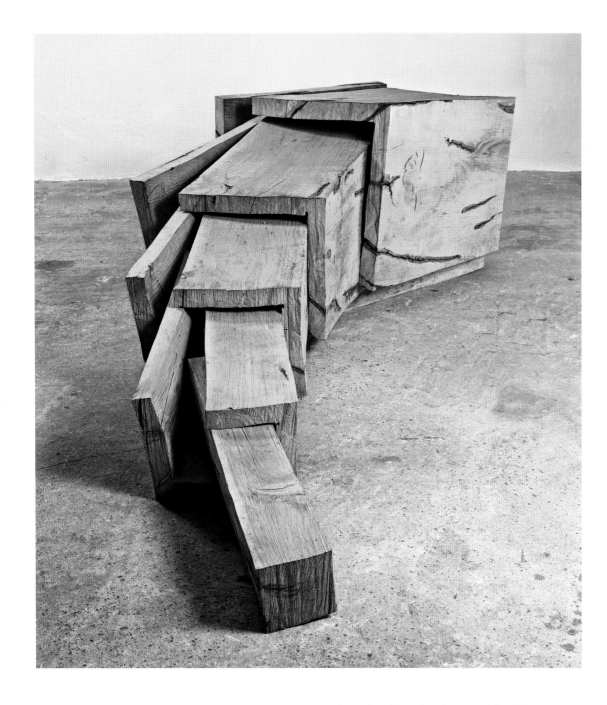

Extended Cube
beech
1986
closed: 71 x 71 x 81 cm
open: 71 x 102 x 279 cm

The heartwood is dense and smells of vinegar when fresh and splits readily. This wood has the character of the living tree: dependable, definite, secure, dense, heavy, reliable, 'bankable'. It is mythological, royal in stature, and often considered the king of the trees.

Unlike the oak, which has consistent qualities the world over, the birch is variable. Its size and density depend on the latitude in which it is growing. In Hokkaido, Japan, for example, birches grow slowly and the wood is dense, heavy and durable. In most of Europe, birch is generally considered a weed, but in Finland it is revered as a sacred tree.

Beech

A pretty tree when small, beech grows beautifully elegant and grand, spreading upwards and outwards until it cannot support its own weight. Big limbs rip off making the tree unstable and likely to topple over. Unlike the oak, it does not invest in its central core. The bark is thin and easily marked: scars remain permanent. The wood is fruity when unseasoned. As it dries it becomes dense and even grained, making it reliable and durable for furniture. Left outside, the wood spalts and quickly rots to pulp and then to humus. When dry, it makes the best fire logs.

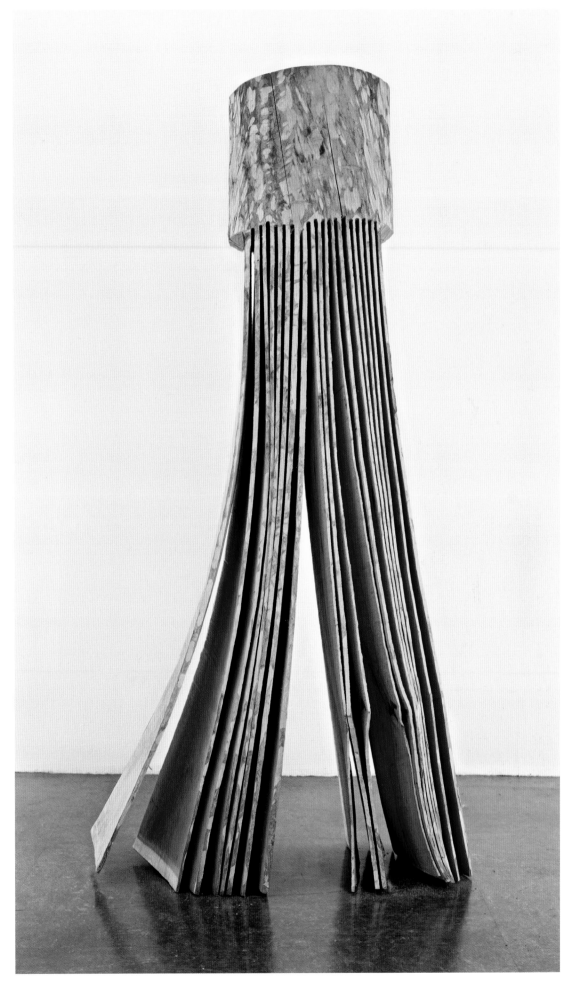

Skirted Beech
beech
1985
210 x 102 x 46 cm

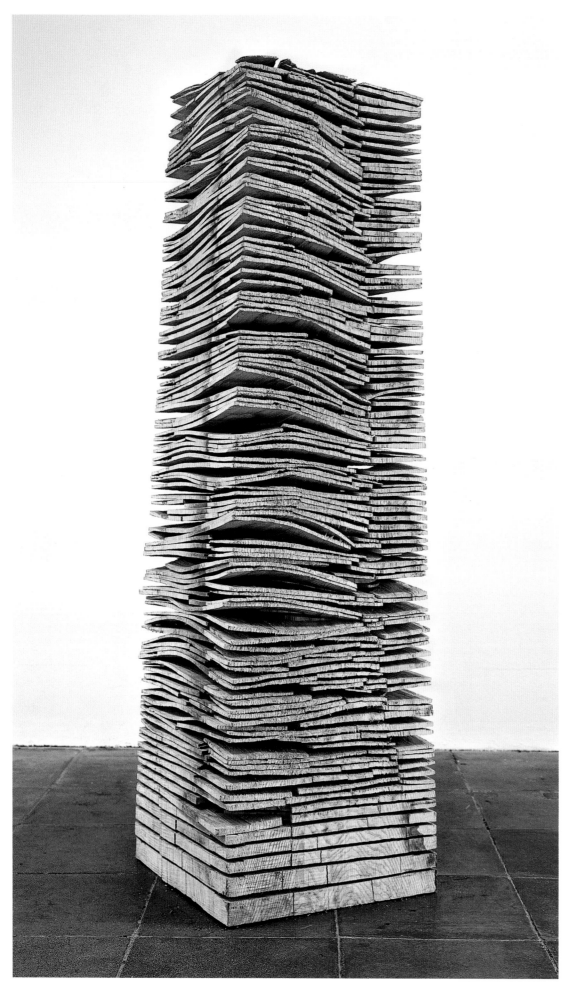

Crack and Warp Column
ash
1985
198 x 61 x 61cm

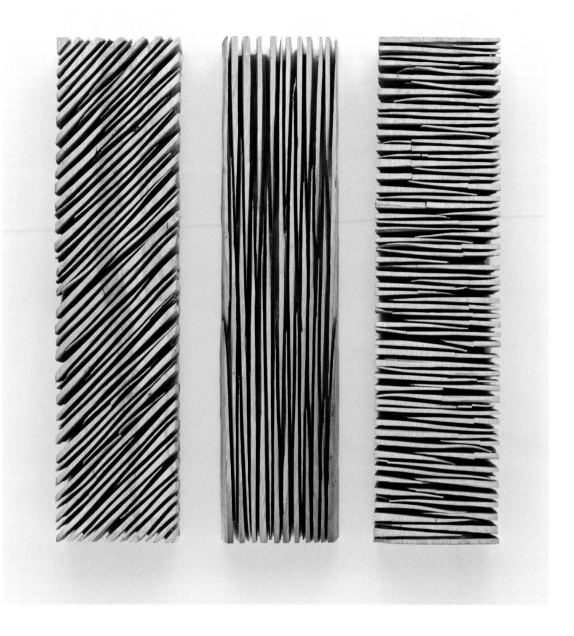

Three Lime Panels
lime
2005
86 x 22 x 10 cm

Ash
A vigorous, eager tree; light-seeking, it can bend and twist, leaning from its roots to grow into a space of light. Its long, bowing branches, tipped with primal black buds in spring, turn up their ends towards the light. Long-grained but fairly brittle, its branches are easily ripped off by the wind. The long grain of ash makes it good for axe handles and spokes for wooden wheels – it is a tree of 'action'. The wood splits willingly, making good firewood that burns brightly whether wet or dry.

Lime/linden (Bass wood in America)
Limes have a soft, benign quality, with tender, rounded, bright green leaves. The trees are amenable to pruning, pollarding and grafting. Often planted as avenues for their vertical growth that does not crowd into the avenue space. Its wood is light with an inner brightness that gleams like satin. Soft when fresh, lime dries to a particular firm/soft quality which yields tenderly to a sharp chisel, making it a perfect carving wood that can take great detail. It has an exquisite balance of resist-and-give; angelic, tender, but firm. Not a good firewood, burning away quickly.

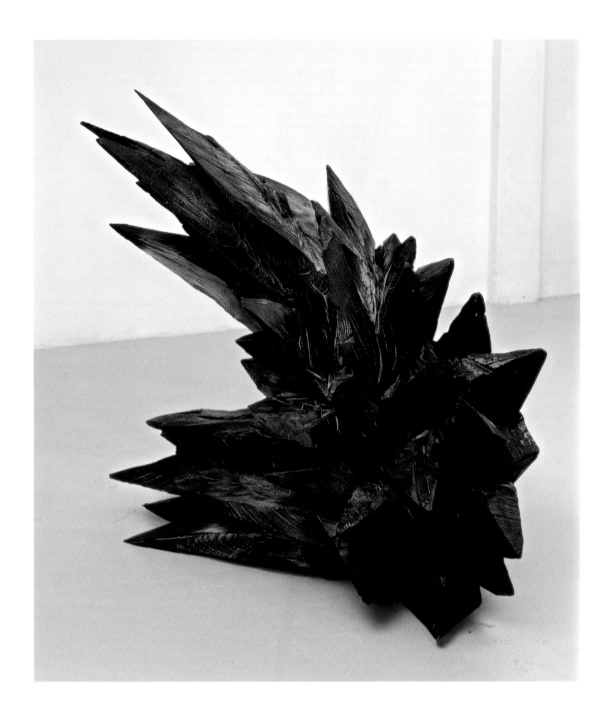

Shooting Star
partly charred elm
1987
75 x 75 x 45 cm

Elm
Usually growing alone, with coffee-coloured wood and a high water content which makes it quite rubbery to work when unseasoned. When first cut, it frequently has a very bad smell which can linger for two or more years. A densely woven wood that resists splitting, it is ideal for the hub of a wooden wheel and for chair seats. If a dead elm lies above ground, it loses its structure and becomes progressively spongier as fungus slowly devours it. Underground and kept damp, however, it is very durable, and has been used for coffins and drainage pipes. Elm makes poor firewood which smoulders rather than burning: a broody inward wood.

Sycamore (Common Maple in America)
Prefers to self-seed rather than being planted. Once established, it grows quickly. Its wood is pale in tone and closely woven, so resists splitting. A reliable, domestic, clean wood used for surfaces that come into contact with food, such as: chopping blocks, bread boards and, traditionally, milking pails as it does not sour the milk. Attracted to its sweet inner bark and sap, squirrels rip off the bark of young trees or the upper branches of mature trees and can cause serious damage.

Hazel

A small tree, generous in its produce. Its long male catkins are one of the first signs of spring, their pollen fertilising the tiny red spiky flowers protruding from the ends of some buds that seven months later produce a crop of hazel nuts. Regularly coppiced, the root stock can be centuries old, the abundant new growth providing straight pliable lengths that can be woven into hurdles for sheepfolds, useful ties for thatching, wattle and daub for houses, faggots for bakers' ovens; split lengths were used for barrel hoops. If gently hammered and twisted, its long grain loosens to become pliable enough to weave into a rope. It is a useful tree producing a useful wood. Dry, it makes great kindling, though rarely grows large enough to be a log.

Willow

There are many varieties of willow, all of them fast-growing and rampant: push a fresh twig or even a large branch into the ground and it will take root. It likes wet conditions and is often used to stabilise river banks. Pollarded at two metres, its numerous branches are regularly cropped. These lengths split easily and retain their strength when dry, making them ideal for baskets. Unreliable for topiary or growing forms as a main branch can suddenly die. Its most famous product is the cricket bat. Its long grain gives it flexibility and its stout but soft quality can absorb the shock of being struck by a hard leather ball. For such a fast-growing wood, it makes a surprisingly good firelog.

Yew

With slow and consistent growth over centuries, the yew is a tree of longevity. The evergreen foliage is a dark green making a deep dense shade over the warm tone of the trunks and branches. Commonly found in churchyards, it was assumed until recently that many ancient yew trees had been planted in the Saxon era, but now it has been proved that they are centuries older than the churches. Some, growing in what were originally pagan sacred sites, are now over two thousand years old. Compared to the oak, the yew has a gentler persistence in its growth and is amenable to human intervention such as hedging and topiary. Two-metre lengths cut from the main trunk were famously used to make the best longbows (sapwood on the outer side of the bow, heartwood on the inner), the most lethal weapon of the English armies of the Middle Ages. The heartwood is red, more orange when first cut, deepening in tone over time. The sapwood is a light cream colour. The yew's growth patterns resemble intertwined thick rope. When carved following the grain, the wood retains strength, but carved across the grain it is very fragile.

Redwood

These giant trees (indigenous to the West Coast of North America) grow vertically with a strong lead growth. A thick, fire-resistant bark protects them from the forest fires (which are in fact needed to help their seeds to break out of the cones). The atmosphere in a redwood grove is benign and calm; there is a feeling of safety, a timeless sense of 'being'. A redwood forest floor is soft with fallen fronds making it very quiet. Full of acid, the wood is resistant to fungi and insects and dead trees last a long time outside. Redwood, widely deployed in construction across America in the late 19th century, has even been used (in tapered plank form) to build huge water pipes three metres in diameter; when these pipes are removed (to be replaced by concrete), the wood is usually retrieved in perfect condition.

The original redwood forests grew densely and very slowly; the wood is close-grained, with the annual ring usually only one millimetre thick. It splits very readily so is not a great carving wood. Its virtue for sculpture is its great mass and colour.

When cut down, the stump quickly puts up new growth; a highly developed root system and access to now abundant light mean that subsequent growth is very fast and annual rings can be spaced by 15 mm and more. But this is not good wood, being light and weak across the grain. As firewood, it burns hot and quickly.

Original growth is rare now and protected, only becoming available if a tree is felled by a storm, or pieces are found that were logged a hundred years ago and had either rolled into inaccessible places or were too short to bother with; now they are valuable enough to haul out and use.

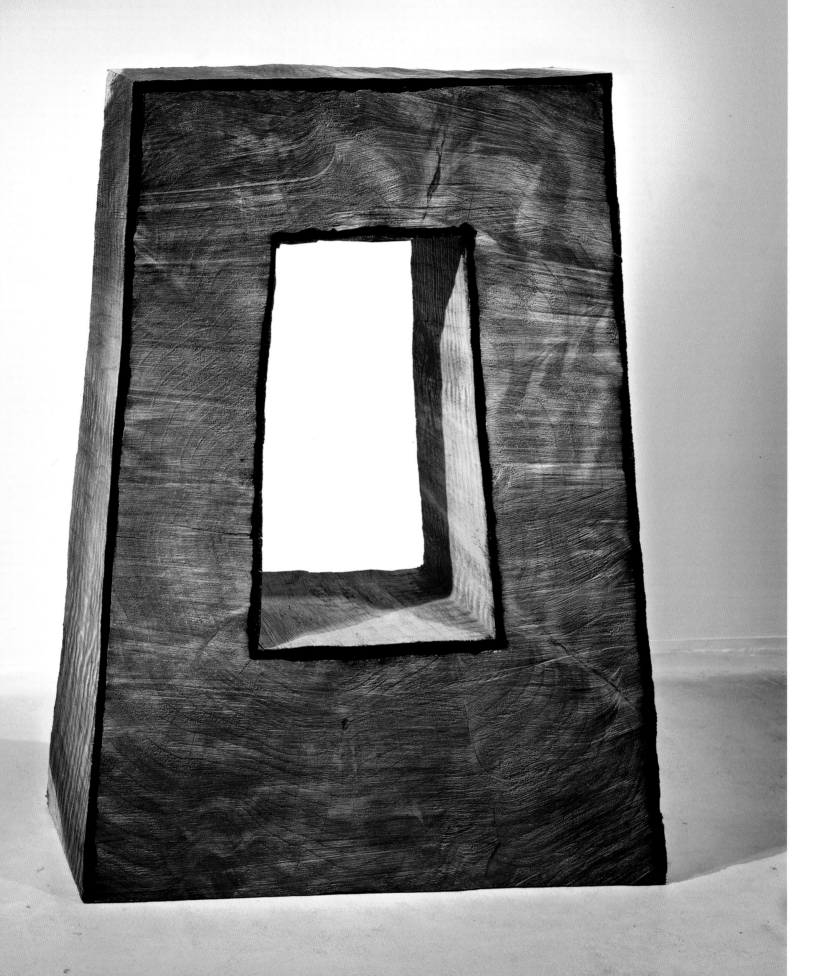

Black Walnut
Native to North America, black walnut is a dark and densely woven wood. Deep chocolate brown in colour, inert, still, silent, slow, amenable and earthy. Good for making small wood items, smokers' pipes, chess pieces. Too valuable to burn.

Olive
Intimately connected with the history of civilisation, the olive is like an ancient ancestor. Olive trees flourish with human attention: with careful pruning, they produce their potent deeply bitter fruit for centuries. Pressed olives yield an oil the same consistency as blood. The trees develop from a young standard form to highly individual shapes as their centres hollow out and new annual rings weave around what remains, sustaining a rock-like trunk that supports new growth. These old beings do not have deep sensitive roots and can be easily transplanted. They seem more connected to the sun and warm air than to the parched earth. They look like crystallised light. Olive wood is heavily grained and figured. Densely woven, it makes reliable domestic items – cutting blocks, cups, bowls, candlesticks – and is put to all manner of household uses. The natural oil in the fibre gives these items an air of permanence that is more like that of fired clay than wood. Tree, wood, fruit, oil, biblical, mythological, this species of tree is in a special category of relationship with the human being.

Outside and unprotected the colour of a wood's surface changes. In six months to a year the dust particles in the rain and ultra violet rays from the sun turn the surface grey, in some situations even bleaching it white. (In the 1970s it took two years in North Wales for wood to go grey outside, but after the Mount St Helen's volcanic eruptions in 1980 which put billions of tons of dust into the upper atmosphere, it took six months). The wood's moisture content is sustained, which helps the natural fungal activity that breaks down wood fibre. With some woods, the process is rapid – birch and beech, with others it is very slow – oak and redwood. (Elm does not deteriorate in water; elm drainage pipes made by the Romans are still being found submerged in wet earth.) The rate of decomposition also depends on the environment. Arizona is so dry that wood outside will last a long time, albeit in a parched and brittle state.

Once originated and made, an object has to be somewhere and is subject to the progression of time. It can be taken inside, or to a place outside. Wood moves; it's a growing tree or a decaying wood. Outside, the elements are active and everything is subject to them. Bringing work into a still, protected space neutralises, subdues the activity of the elements: the extremes of wet/dry, hot/cold are reduced to a minimum. The works I make inside are distinctly different from those made for the outside: although conceptually they are very close, the circumstances in which they are made are very different.

Wood reacts differently inside. Its moisture content gradually evaporates, the wood cells harden and shrink; each species will crack and bend differently. The surface colour will stay the same. At art college we were told that unseasoned wood was unusable because it would crack and warp. That is certainly true and a problem if one wants the material to be inert and permanently obedient to one's will. Furniture makers go to great lengths to prepare their wood so that it remains stable.

When I was setting out to make the basic hacked spheres that were to become *Nine Cracked Balls*, I had to use fresh wood because I had no other source of timber and made the discovery that the forms declared more about themselves, for me at least, as they cracked. The deliberately rough and robust attitude expressed by the object was emphasised and enhanced by the physical changes that occurred naturally: small cracks appeared as dark lines articulating the form, wider ones as entrances into the volume. While the eye tends to slide off a polished surface, it is engaged by rough surfaces which slow it down and play with it as the object is read.

Cut Corners Frame
partly charred redwood
1998
125 x 95 x 40 cm

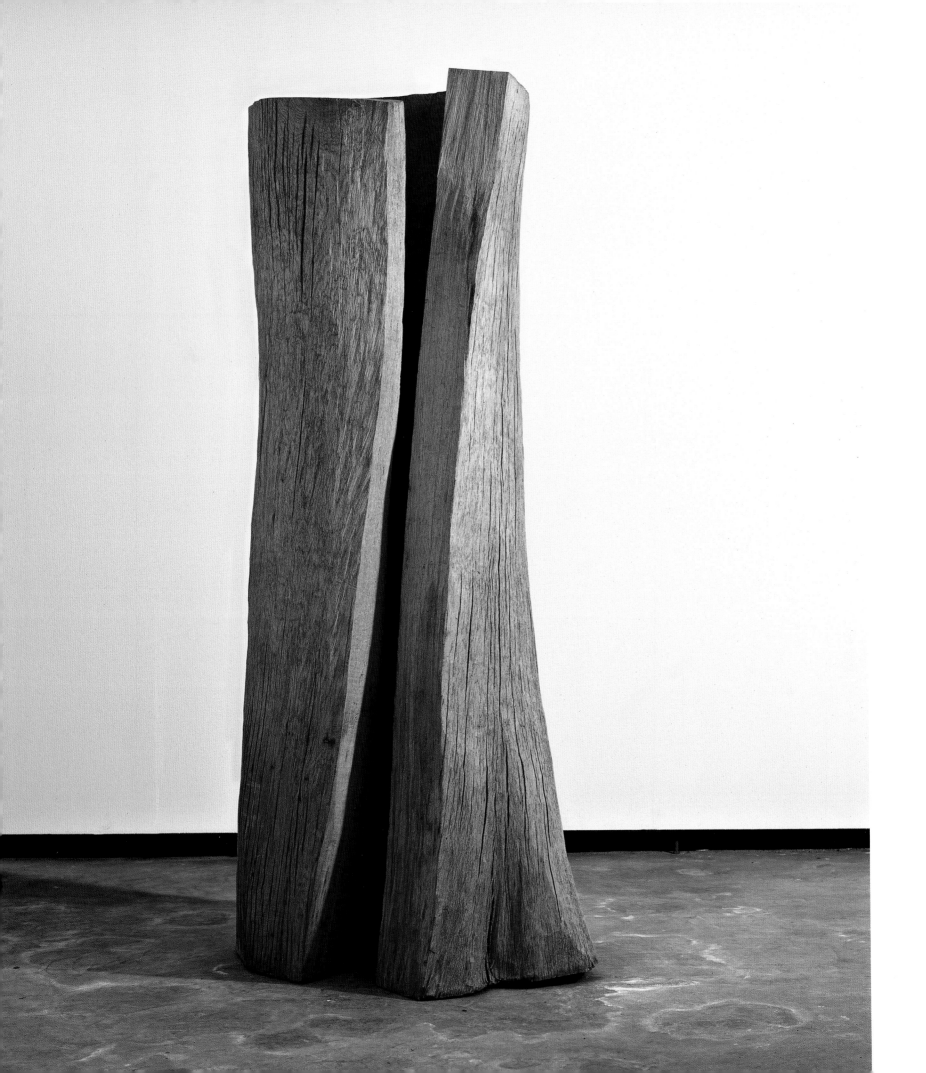

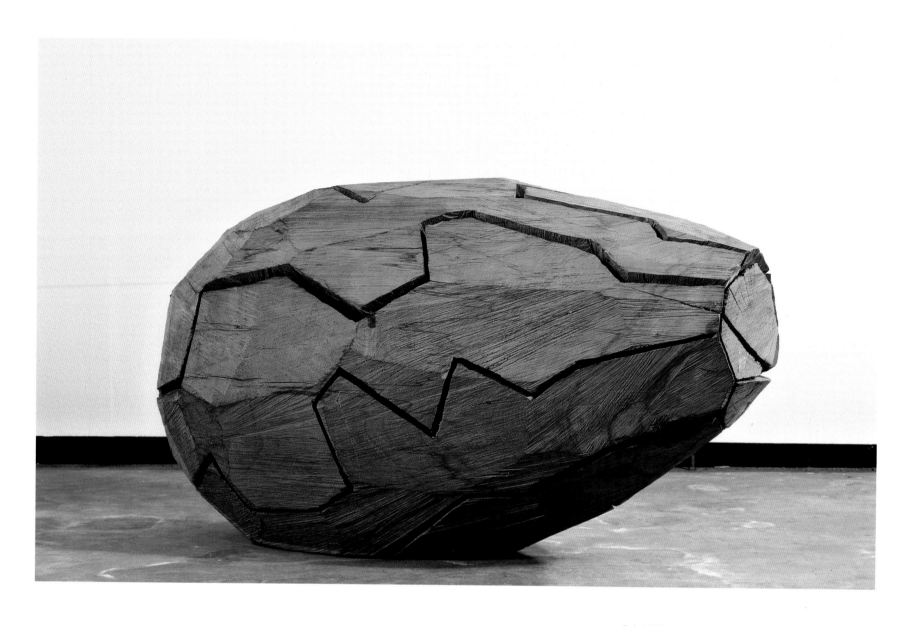

Inlaid Egg
beech
1996
100 x 100 x 52 cm

The egg form is deeply 'known'. From birds' eggs to tree buds, the shape signifies an encapsulation of life to come, a concentration, a distillation of all that is complex in nature. Simple, primal, potent, precious. Make an egg of clay then push the form into a head, a seal, a fish, a bear – every form. The egg sits in space between interior and exterior. Inside time is paused, outside time rushes on. The surface is all one, curving, rounded, elliptical. The relationship of two different radii at either end and the stretch between the ends all vary so that every egg is unique. Its shape and posture – vertical, angled or lying – the material and size all speak to our subliminal 'knowing' of the egg.

Opposite page:
Coil
oak
207 x 77 x 84 cm

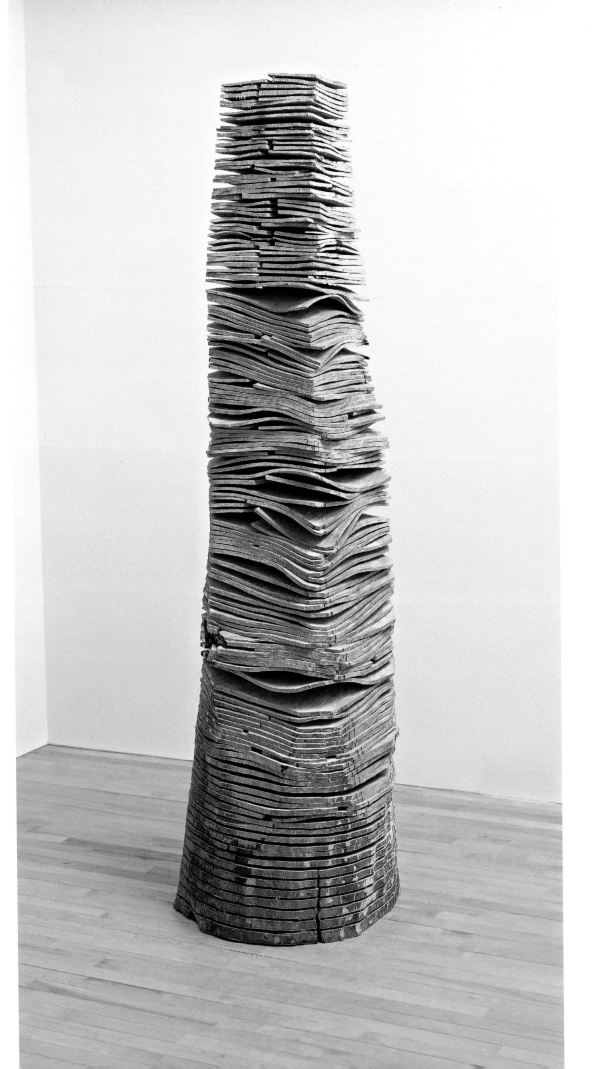

Crack and Warp Column
birch
1989
218 x 53 x 53 cm

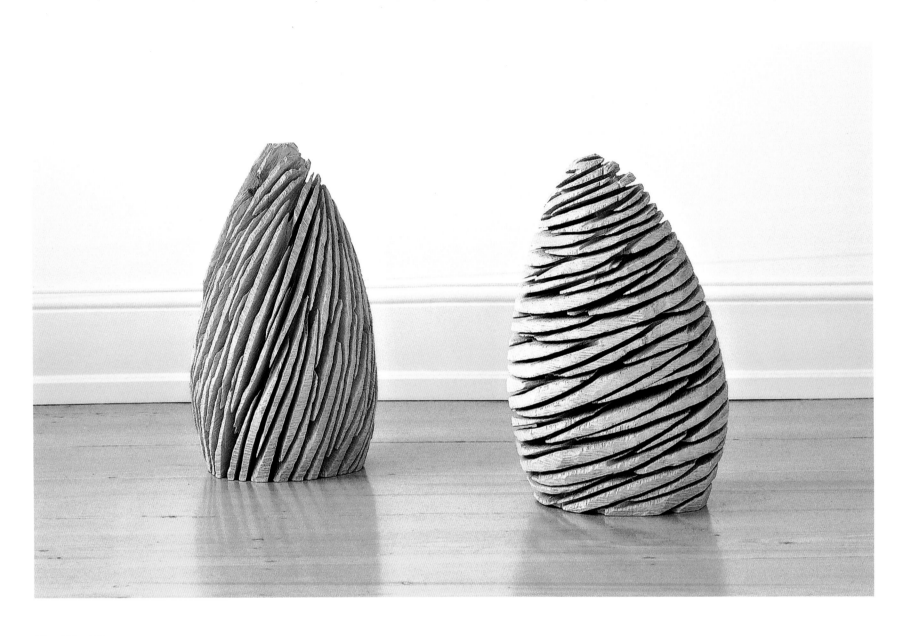

Two Sliced Eggs
lime
2002
52 x 30 x 30 cm (left)
50 x 30 x 26 cm (right)

Overleaf
Left:
Cut Corners Oak
oak
1998
114 x 89 x 36 cm

Right:
Folds
beech
2000
180 x 69 x 25 cm

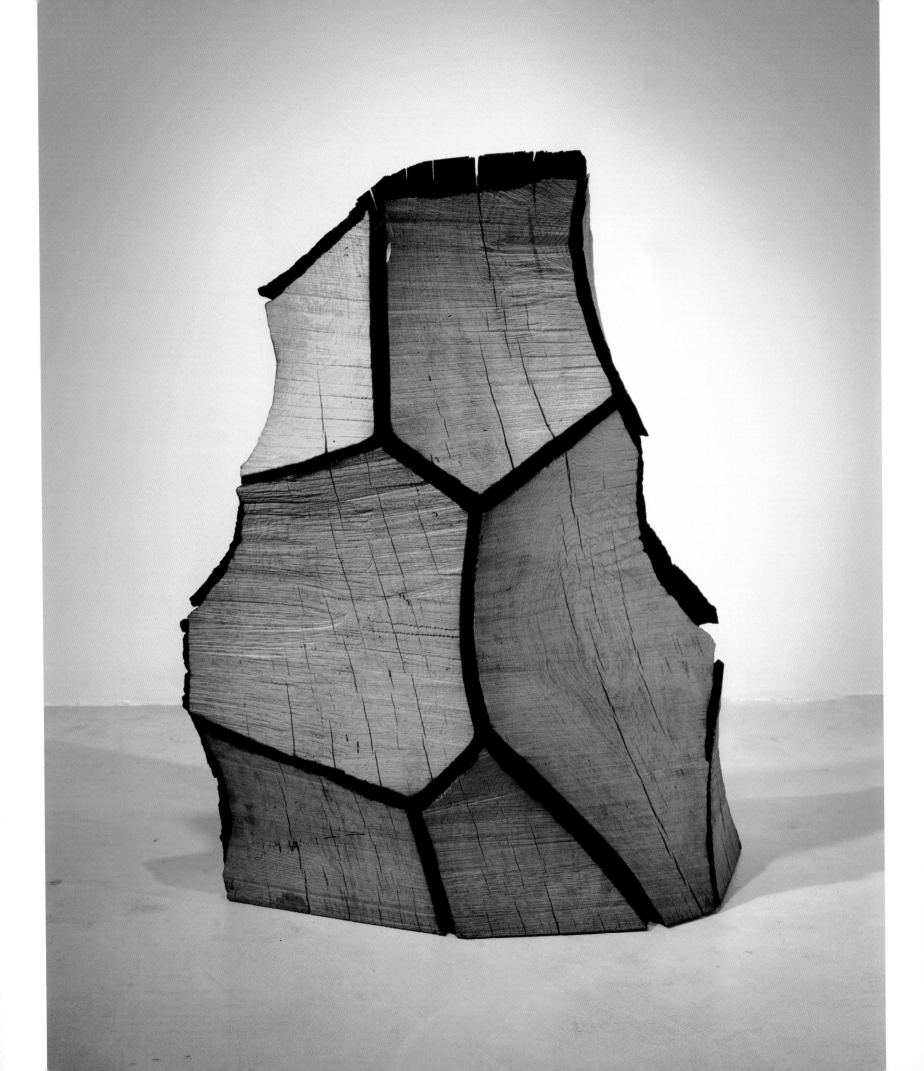

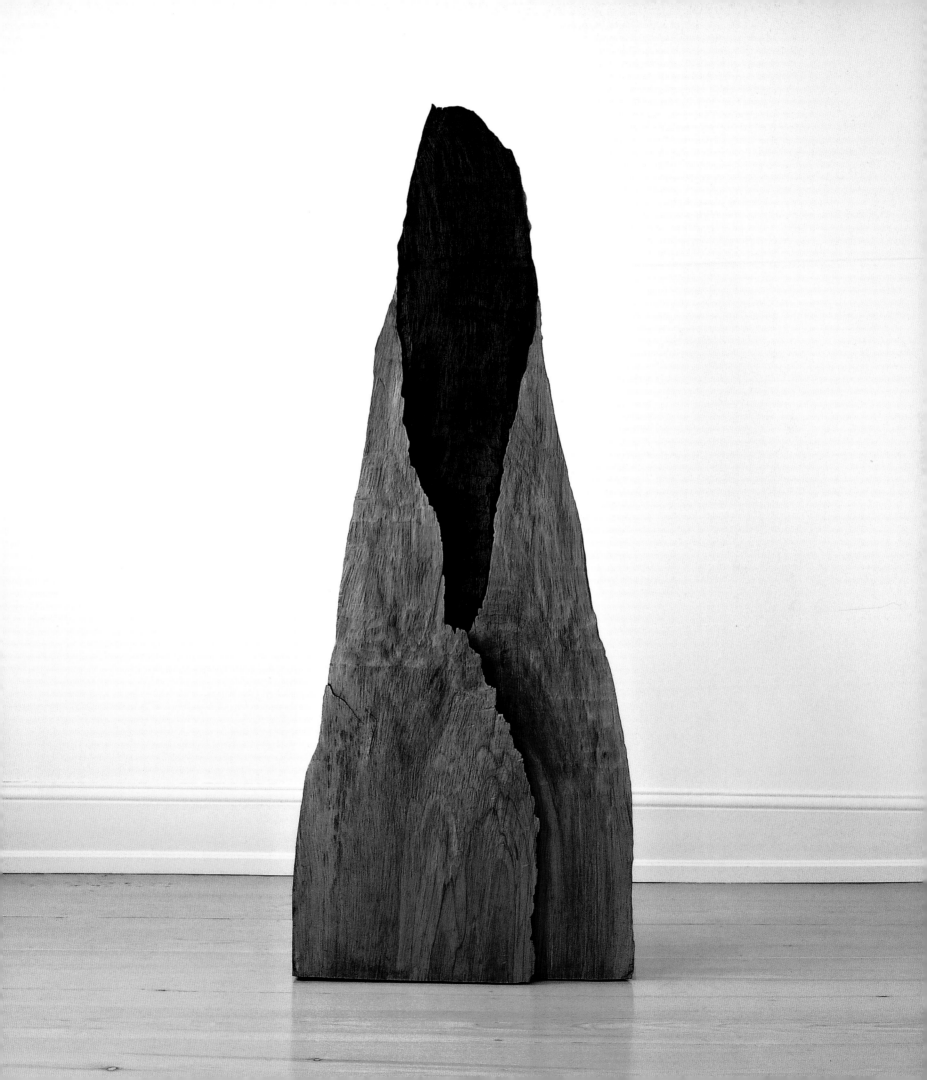

BLACK

When one looks at wood sculpture one tends to see 'wood', a warm, familiar material, before reading the form: wood first, form second. Charring radically changes this experience. The surface is transformed from a vegetable to a mineral, carbon, and one sees the form before the material. The sense of scale and time are strangely changed, the charred form feels compacted yet distanced in an expanded space. Rudolf Steiner spoke about human responses to carbon being on two levels; the feeling and the thinking. The feeling instinct – connected to one's soul – is repulsed, withdraws; while the thinking instinct – connected to one's spirit – is attracted and advances. These two simultaneous experiences vie with each other.

The experience of a white surface is of reflected light coming at the eye. The pupil of the eye reacts by reducing in size. The experience of black is the opposite: light is absorbed, drawn away from the eye, the pupil opens and there is a sense of being pulled into the surface. Ad Reinhart's black paintings play with this phenomenon. At first sight, in a well-lit gallery, a painting appears to be a single tall black oblong. After a few seconds, as the eye's pupil begins to open, the oblong suddenly divides into two squares of different blacks; a little later each square divides again and then again and again. After five minutes, one is seeing a surface of hundreds of squares.

There are variations of tone in a charred sculpture. The shadow of an undercut or an aperture will be of a deeper black than the outer surface. Carved fissures and contours can be emphasised by charring inside the cuts, thus exaggerating the shadow while leaving the rest of the surface the natural colour of wood.

Charring can be done to different to degrees. A raging fire bakes the wood surface and creates large brittle segments of carbon. There is more control with a propane torch: it can scorch a surface lightly or, with more burning, create a medium texture in which the wood fibres craze and make a relatively stable surface. Each wood species chars differently: beech and birch char easily and evenly; oak, true to character, is awkward and resistant, flaking off in thin layers. Whole sculptures can be moulded by fire. A narrow cut, for example, will burn and widen into an elegant rounded aperture.

Cube, Sphere, Pyramid
charred oak
2003-04

Charring in progress at Llwyngell workshops, Blaenau Ffestiniog, North Wales, June 2005 (*see* page 167 for finished sculpture).

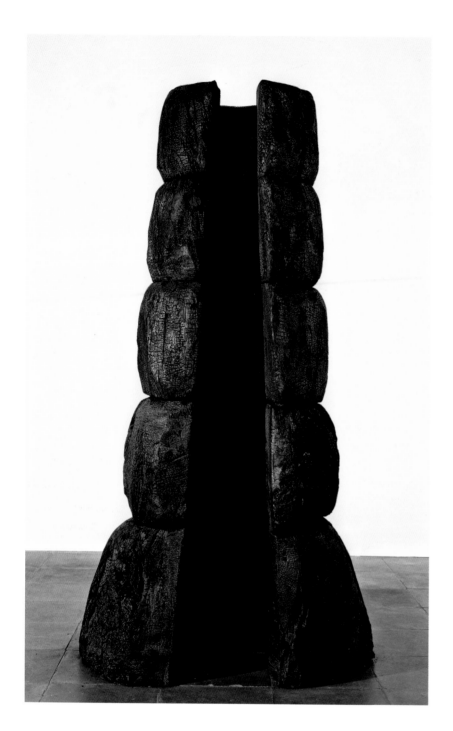

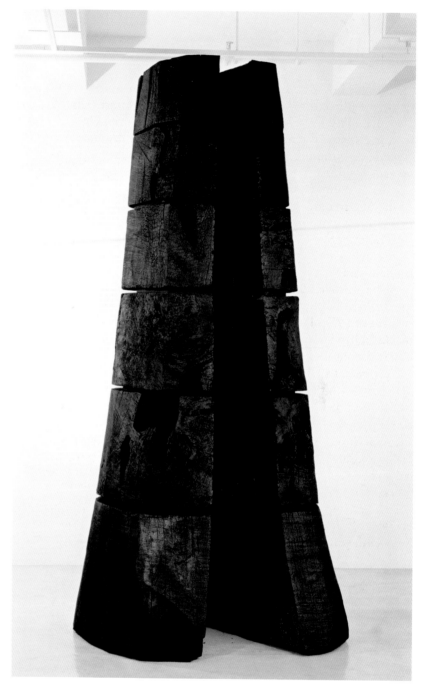

Left:
Threshold Column
charred elm
1990
250 x 122 x 110 cm

Right:
Threshold Column
charred oak
1998
292.5 x 137.5 x 127.5 cm

In 2002, there was an exhibition at the S 65 Galerie in Cologne composed exclusively of charred sculptures. Lieven Van Den Abeele, writing in the catalogue, talked succinctly about black:

> From a theoretical point of view, black is not only the absence of colour, it is also the synthesis of all colours. black stands for presence, as it stands for absence. black refers to both matter and spirit. Black is not so much 'all *or* nothing', as 'all *and* nothing [...] There are many sorts of black: pitch black, ink black, jet black, black as soot or ebony, the black of the sea, of the night or of the forest. The colour differs to the extent of whether it is matt or shiny, whether it is exposed to light or lurks in the shadow. Hokusai even speaks about an 'old black' and a 'new black' and thus introduces the dimension of time. The black of David Nash is jet black. His sculptures are not painted black, but charred black. The surface of the wood has not been covered with colour but is transformed by fire. The wood is not burnt to ashes, but charred. The vegetal material has become mineral.

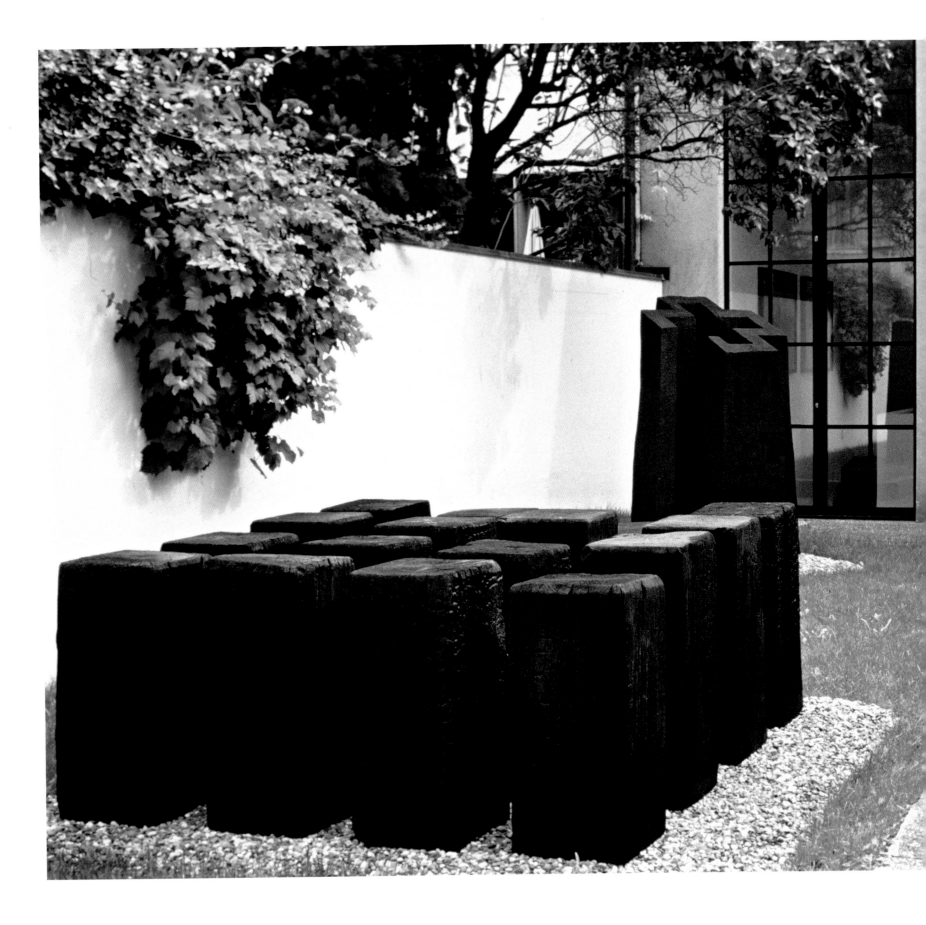

Four by Four
charred pitch pine
2002
each block 74 x 33 x 33 cm

Black Mound
charred oak
2006
300 x 800 x 700 cm

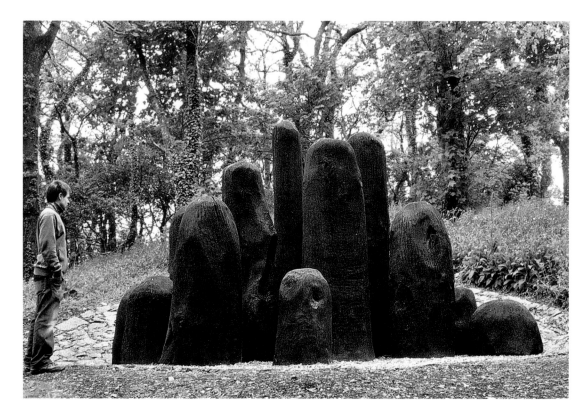

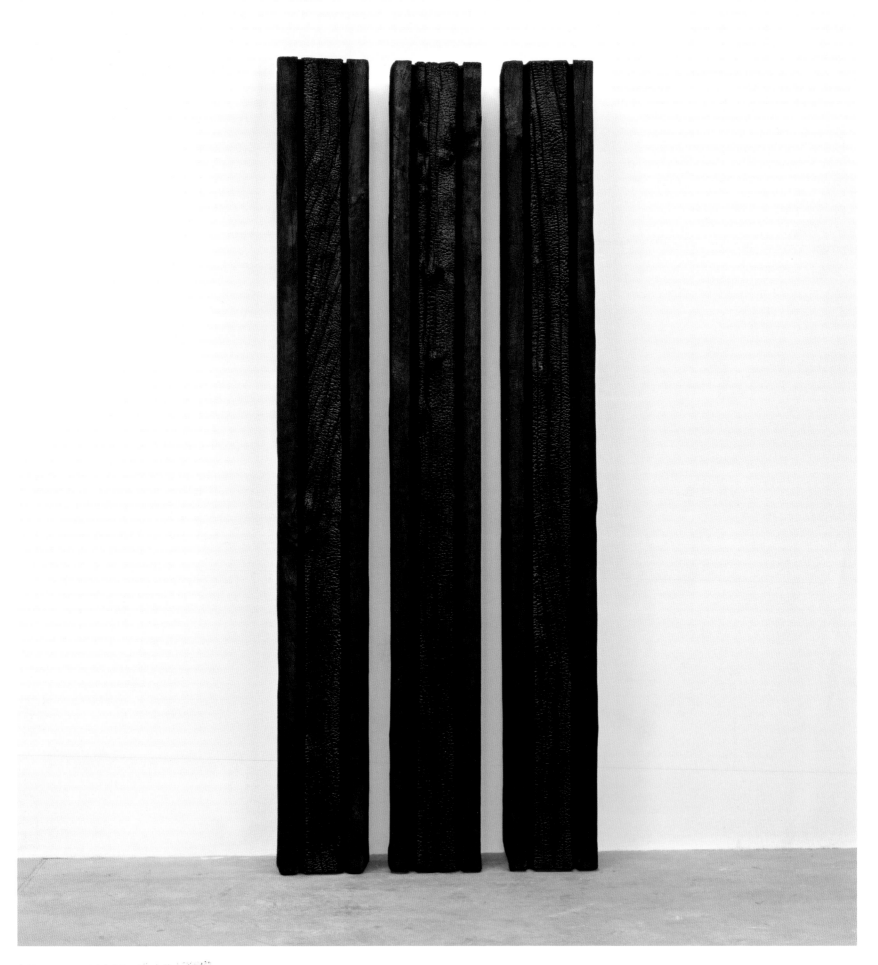

Opposite page:
Three Charred Columns
charred oak and maple
2001
each 242 x 28 x 28 cm

Right:
Two Charred Panels
charred hornbeam
1999
36 x 60 cm

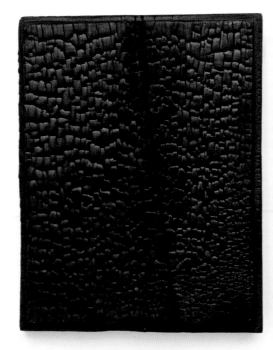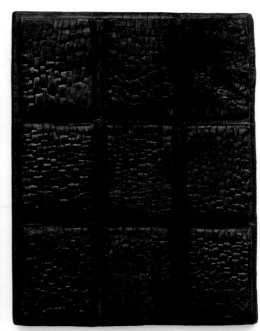

Below:
Village Husk
charred sugar maple
1998
55 x 277 x 137 cm

The impetus for this sculpture came in 1987 from
a newspaper photograph of a Middle Eastern
village that had been destroyed in a retaliatory
act of war.

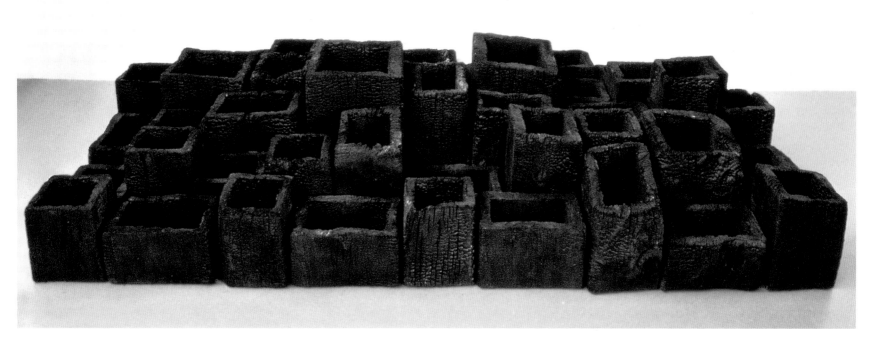

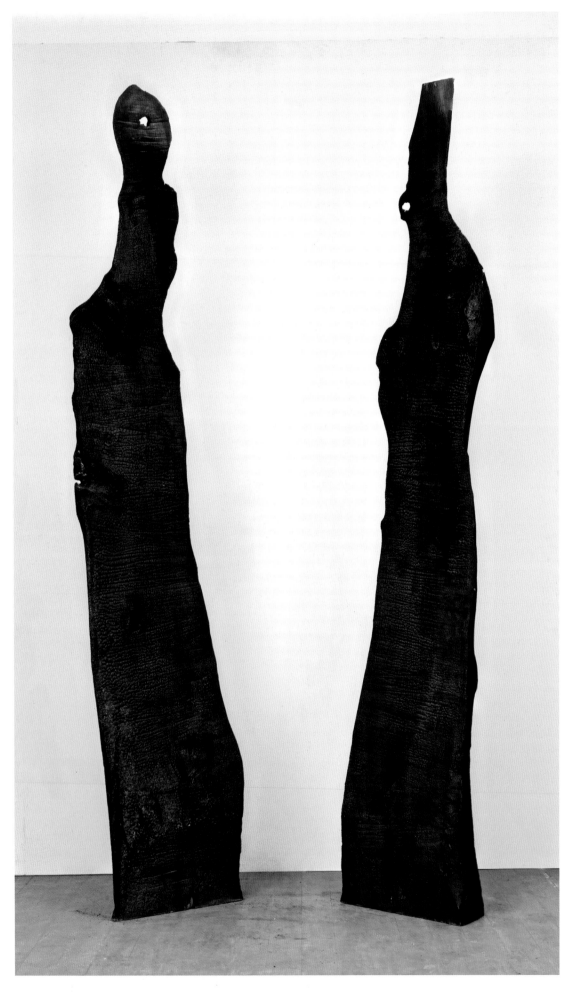

Two Charred Menhirs (King and Queen)
charred oak
1991
360 x 70 x 28 cm (left)
360 x 70 x 30 cm (right)

Opposite page:
Two Charred Menhirs
charred oak
1996
each 300 x 45 x 70 cm

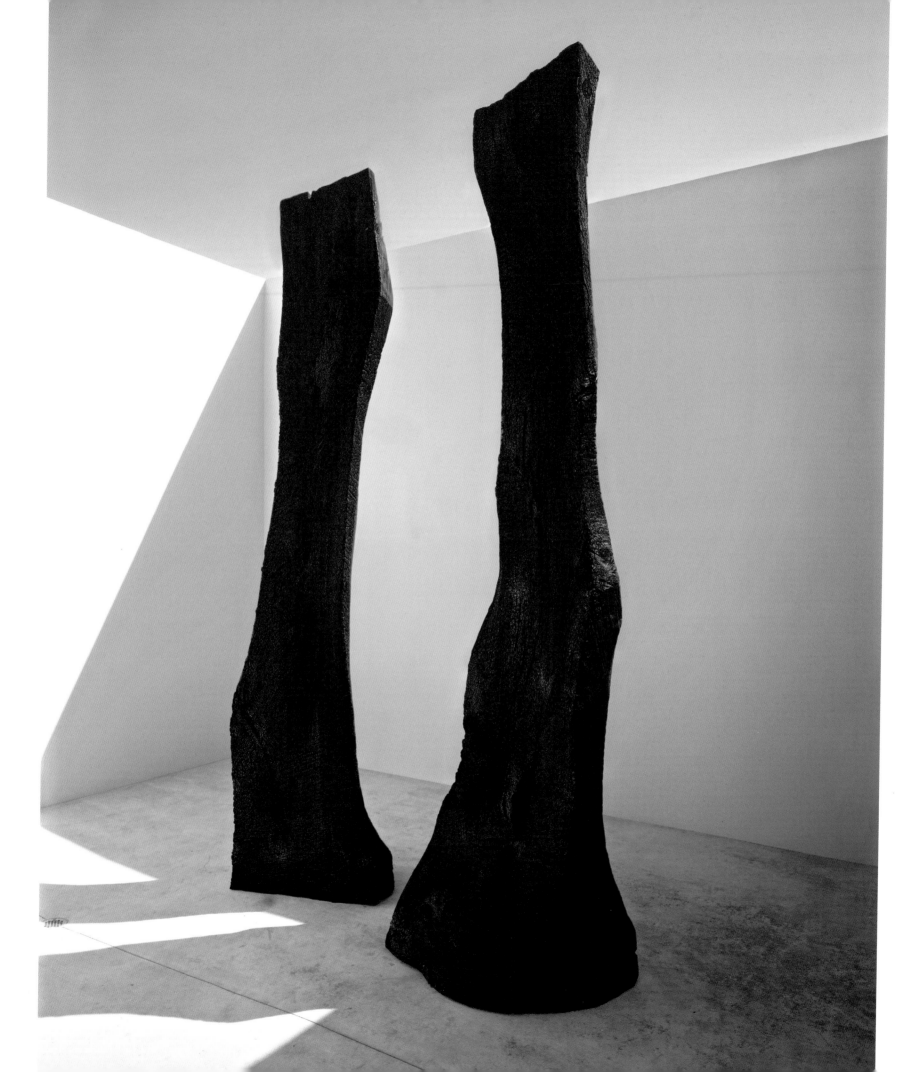

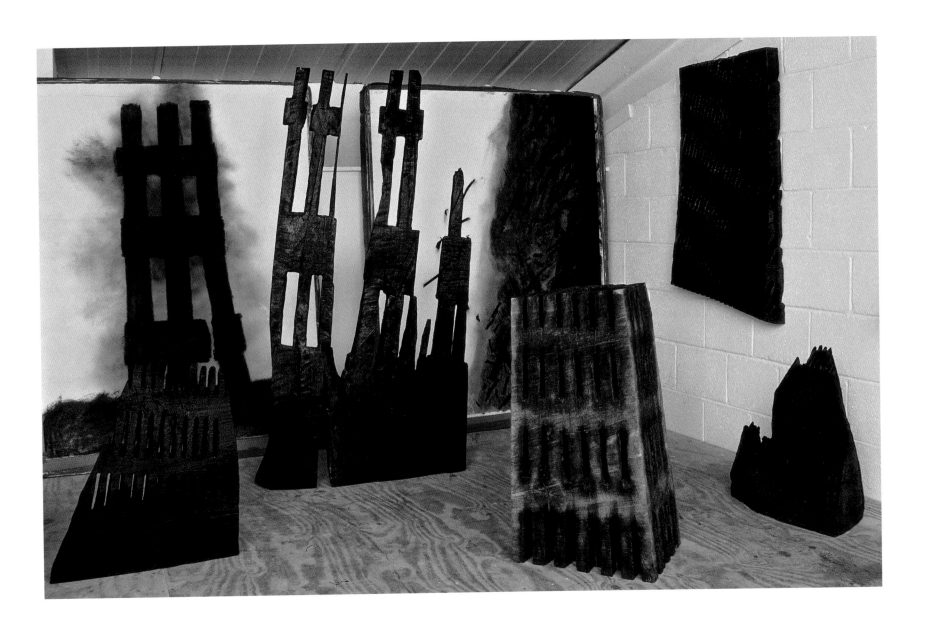

An Awful Falling 9.11

The image of the stricken Twin Towers of the World Trade Center in New York in September 2001 was overwhelming. The suddenness and enormity of the event called everything – all one's plans, schedules, ideas – into question, into pause. It was not my intention to respond through my work, but an offcut from a beech cube I was making at that time stood with three leaning verticals that looked hauntingly like one of the images of the devastation appearing in the press coverage. It needed only a few cuts to bring it into closer visual association. I became aware that the protective gear I wear for chainsaw work was similar to that of firefighters desperately digging in the rubble for their colleagues.

On the flat top of a stump of elm I carved the outline of a fallen section of girders. I cut blocks into broken and burnt geometry, and pushed charcoal downwards on paper, remembering the roaring grinding of that awful falling that went on replaying in the minds of all those who witnessed it, however remote from the scene they were.

The feeling of diverting my materials, tools, habit of working to this imagery seemed to articulate the hollowed-out space in my emotional guts; instead of being cut adrift I felt connected. These pieces are separate from my evolving stream of sculpture and drawings and are kept in a separate room. When I'm in that space the feeling of that time is strongly present, and reminds me of how human consciousness of the world changed at that moment. When they see this room, New Yorkers have commented that the visual experience in the aftermath was of white from the ash and dust and the paper. For me, 3000 miles away, it was black.

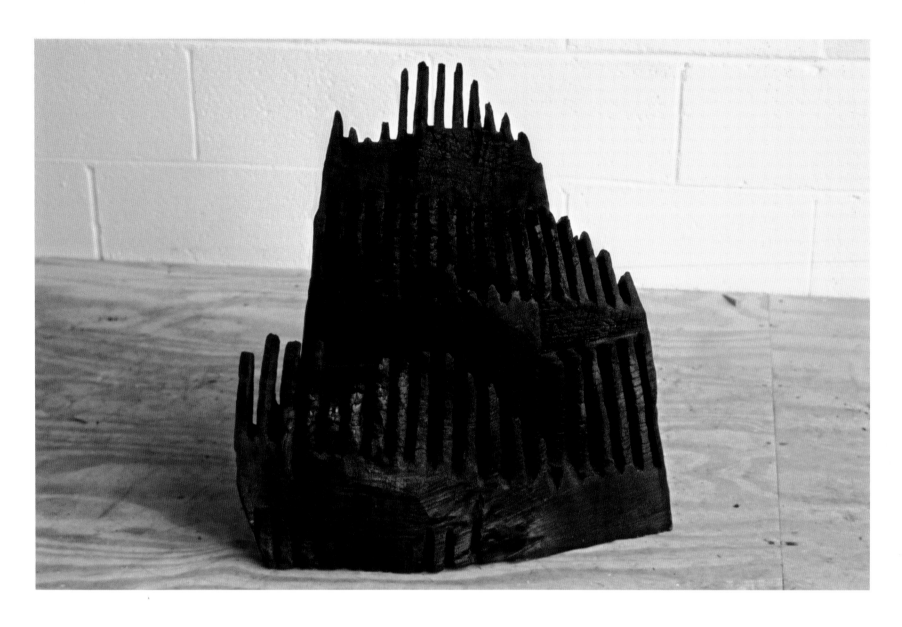

An Awful Falling
charred elm
2001
56 x 55 x 26 cm

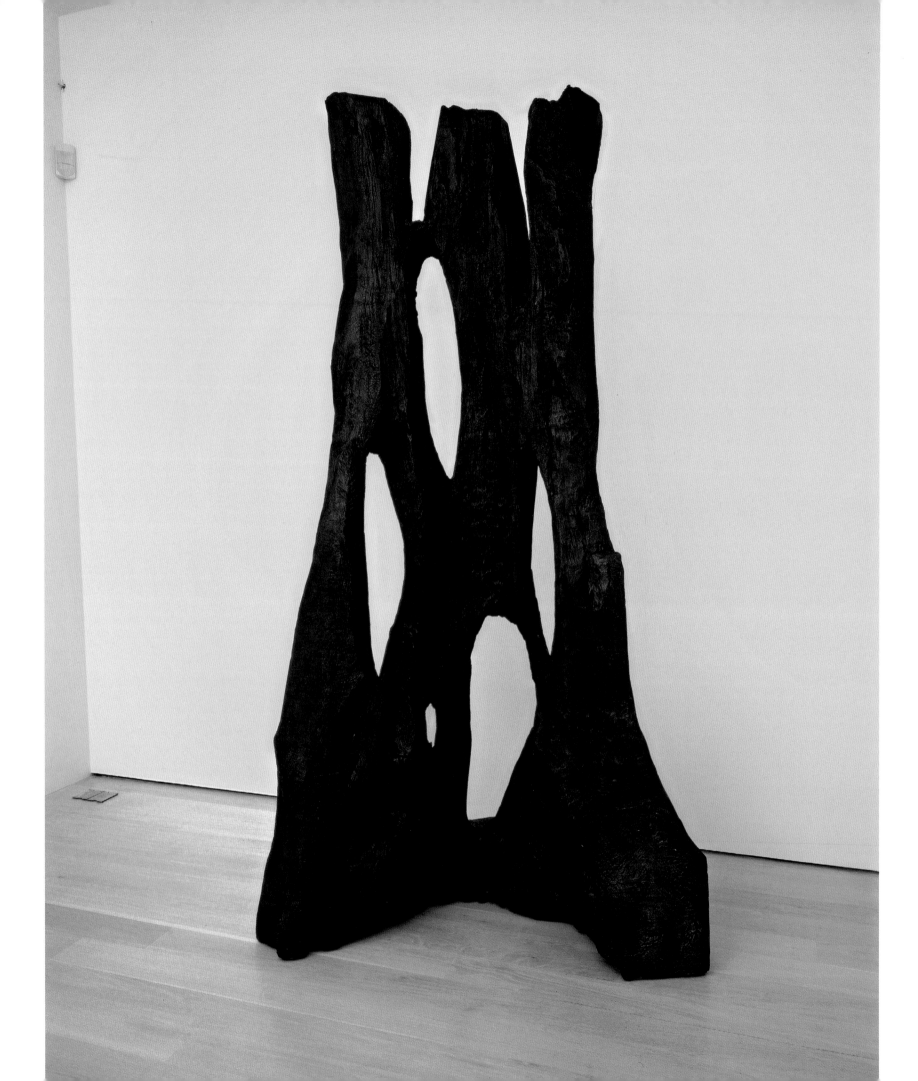

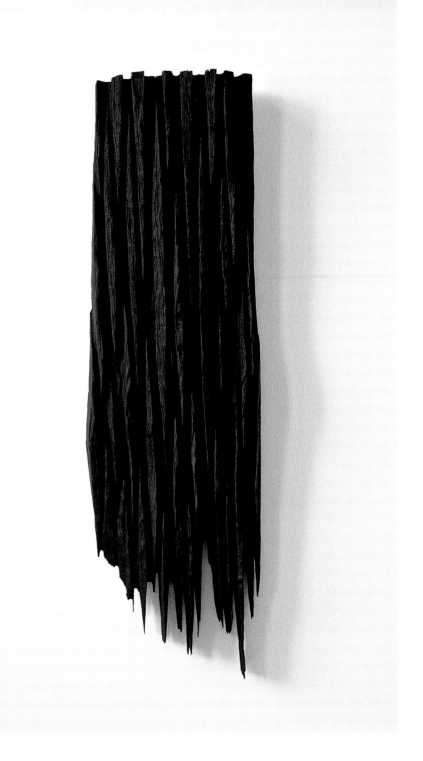

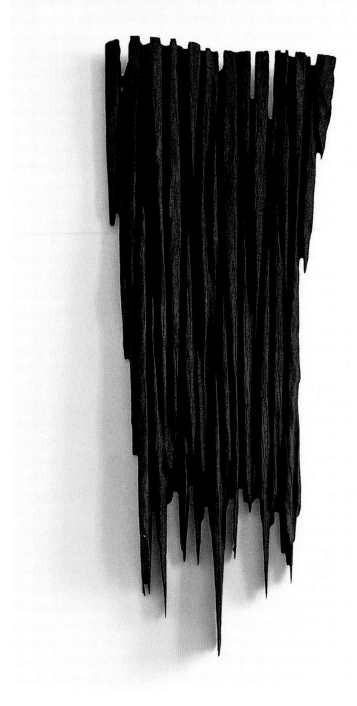

Black Downpour I
charred beech
2002
125 x 36 x 18 cm

Black Downpour II
charred beech
2002
94 x 36 x 8 cm

Opposite page:
Black Holes
charred yew
2007
219 x 121 x 76 cm

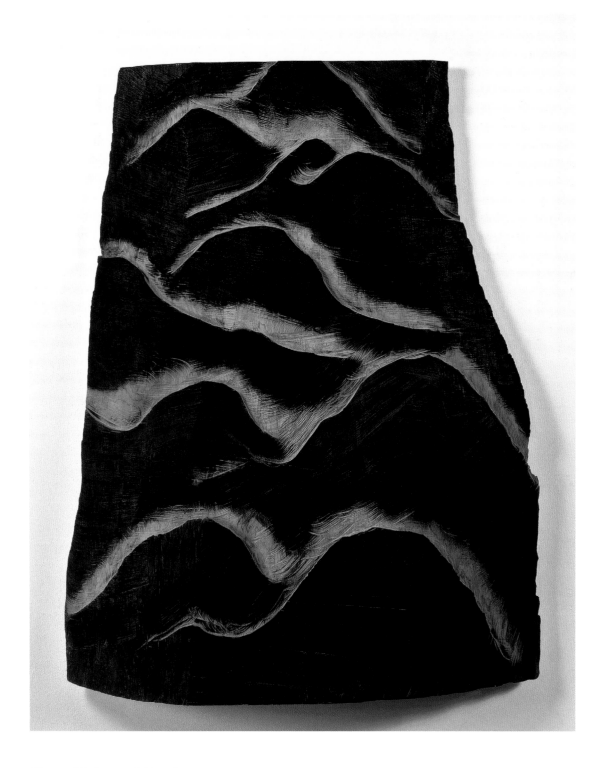

Twmps, Moelwyn and Manods
partly charred redwood
2000
120 x 64 x 15 cm

Opposite page:
Seven Slices
partly charred beech
2000
140 x 57 x 63 cm

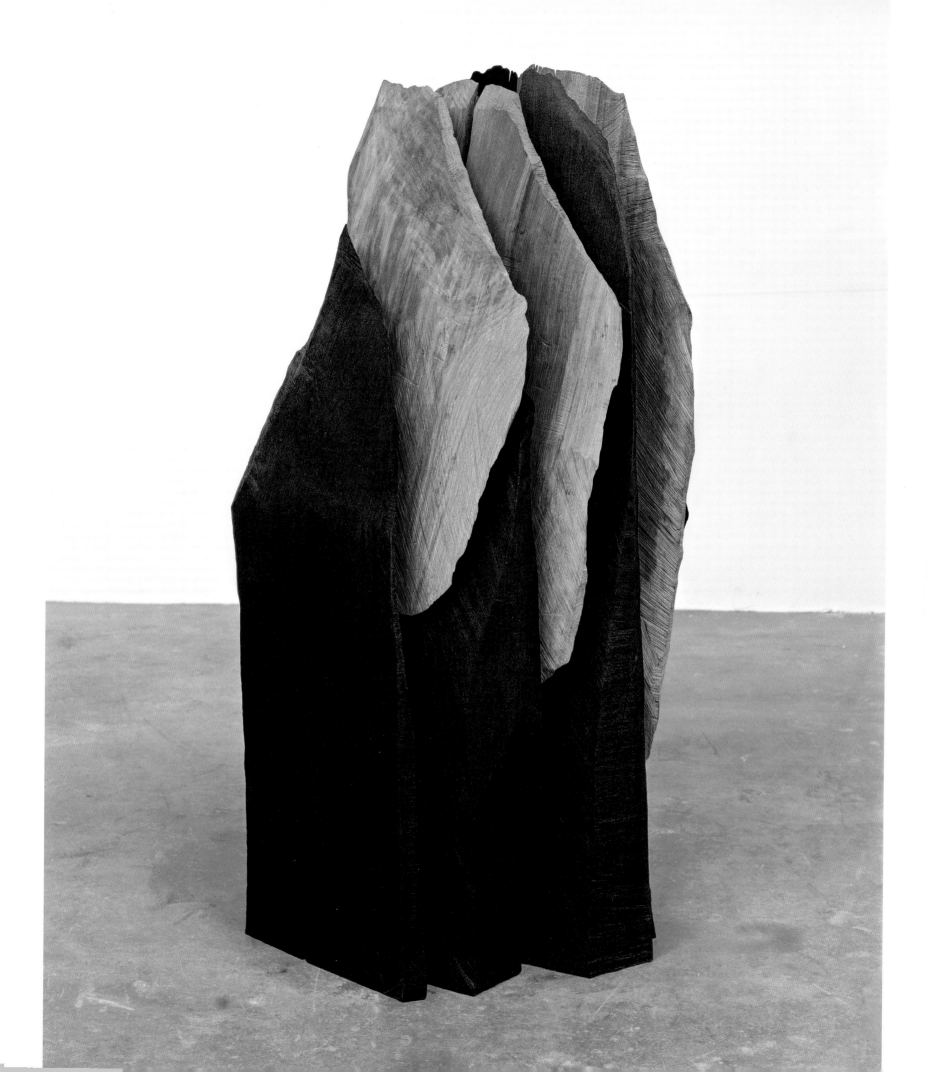

The New Generation British sculptors of the early 'sixties combined colour with three-dimensional form, boldly putting colour into space. As a student I found this dynamic and stimulating. I realised that my dissatisfaction with my own attempts at painting stemmed from the fact that the two-dimensional image was removed from the reality of form. Colour in real volume and in real space was so much more present and potent than it could be when flat on the wall. This also advanced my fascination with Kandinsky's notion of sound made visible through shape and colour.

My early sculpture was about putting colour into space. Wood was a useful support for the colour. Gradually I came to feel dissatisfied with the colour being only a skin. I tried staining the wood, then soaking the wood in colour to give it physical depth.

Eventually when I started working with fresh unseasoned wood I accepted its natural colour as given. The interest in colour continued. Black is naturally achieved by burning the wood's surface and is within the ethos of my working method as an inherent quality of wood. The red of certain species – yew, alder, and redwood – gives black a particular power when a piece was partly charred – a potency I continued to explore with works on paper, rubbing red pigment and black pigment onto white paper and merging the surface dust to make a particular zone where the two pigments met.

This led to trying other colours with black: green and black, and blue and black (yellow and black did not lead me anywhere.) Exploring these meetings of raw colour with black carbon on paper, I looked for ways of bringing them together in my sculpture, which led me to experiment with bringing metal to my wood. Bronze oxidises naturally to green. Pouring molten bronze onto wood creates an object that is naturally green and black – charred wood and oxidised bronze. Iron in contact with freshly cut oak stains the wood surface a deep blue (the tannin in the oak reacts to the iron). This is a phenomenon that I am currently exploring, as well as investigating bronze and iron further in their own right.

The origins of red and black lie in a forest in north-eastern Poland where, in 1991, I was working on a group of sculptures for a collaborative show with the painter Leon Tarasewizc. On a preliminary visit to the forest where Leon lives, I had noticed large

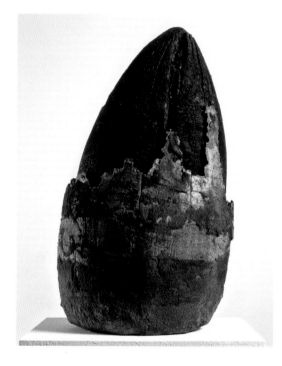

Encased Egg
charred beech and bronze
2004
54 x 32 x 36 cm

Red and Black
pastel on paper
2003
54 x 70 cm

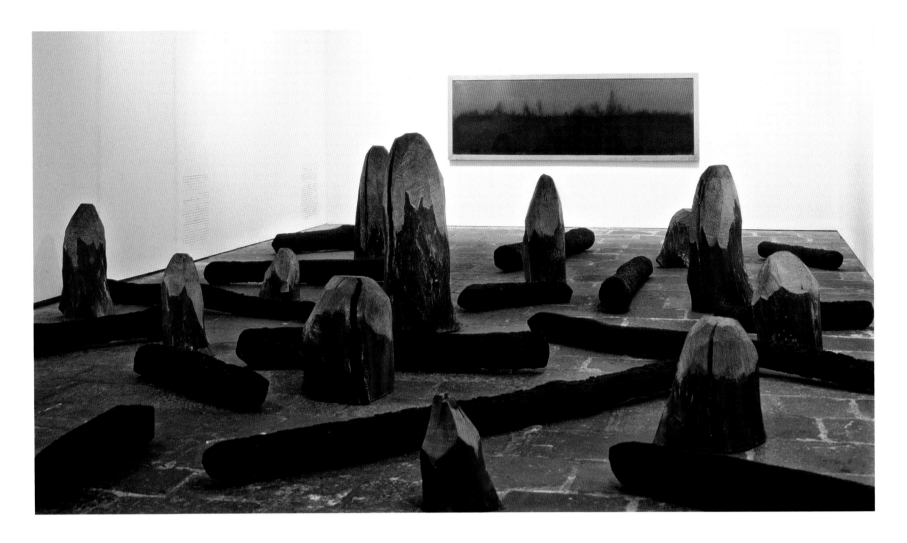

Red and Black II
alder and charred tamo
1993
dimensions variable

Red and Black
pastel and charcoal on paper
1995
60 x 240 cm

In the works on paper, the red shapes are made on a flat surface using soft pastel. Most of the pastel adheres to the paper, some remains as loose dust. When all the red shapes have been drawn, the paper is shaken to make the dust spread upwards and the images are sprayed with fixative. The black shapes are then drawn with charcoal, and the resulting dust is shaken downwards and fixed. The upward gesture is appropriate to the life force in red; the downward gesture is appropriate to the death force of black.

commercially grown alders which were about to be felled. When an alder is cut, the wood is pure white but after twelve hours the sap oxidises and the wood turns bright red; it holds that colour for several months, then, as it dries, it becomes orange. I was also offered a damaged oak and some large birch. Intending to make some charred pieces, I realised there was the potential for a powerful triad of black, red and white – charred oak, alder and birch bark. Looked at separately these colours have many associations: black – dark, density out of contraction, death; white – light, expansion, innocence; red – activity, stimulation, life, passion. Red stands between black and white as darkened light and lightened dark.

These colours occur in many European myths and legends. In an Arthurian story a knight is transfixed by the image of drops of blood in the snow from a wounded black crow. In the Holy Grail Parzival is the red knight and his brother's skin is mottled black and white like a magpie; only together can they find the Grail. In another legend Flore's horse is white on one side, red on the other, divided by a strip of black three fingers wide bearing the inscription, 'only he is worthy to ride me who is worthy of a crown'.

When I returned to the Polish forest later that year I found painted on a tree near my work site a sign of three stripes, white, red and black. No-one seemed sure of its origin. I was initially unsure of how to work with these colours and started by simply bringing them together; sections of red alder, charred wood (from the fire used to char other sculptures), and slices of birch bark. The alders were unusually large for their age, growing out of deep, crater-like pits – an ideal damp environment for alders. I asked if the pits had been dug especially for growing alders. The reply was that we were working in the area of a long and bloody First World War battle between Russian and German armies, and that the pits were in fact shell craters. The fresh blood of the alders and the doom of the charred oak took on a deeper significance being made in that place. Installing the work in the Warsaw Museum, I found that the painted walls provided the element of white, making the birch bark unnecessary.

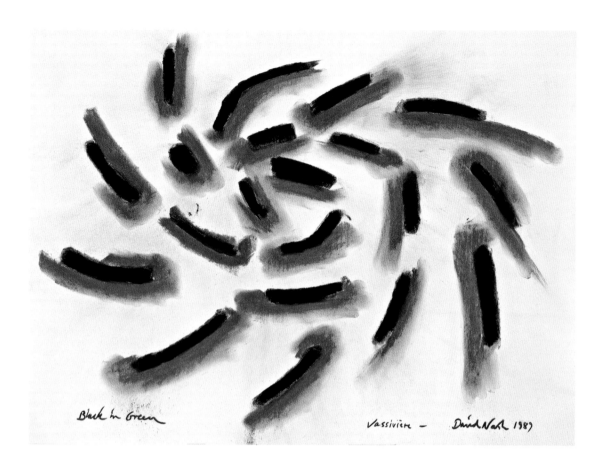

Above:
Black in Green – Vassivière
pastel and charcoal on paper
1989
56 x 76 cm

Below:
Black into Green
charred oak in moss
Les Yvelines, France, 2003

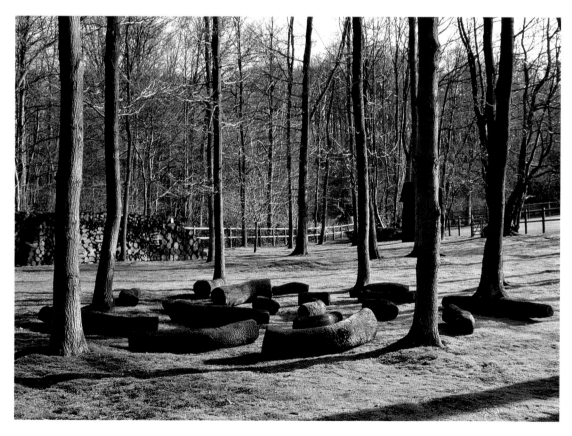

Blue Ring
pastel on canvas
1992
280 x 265 cm

The experience of blue tends to be one of distance, of being drawn out into space. It seems to resist any fixed shape.

Working at 'planted' sculpture drew me more consciously into the cycle of the year; each year there is an abundance of wild bluebells all over the hillside of Cae'n-y-Coed. I realised that there was a chance to make a work about blue which acknowledged both its transient quality and its resistance to being held in a fixed form. The closest acceptable form for blue seemed to be a loose-edged circle, a circular indication amidst a sea of blue. In 1984 I moved thousands of bluebell bulbs into a ring thirty metres in diameter on an open slope, and each spring, from a distance, you could make out a faint circle. Four years later the form had vanished into the general covering of blue.

The tiny tear-shaped seed of the bluebell is a deep indigo blue. When in flower the plant droops but lifts itself up as the seed heads form, the fleshy green walls dry out and become a spring-loaded cup: the merest touch on the stem triggers the seeds to fly out. As a way of presenting the notion of the *Blue Ring* I gathered enough seeds to make a loosely scattered circle on a flat surface accompanied, on the wall above, by a loose blue circle on canvas.

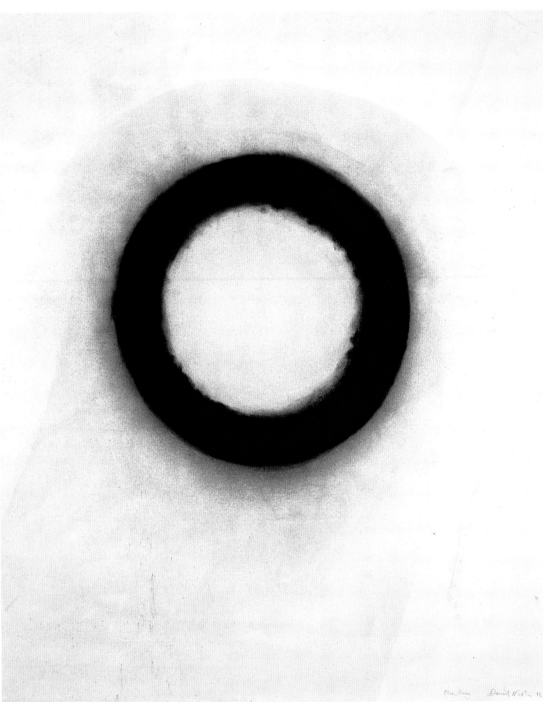

Below left: bluebell seedheads drying.

Below right:
Blue Ring
bluebell seed scattered on paper
1988
150 x 150 cm

151

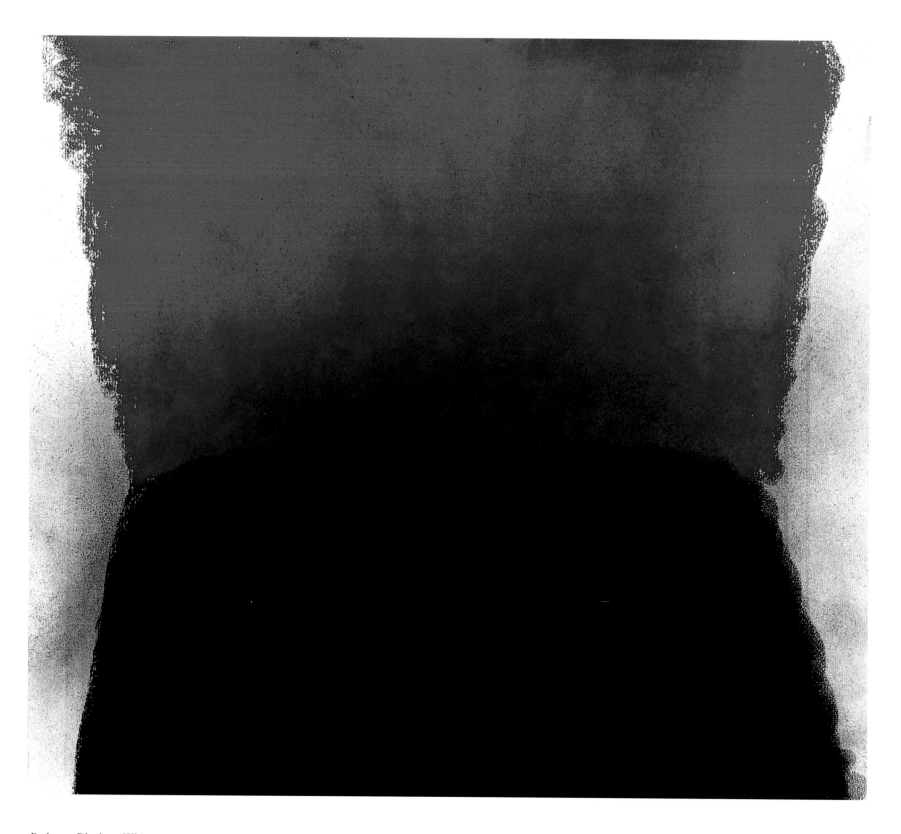

Red over Black on White
pastel on paper
2003
50 x 57 cm

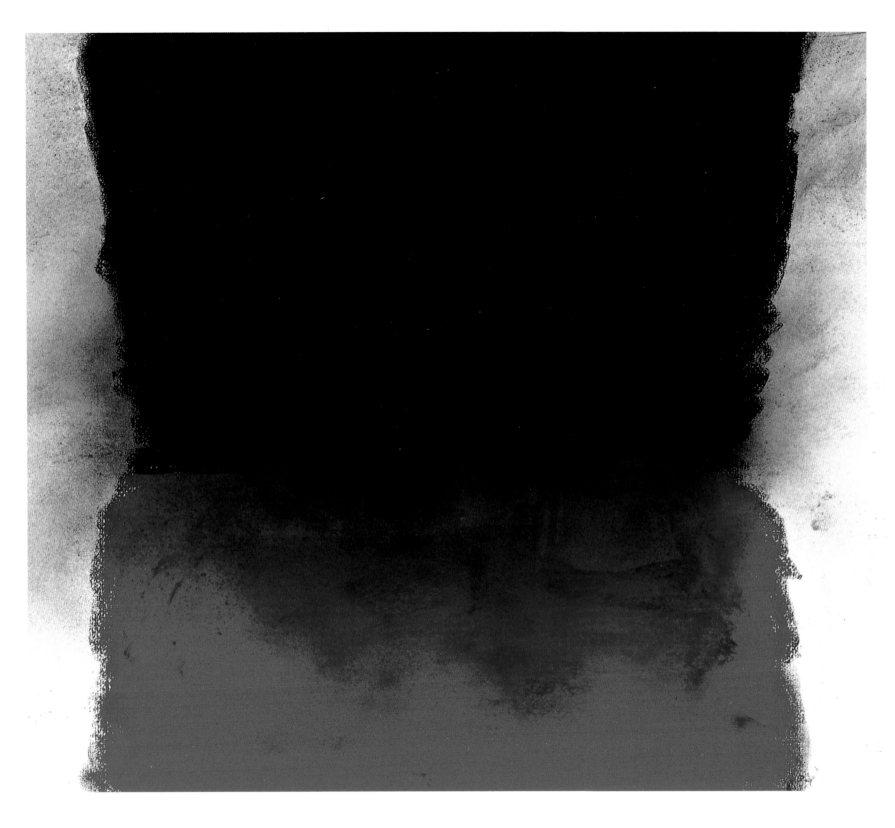

Black over Red on White
pastel on paper
2003
50 x 57 cm

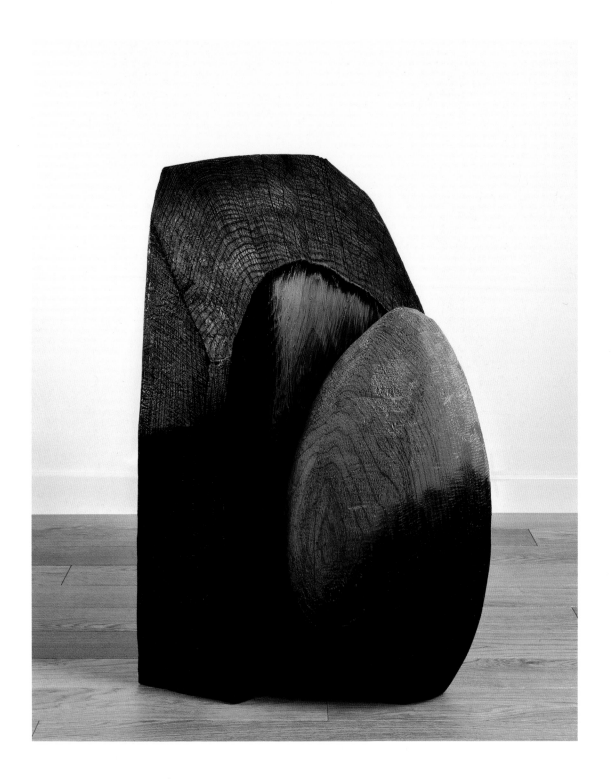

Red and Black: Egg and Space
partly charred redwood
2004
85 x 70 x 40 cm

Opposite page:
Red and Black Cross Column
charred redwood
2001
216 x 79 x 40.5 cm

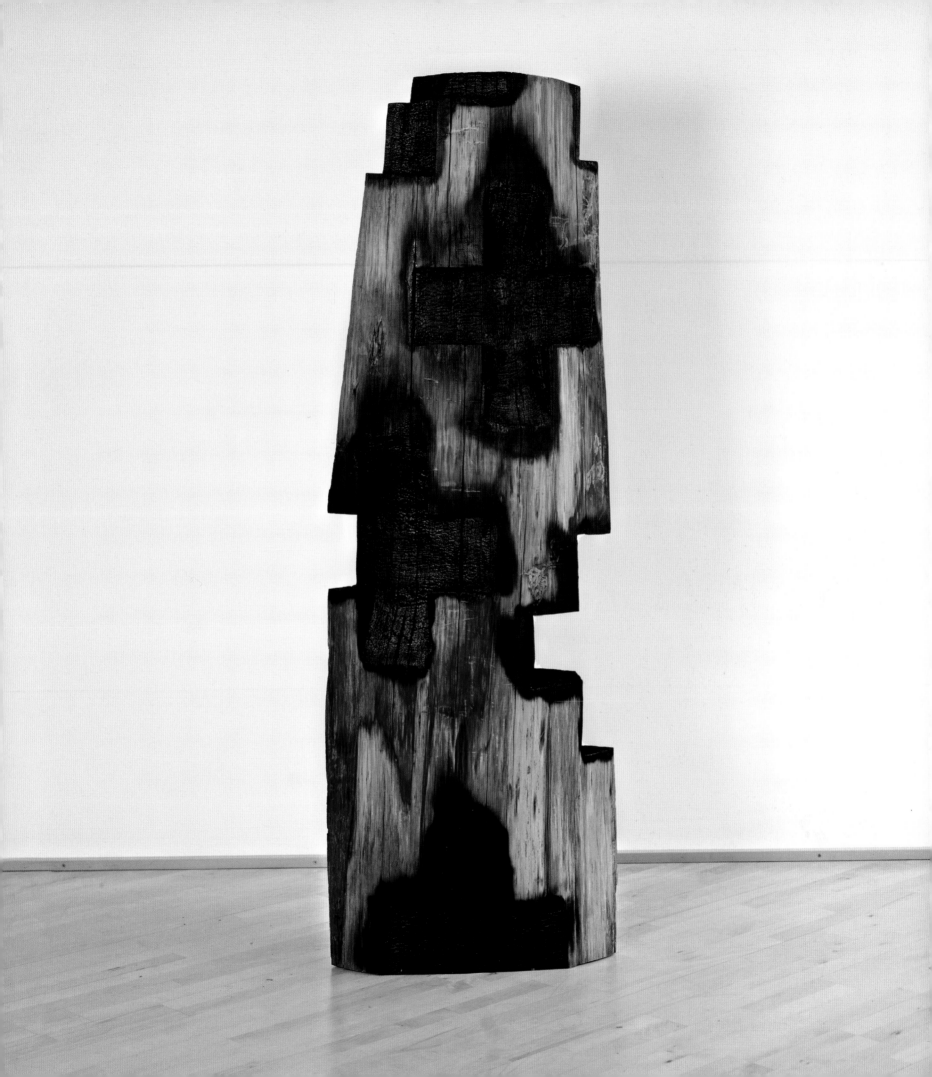

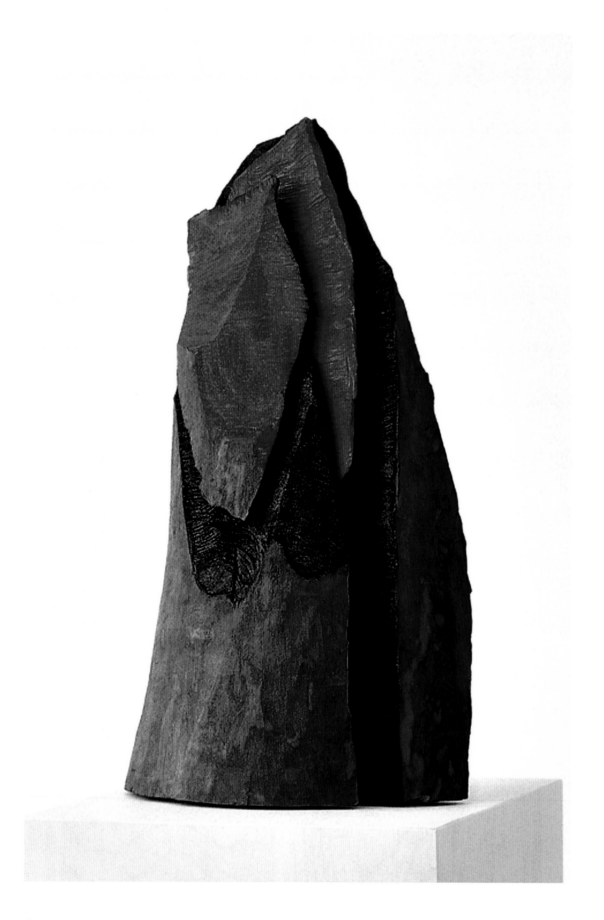

Red and Black Sheaves
partly charred bay laurel
with red pigment and oil
2001
51 x 31 x 15 cm

Below:
Red and Black Sheaves
pastel on paper
2003
78 x 56 cm

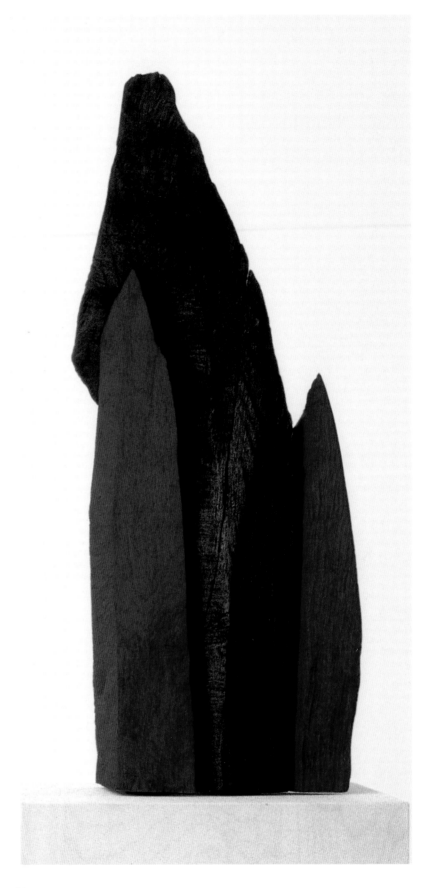

Above:
Red and Black
partly charred oak
with red pigment and oil
2001
65 x 30 x 12 cm

UNIVERSAL FORMS

The simple gesture of putting crudely carved, geometrical forms into a natural environment was prompted by the idea that geometry could offer a way of understanding nature, gravity, space and time. As a child at primary school I engaged eagerly with maths, algebra and particularly geometry, an enthusiasm that diminished through secondary school as the teaching became exam-focused, but was encouraged again by lessons in drawing. Our art teacher taught us to draw in the manner of Cézanne – to deal with nature by means of the cylinder, sphere and the cone. When we complained about this endless drawing of geometric shapes, the reply always referred to Cézanne and curiously to Redon, whose architect teacher made him draw these objects for years (an experience that Redon later valued greatly, describing it as fundamental to his later work).

I have long been fascinated by these universal forms. They are present in three mountains seen from Porthmadog, close to where I live in North Wales: the pyramid in Cnicht, the sphere in Moelwyn Mawr and a rugged cube in Moelwyn Bach. For over thirty years, I have lived at the foot of one of Blaenau Ffestiniog's slate tips, formed from unusable slate from the workings. Loads are pushed along a level railway track and tipped at the end of the line. As a result the structure of the tip is one of horizontal and diagonal lines. My work involves geometric cuts in the natural form of the wood, and I think that these geometrical forms have grown into me while I have lived among the slate tips. Ancient cultures revered geometry as a living force active in all things. For the ancient Greeks, Geometria was one of the seven hand-maidens of the Goddess Natura. By contrast, our materialism has largely reduced our perception of geometry to a two-dimensional static abstraction – a sort of design tool.

These forms are entirely independent of each other and from early on in my career, I have worked them as single forms: the cube (in particular), the sphere and the pyramid. Being in awe of these forms, I found it difficult at first to work with them. I made some attempts in the early 'seventies – a small carving of a pyramid and cube on three shelves,

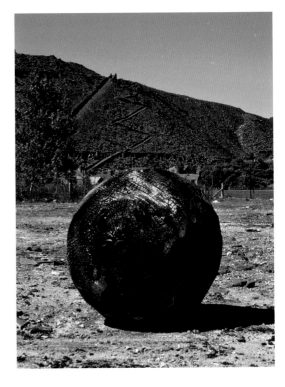

Above: *Sphere* from *Cube, Sphere, Pyramid,* charred oak, 1996, at Blaenau Ffestiniog, North Wales.

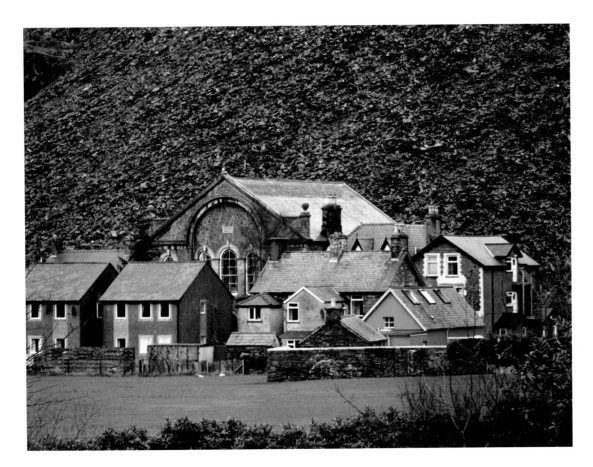

Left: Capel Rhiw, Blaenau Ffestiniog, 1996. The chapel in the centre is Capel Rhiw, David Nash's studio since 1968. The painted building to the right is a converted shop, now Nash's drawing studio.

Above: pyramid, sphere and cube identified by Nash in the mountains of Cnicht, Moelwyn Mawr and Moelwyn Bach, seen from Porthmadog, Gwynedd, North Wales.

Centre, left:
Block Oak Root
1970
64 x 52 x 54 cm

One of the small number of representational sculptures made by Nash: the cube refers to his studio chapel, and the knotted oak root to the mountains surrounding it.

Centre, right:
Cutting Round the Cube
sycamore
1979
25 x 25 x 25 cm

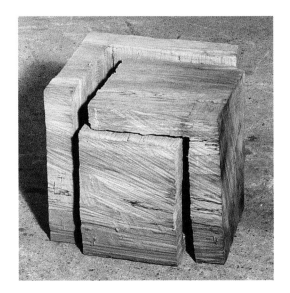

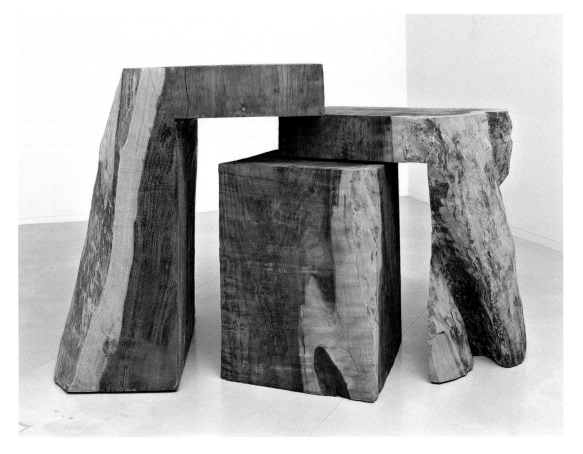

Right:
Capped Block
redwood
1998
115 x 127 x 134.5 cm

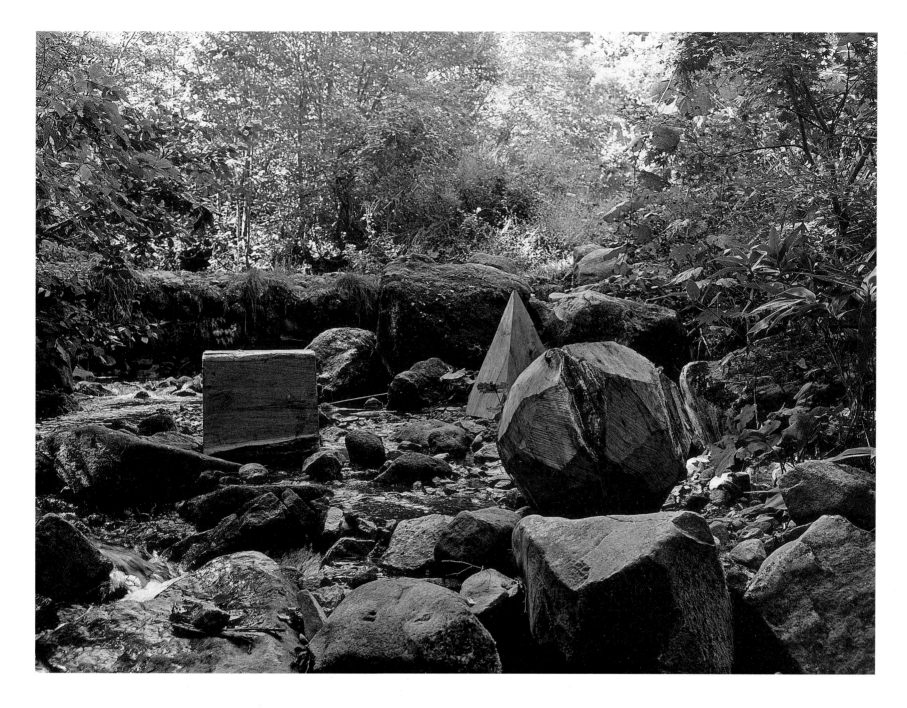

the rough spheres and the table with cubes – but it was not until 1978 that I found a direct way of approaching them with the *Wooden Boulder*, a rough sphere of oak, which ended up in a stream (*see* pages 66-75).

My main interest is to bring an activity to geometrical form. The rough marks of carving on the *Wooden Boulder* indicate to an observer that the object is man-made, and this connection becomes a stepping stone into the activity of its environment – the time reality of the streaming water. The same is true of the Cracking Boxes – hollow cubes constructed as square as I can make them with very rough green (unseasoned) slabs of wood, knowing that they will crack, warp and bend as they dry out. The observer can sense the original geometrical form in relation to what it has become and connects with the active reality of the material as it dries, breaking that order, challenging it. I've made probably a dozen boxes, some are tiny, some are large. All woods behave differently. There was a redwood one which wouldn't crack at all so it was renamed *Strongbox* (1989).

In 1984, when working next to a shallow river in Japan, I was told that in the rainy season it became a raging torrent. In response to this information I carved an oak pyramid, sphere and cube and placed them in shallow water in anticipation of them being swept away – scattered to other places.

Nature to Nature
oak
Japan, 1984
cube: 60 x 50 x 50 cm
sphere: 55 cm in diameter
pyramid: 70 x 40 x 40 cm

In Australia I applied fire to the same forms but in this case retrieved them when I realised drawings could be made of the shapes using their charred surfaces. There was an exhibition of the results of a wood quarry in Melbourne, Australia, at Heide Art Gallery and Park, a private home built to house a collection of contemporary art (and cleverly designed ultimately to become a public museum). One room had a wide fireplace and it occurred to me to make a burnt set of Cube Sphere and Pyramid (pulling them out of the fire once they were charred) and to set them in the fireplace. It also seemed appropriate to place drawings of the forms in the hearth on the blank wall above. I used the charred surfaces of the objects to start the drawing – a process which made quite a mess over the paper – and then used regular charcoal to give definition and density to the triangle, square and circle.

This in turn led to my realising the difference in how we read three-dimensional objects and two-dimensional images. An object exists in space subject to gravity and we read its size in relation to our own body scale; its physical presence is a strong part of the experience. A two-dimensional image is read more directly by the imagination, and its size is less significant. Placing a physical object on the floor and its image on the wall – juxtaposing the three-dimensional with the two-dimensional – two different kinds of seeing, a simultaneous dual perception which enhances both object and image. (This works only with very basic forms.) The experience is complete, simple, continuous and curiously satisfying.

While working on a project in Japan, in northern Hokkaido, I noticed that one of the dead trees I had been given, a big elm, appeared very rotten, indicating the opportunity for a tall, hollow form. When we came to cut it down, the rot proved not to be deep, and

Red and Black, Cube Sphere Pyramid
partly charred redwood
and pastel and charcoal on paper
1997-1999
cube: 65 x 61 x 61 cm
sphere: 63 x 55 x 55 cm
pyramid: 86.5 x 71 x 64 cm

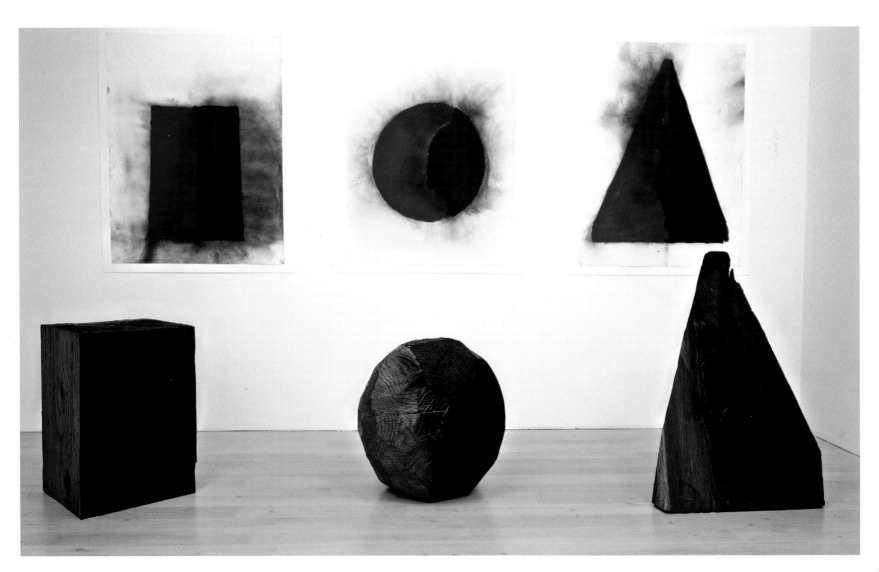

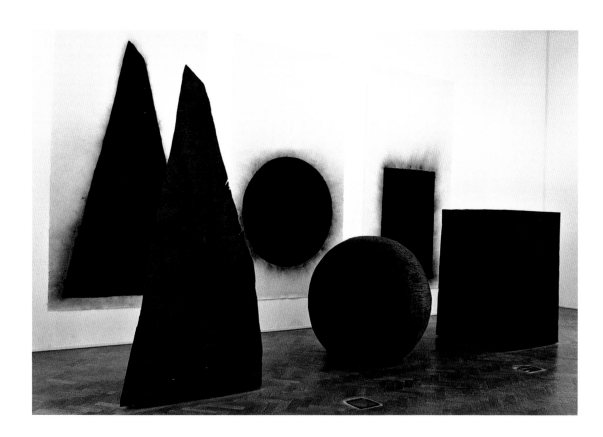

Left:
Pyramid, Sphere and Cube
charred oak
and charcoal on paper
1999
pyramid: 235 x 110 x 105 cm
sphere: 105 cm in diameter
cube: 137 x 92 x 92 cm
installation including drawings: 300 x 420 x 110 cm

Below:
Cube, Sphere, Pyramid
yew
1997
cube: 32 x 25 x 25 cm
sphere: 31 x 30 x 30 cm
pyramid: 51 x 29 x 29 cm

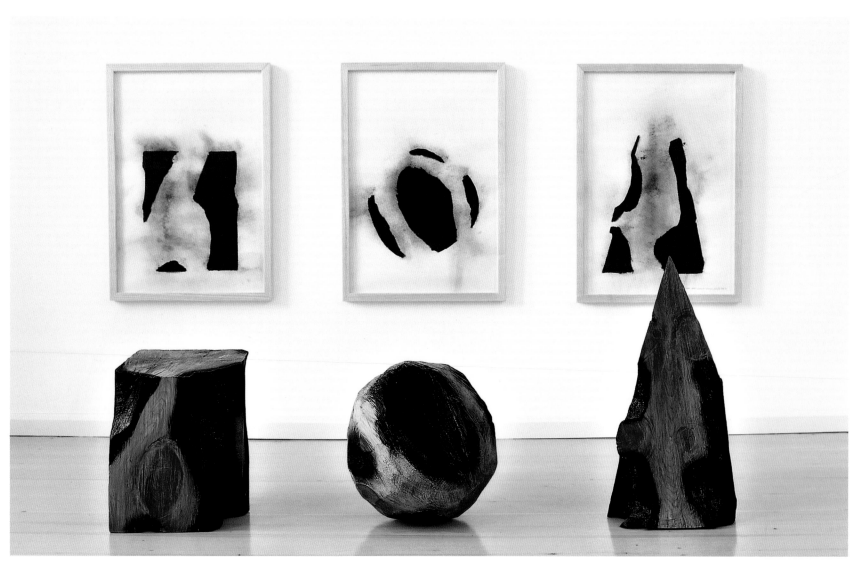

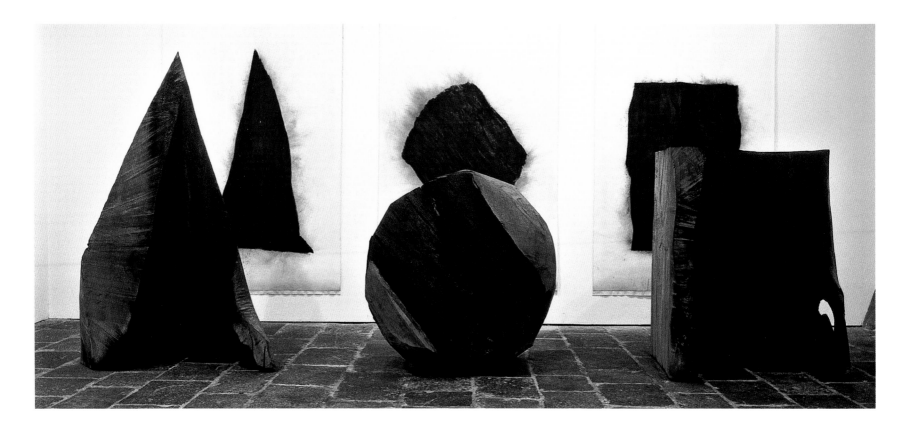

Pyramid, Sphere, Cube
partly charred elm
and charcoal on paper
1993-1994
pyramid: 205 x 135 x 135 cm
sphere: 136 x 130 x 105 cm
cube: 140 x 108 x 97 cm
installation including drawings: 300 x 514 x 150 cm

there was much more weight and carvable wood than had been anticipated. The opportunity changed to a large version of Pyramid, Sphere, Cube. The shapes were cut to include the presence of the rotten areas which were then carved out and purged by fire. Drawings were made of the charred shapes which penetrated the geometric forms.

If I am lining them up, I always put the sphere in the middle. The cube and the pyramid are more similar to each other than to the sphere, especially as I use a three-sided pyramid (strictly speaking a tetrahedron). Herding the three forms together provoked contemplation about the three different characters, qualities and representations.

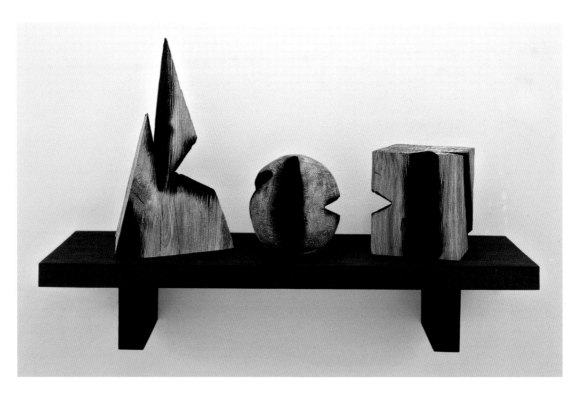

Pyramid, Sphere, Cube, Incised
partly charred lime
2005
47 x 91.3 x 30.5 cm overall

163

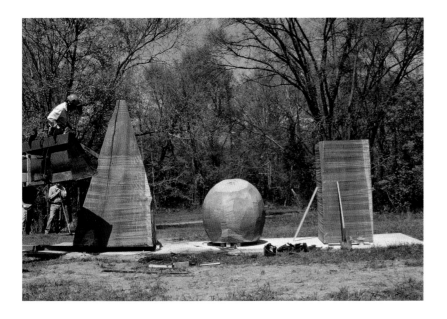

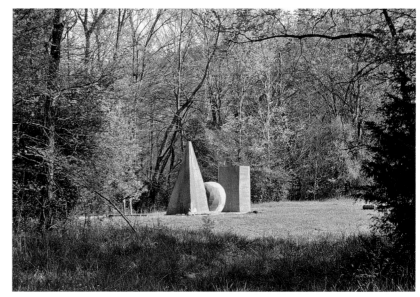

Cube – two, four, six. Even numbers: balanced, static, inert. Two sets of parallel vertical sides, two horizontal surfaces – top and base; four corners, six sides. The cube represents all that is material.

Sphere – one, centre of all directions, one continual surface, mobile orbital represents movement.

Pyramid (three-sided, strictly a tetrahedron) – three, the first 'odd' number; active, rising dynamic; represents time and space.

These 'representations' come out of my experience of making and of living with these forms. I remain fascinated by how different they are while being so closely related. The Japanese Zen artist Sengai represents the movement from spirit to material through action (phases) by overlapping a circle (spirit) with a triangle (action) which in turn is overlapped by a square (material).

I found that the qualities of the forms were enhanced by subtle distortion. The cube

Pyramid, Sphere and Cube
redwood
Arkansas, 2004
pyramid: 290 x 150 x 185 cm
sphere: 125 cm high, 118 cm in diameter
cube: 195 x 105 x 100 cm
installation: 290 x 573 x 150 cm

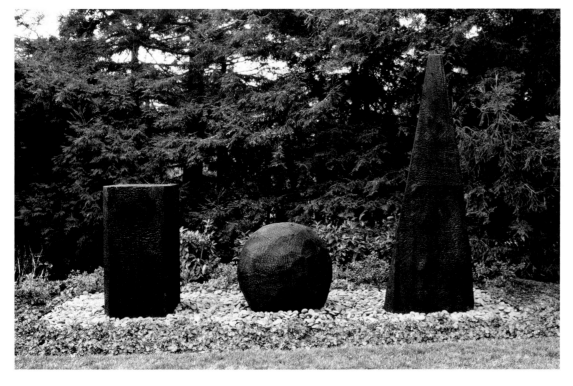

Left:
Cube, Sphere, Pyramid
charred redwood
California, 1997
cube: 150 x 115 x 115 cm
sphere: 115 in diameter
pyramid: 300 x 120 x 120 cm
installation: 200 x 550 x 120 cm

Opposite page:
*Pyramids Rise, Spheres Turn
and Cubes Stand Still*
charred oak (recycled from a highways project),
2000
pyramid: 270 x 210 x 210 cm
sphere: 250 x 260 x 260 cm
cube: 280 x 220 x 220 cm

The site chosen for this sculpture, in collaboration with the City Art Programme of Chicago, is at the balancing point between three vistas: the line of the lake's horizon, the neo-classical architecture of the museums and the contemporary Chicago cityscape. The two styles of architecture are opposites, but the forms of the sculpture relate to both.

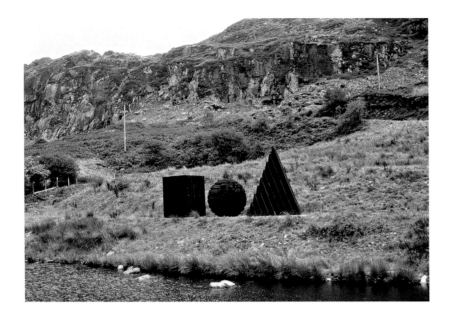

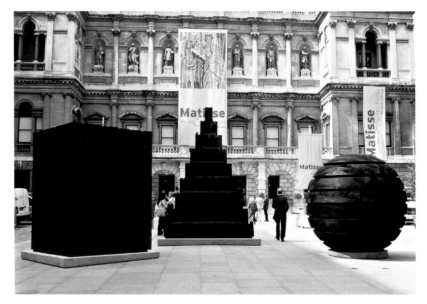

Pyramids Rise, Spheres Turn and Cubes Stay Still
charred oak
2002
pyramid: 260 x 210 x 210 cm
sphere: 240 cm high x 250 cm in diameter
cube: 250 x 200 x 200 cm
In Blaenau Ffestiniog, North Wales (left), and at
the Royal Academy, London (right).

is inert and squat when all sides are equal, and alert when the 'cube' is taller than it is wide. The pyramid has more dynamic when it is three-sided on a triangular base, four-sided it is too solid in feeling, too connected to the cube. Their qualities are also enhanced by the addition of the three cardinal directions of a straight line: the vertical can be applied to the cube, the horizontal to the sphere, and the diagonal to the pyramid.

I discovered that these forms need only to be hinted at to be seen. There is a barely discernible square sheepfold on a hillside near Blaenau. All the stone walls have collapsed so that only a trace remains, but it is enough to allow the eye to make out the original square shape. No more than a suggestion of a triangle or pyramid shape or a fragment of a circle will prompt the mind to complete the form. This realisation led me to make forms larger than the wood can completely contain.

According to Plato for whom reincarnation was a reality, our experience as non-material beings between successive material incarnations is 'geometric'. Contained within us is a geometrical essence, and thus, when we see these shapes we recognise them instantly, even if subliminally. These are universal forms.

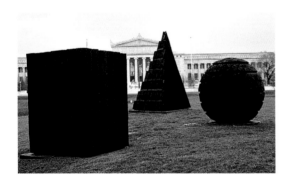

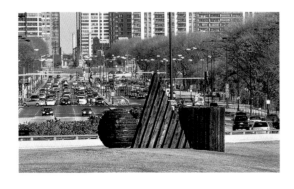

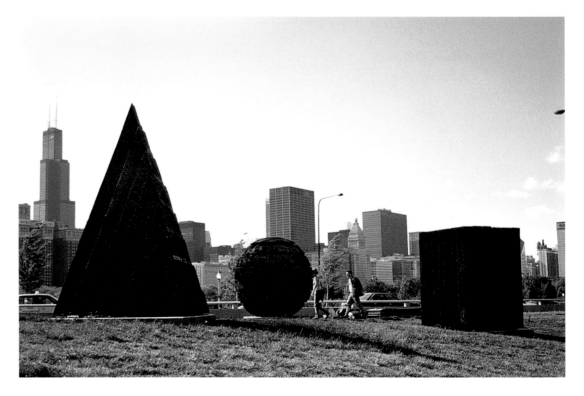

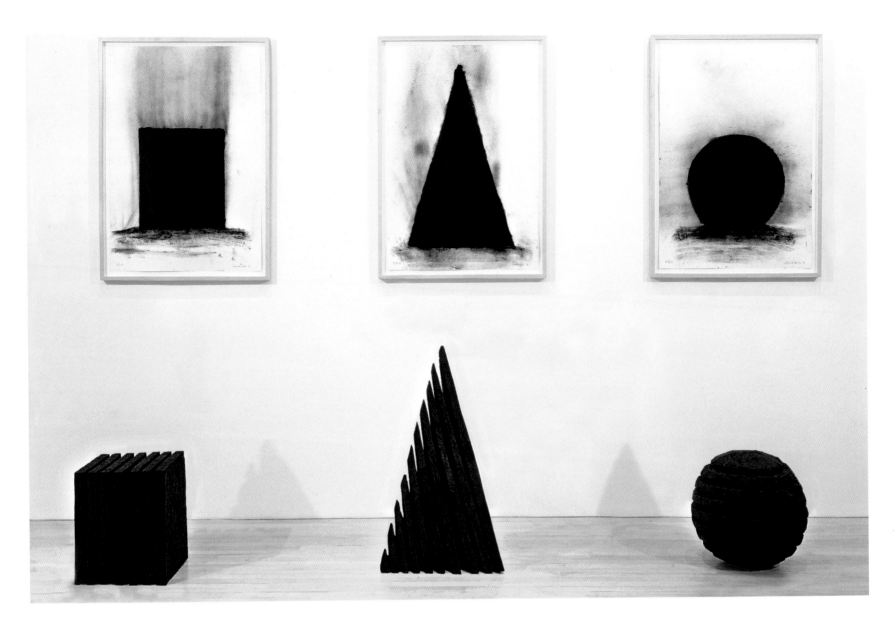

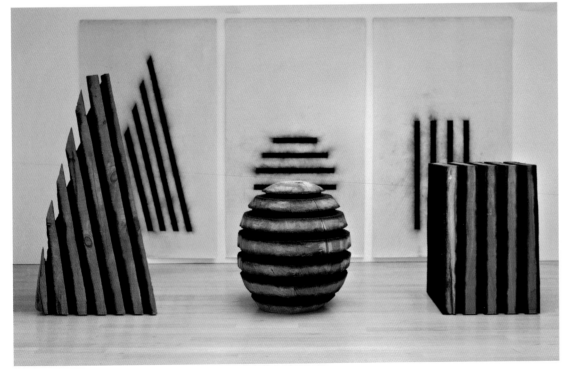

Three Forms, Incised and Charred
cube - vertical, sphere - horizontal, pyramid - diagonal
charred ash, and charcoal on paper
1992
cube: 58.5 x 48 x 48 cm
sphere: 61 cm in diameter
pyramid: 119 x 56 x 56 cm
drawings: 108 x 78 cm

Pyramid, Sphere, Cube, Incised
partly charred cypress, and charcoal on paper
2000
pyramid: 197 x 105 x 70 cm
sphere: 105 x 80 x 100 cm
cube: 119 x 80 x 75 cm

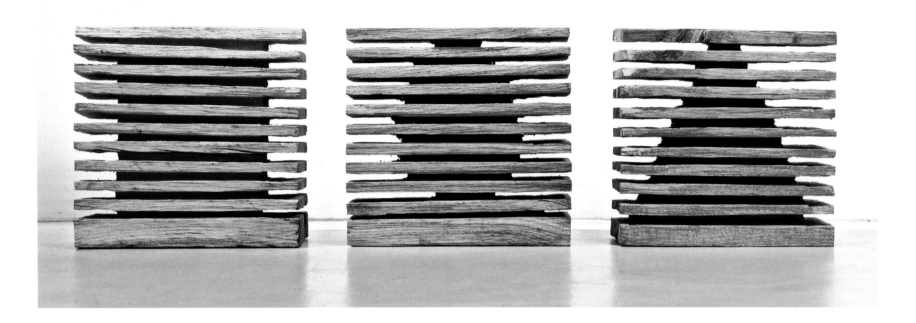

Serrated Blocks, Cube Sphere Pyramid
oak
2000
each 28 x 28 x 13 cm

Cube, Sphere, Pyramid
charred oak
2005
cube: 137.5 x 95 x 92.5 cm
sphere: 107.5 x 95 x 107.5 cm
pyramid: 272.5 x 145 x 115 cm

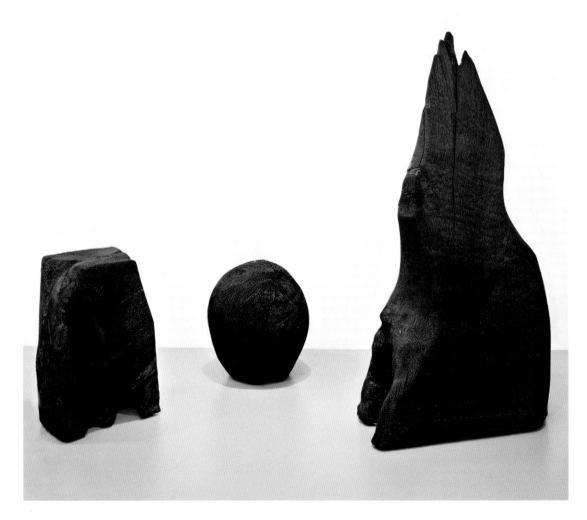

cube solid unmoving matter

sphere movement turning time

pyramid rising expanding space

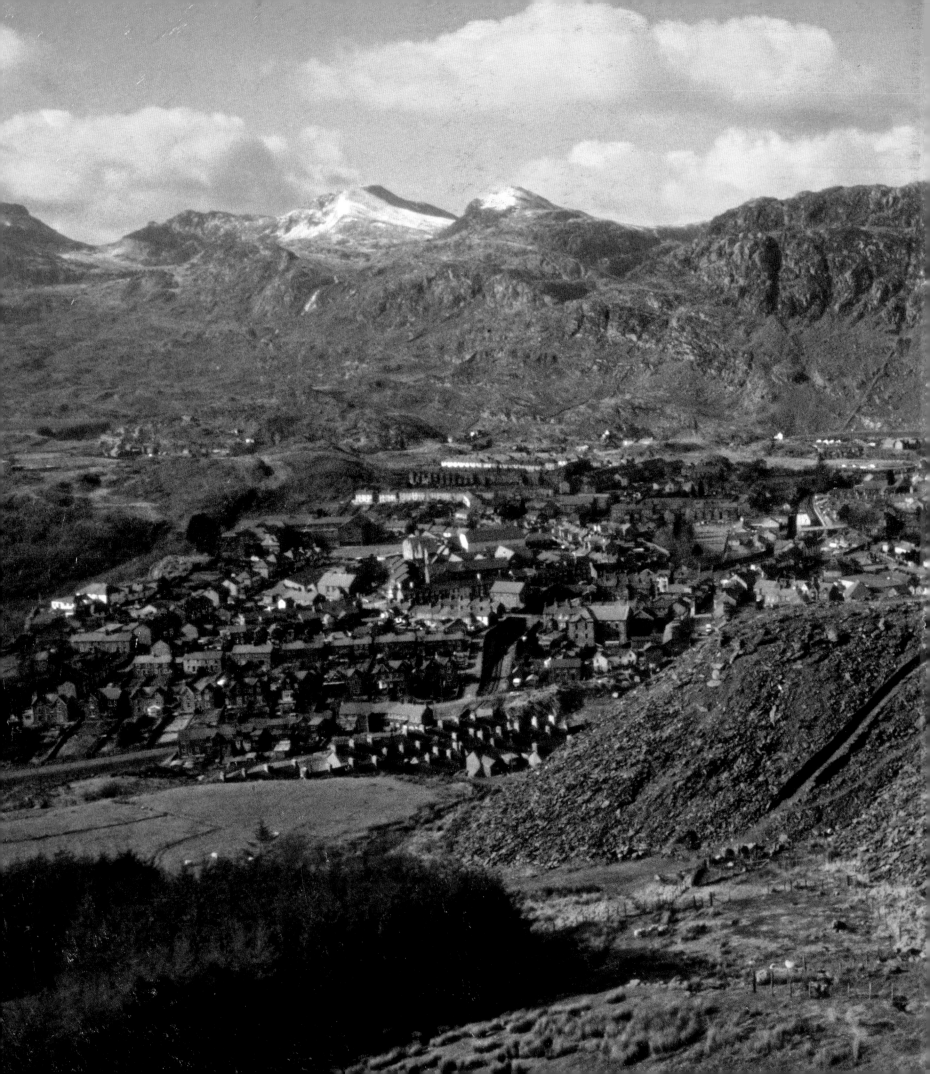